MUSEUM LANGUAGES

Museum Languages: Objects and Texts

EDITED BY GAYNOR KAVANAGH

LEICESTER UNIVERSITY PRESS
Leicester, London and New York

© Editor and Contributors 1991
First published in Great Britain in 1991 by Leicester University Press
(a division of Pinter Publishers)

Reprinted 1996

Editorial offices
Fielding Johnson Building, University of Leicester, University Road, Leicester,
LE1 7RH, England

Trade and other enquiries
Wellington House, 125 Strand, London, WC2R 0BB

For enquiries in North America please contact PO Box 197, Irvington,
NY 10533

British Library cataloguing in publication data
A CIP catalogue record for this book is available from the British Library.

ISBN 0-7185-1359-2

Library of Congress cataloging in publication data
A CIP catalog record for this book is available from the Library of Congress.

Typeset by Witwell Ltd, Southport, in 10/12 point Times
Printed and bound in Great Britain by SRP Ltd., Exeter.

Contents

List of figures

List of tables

Acknowledgments

I am pleased to acknowledge and thank: British Gas, British Gas East Midlands and the Museums and Galleries Commission, who sponsored the conference 'Breaking New Ground', all those who contributed to the conference or helped with its administration, and Leicester University Press for its continued commitment to the publication of museum studies literature. Special thanks are due to Dr Eilean Hooper-Greenhill, Dr Susan Pearce, Jim Roberts and Madeline Lowe for their advice on aspects of this volume.

GAYNOR KAVANAGH
April 1991

1 *Introduction*

GAYNOR KAVANAGH

Introduction

GAYNOR KAVANAGH

In April 1990, the Department of Museum Studies at the University of Leicester staged its second major conference. It brought together a group of academics, consultants and museum professionals whose current research was felt to be innovative or addressing current museum issues. The conference was given the title 'Breaking New Ground', in recognition of the new perspectives the speakers brought with them. This volume and its companion, *The Museums Profession: Internal and External Relations*, arise out of it.

The span of contents indicate those research fields currently receiving attention. In *The Museums Profession: Internal and External Relations*, the emphasis is on issues of professional development, museum management and performance. In contrast, *Museum Languages: Objects and Texts* contains chapters on museum communication in its many forms, museum visiting, and collecting. Together, these two volumes cover those areas most evident in museum thinking and planning today. The quality of museum provision and the dependence of this not only on skilful management, but also effective development of the museums profession have dominated discussions since the early 1980s. Equally, the ability of museums to communicate successfully and to create meaningful and relevant provision are central issues, ones continually open to debate.

Certain themes may be seen to be absent. Most obvious is collection management. Although significant developments have occurred, research appears to take the form of commissioned work and one-off projects such as that undertaken in Scotland (Ramer 1989) and by the Office of Arts and Libraries (Lord *et al.* 1989). The importance of collection management has by no means diminished, but it appears not to be

attracting research interest at postgraduate and postdoctoral level to the same degree as other fields.

Research on the scale and variance of museum provision is also not represented here. In this regard, the discontinuance of the Museums Association's Data-Base survey, which provided a detailed study of museum provision in 1986 and 1987, has to be regretted. Continual mapping of current levels of provision is a sound basis for forward planning, especially if this is carried out in cognition of active research within museum, social and cultural studies. In the years since 1987, this has not been possible on a national level because of the absence of statistics. But in the early 1990s, this situation will change. The Museums and Galleries Commission plans to provide analysis of the information being generated through the registration of museums and to publish this as a *Digest of Museum Statistics*. This will be a welcome development and a considerable help to museum studies research.

It is highly appropriate that this volume should be devoted to the consideration of museum languages, essentially different aspects of communication within museums and between them and the public. In a recently published report on the future management of independent museums, Victor T.C. Middleton made two important observations. The first is that museums in all sectors of provision 'changed more in the 1980s than in any other decade this century'. The second is that we are witnessing transition to new patterns of demand, which are likely to influence the supply, character and management of museums in the twenty-first century (Middleton 1990: 9–10). The change brought about in museums in the 1980s largely evidenced itself in the increased standard of care and service offered to the visiting public. The future success of museums lies fundamentally in the relationships developed and nurtured with museum visitors and all those within potential and real museum constituencies. This must rest to some extent on the understanding of, first, the museum as a cultural and social institution and, second, all those processes through which knowledge is gathered and exchanged. This volume is a contribution to that understanding.

Much research in this area has had to try and lay to rest a number of well-established, often untested, convictions. These include the notion that the museum is a neutral space, innocent of conveying anything but the word-for-word content of labels and the silent unambiguous messages transmitted by objects 'speaking for themselves'. Strongly held assumptions that there is a 'general public', undifferentiated by gender, age and cultural background, which respond uniformly to the museum's expectations of it, have had to be confronted. The role of scholarship has had to be explored and where it obscures rather than enlightens it has had to be criticized. The conviction that all museums by definition are 'Good Things' has been particularly difficult to challenge. The unques-

tioned belief that museum practice is without real flaw still holds sway in some quarters. Arguably, some of the attitudes encountered, although by no means held by the majority of museum professionals, are borne of curatorial traditions and have developed to the point of belief systems.

Perhaps because research within museum communication has had, in the first instance, to address these convictions, many of the important ideas expressed and practices demonstrated have met with hostility and, in some quarters, rejection. This is not, however, universal. Museum practice which seeks positive development, in terms of scholarship and relationships with visitors, and which is aware of both the dynamics of its discipline and changing public attitudes and needs, is already drawing on and often experimenting with some of the ideas discussed in this volume. A growing number of museums are conducting their own evaluative research on their systems of communication or are commissioning independent consultants to carry out this work. Further, there has also been a significant increase in the number of postgraduate museum studies students undertaking original work, especially at doctoral level, in different aspects of this field.

In general terms, communication studies is a very wide academic subject indeed and may include aspects of cultural and gender studies, linguistics, semiotics, psychology and education. Research conducted on museums and debate about them have come from two different directions: from inside the museum field and from those operating outside it, often cultural historians, sociologists, semiologists and journalists. The work of Donald Horne (1984), Patrick Wright (1985), Robert Hewison (1987), Ludmilla Jordanova (1989) are examples of the latter. Their arguments have been unencumbered by knowledge of the difficulties entailed in running a museum and enlivened by an independence of perspective. As contentious as their views have been, they and others have helped provoke the museums profession out of a long-held complacency about the roles and impact of museums.

Critical views from allied academic subjects are helpful. If the sign which is the museum is not understood by museum professionals, there cannot be a way forward. Therefore, the semiotics of signification have received much attention from people studying, writing and working within museum studies. But it is recognized that this is not enough in itself. The cultural analysis and de-construction of the museum serves well the intellect, but does not necessarily offer useful means of developing more effective, relevant provision. Consequently, the research being generated within museum studies is characterized by both its very critical examination of established museums and its search for theories and methods which both strengthen practice and empower positive, constructive change.

There is a distinct tension here between the exploration of hidden

agendas and social codes *and* the development of intended messages, positive environments and open dialogue between museums and visitors. The more that museums are studied the more we are aware of the complexities of power and possession within them. The more that museum visiting is studied, the more it is evident that it is not a straightforward phenomenon on which there is agreement. Further, such studies uncomfortably reveal how great a gap exists between their results and the belief, held firmly by many in museum employment, that museum provision should be democratic and enabling. There are no smooth paths and no easy answers.

Ghislaine Lawrence (chapter 2) considers the approaches taken to the evaluation of museum exhibitions. She traces the origins, and some of the assumptions and implications of evaluation used in museums, and examines the relationship of evaluative techniques to other forms of critical practice which might be brought to bear on exhibitions. Dr Lawrence discusses how museums have continued a positivist, empirist and behaviourist approach to evaluation, even though this has been largely discredited within the field of cognitive psychology. She goes further by arguing the value of interpretative sociology, enthnometho-dolgy, psychology of remembering, and cultural studies to the explor-ation of the production of meaning in exhibitions and to the development of understanding of museum visiting.

Dr Paulette McManus (chapter 3) exemplifies the behavioural approach to the study of museum visiting. She draws on evaluative work undertaken at the Natural History Museum and the Science Museum in which she studied the behaviour of visitors within the exhibition environment. From this, she examines communication models useful in the preparation of exhibitions in museums. In particular, she seeks to illustrate factors which she sees as leading to success or failure in the museum's formulation of messages for the visitor.

Dr Eilean Hooper-Greenhill (chapter 4) similarly addresses the need to develop communication models for museums, although her perspective draws on semiological studies of meaning and relevance. She analyses the attempts made to interpret museums from a semiological perspective and examines the ways in which these might be of value in understanding more about the meanings to be found in museums. She points to a fundamental contrast of approach between the semiology of signification, the study of sign which is the museum, the semiology of communication, the study of the presentation and reading of intended messages. From these, she develops a new communication model for museums which embraces the whole museum experience, the visitor as an individual and active creator of meanings, and the museum team as enablers.

In chapter 5, Dr Alan Radley focuses on the experience of people rather than the qualities of visitors. He argues that people's recollections

of visiting museums are constructed out of their experiences, and that their grasp of museum objects relates to their grasp of a past, the memories of which are culturally formed. He argues that it is not enough to consider the experience of a museum visit solely from analysing the intentions of the curators in the preparation of exhibitions. A museum visit is made significant to an individual through a range of factors beyond the curatorial and include the social, physical and personal.

Helen Coxall (chapter 6) explores the use of language in museum texts, which she acknowledges to be a neglected area of study. Through linguistic analysis, she considers how the official policy of the museum and the ideological perspective of the text writer are exposed through museum labels, signs and publications. Using examples of museum text, she discusses the ways in which the language adopted in museums conveys socially constructed views, assumptions and bias.

Gaby Porter (chapter 7) examines representation in museums, drawing on critical practices employed in other media, particularly literature and popular culture. Her exploration of museum practice invokes post-structuralist and feminist critiques of impartial, objective knowledge and truth. Through the consideration of two case studies, Gaby Porter examines two themes: the feminine as the border of male knowledge, and the relationship of gender and technology. She argues the case for the de-construction of museums so that re-construction, and in consequence the production of new representations, can take place.

Dr Nima Poovaya Smith (chapter 8) reflects on changes in the art scene which have taken place since the race riots of 1981. She considers three temporary exhibitions, which involved the historical and con-temporary works of Asian and Afro-Carribbean peoples, as evidence of changing attitudes to catering for a pluralistic public. She also considers the public and media responses to such exhibitions. Further, she questions whether they create or promote change, or whether their impact is significantly less than desired. Through the proposition that collections are what we are, Dr Susan Pearce argues that collection studies exists as legitimate academic field. In chapter 9, she explores aspects of the nature of collections and collecting, in an effort to identify the cultural implications of this most central of all museum activities. She identifies three modes of collecting, to which museum collections belong: collections as 'souvenirs', 'fetish objects' and 'systematics'. These are explored within a phenomenological framework.

Finally, in chapter 10, Kevin Moore examines the exhibitions held in the Liverpool Mechanics Institution in the 1840s. He suggests that there is much to be derived from studying past exhibition forms. They demonstrate changing ideas about education, entertainment and audiences. Kevin Moore proposes that the study of the mechanics institutes offers signposts to the ways in which museums today might,

first, be less isolated from other cultural and social institutions and, second, more accessible to working-class audiences.

All the chapters in this volume either implicitly or explicitly underline the case for further research on museum languages. They make evident how great the need is to understand more about what happens *inside* museums and how this relates to the world *outside* them. Both the weight of convention within curatorial practice and the connectedness of museums to their social and political environments leave no room for doubt about the need to keep provision continually under review.

A number of very different theoretical approaches have been adopted here and make evident the exploratory nature of current research. Obviously, there is a great deal more to be questioned and understood. But, the work is now under way and the agenda quite clear. A central part of the process of building more effective museum provision must be founded on detailed comprehension of the museum as it exists today, with all its flaws and merits, in the context of the complex society it aims to serve. Having grasped this, the adaption and development of provision for a constantly changing world becomes a particularly challenging task, but one more likely to meet with success.

BIBLIOGRAPHY

Hewison, R., 1987. *The Heritage Industry: Britain in a Climate of Decline*, Methuen, London.

Horne, D., 1984. *The Great Museum. The Re-presentation of History*, Pluto, London.

Jordanova, L., 1989. 'Objects of knowledge; a historical perspective on museums', in Vergo, P. (ed.), *The New Museology*, Reaktion Books, London.

Lord, B. *et al.*, 1989. *The Cost of Collecting. Collection Management in the UK*, HMSO, London.

Middleton, V. C. T., 1990. *New Visions for Independent Museums in the UK*, AIM, West Sussex.

Ramer, B., 1989. *A Conservation Survey of Museum Collections in Scotland*, Scottish Museums Council, Edinburgh.

Wright, P., 1985. *On Living in an Old Country. The National Past in Contemporary Britain*, Verso, London.

2 Rats, street gangs and culture: evaluation in museums

GHISLAINE LAWRENCE

Rats, street gangs and culture: evaluation in museums

GHISLAINE LAWRENCE

Evaluation has been described by its advocates in museums as the 'scientific' approach to furthering knowledge about effective exhibits (Miles 1988: 127). This paper is about the origins and some of the assumptions and implications of professional evaluation as used in museums, and briefly considers how the technique relates to other forms of critical practice which may be brought to bear on exhibitions.

Exhibition evaluation has come to prominence in the museum world in the last fifteen to twenty years (Griggs 1984: 412). The systematic evaluation of projects, programmes or policies was, however, used considerably earlier in other fields. Some authors consider work in educational institutions dating from the 1890s as the earliest examples (Deutscher and Ostrander 1985: 13). Others record that systematic evaluation was devised in the modern form by sociologists assessing rural technology programmes in the United States in the 1930s (Coleman 1978: 683, 696). After the Second World War, evaluation research appeared sporadically, and after 1960 with increasing frequency, in the literature of applied sociology, often in connection with social policy research, particularly in the rather specialized applied field of education (Deutscher and Ostrander 1985: 14–24).

Historical accounts of the disciplines in which evaluative research was first adopted have revealed marked ideological similarities during the early years of this century. In sociology, practitioners struggling to establish departments in the universities of Britain and North America were careful to distance themselves from certain ideas current in European thought; not for them the phenomenological or existentialist philosophies of Husserl, Merleau-Ponty or Heidegger which flourished on the Continent – all world views which gave the subjective equal or

greater priority than the so-called objective viewpoint. 'In the social sciences the subjective . . . became disreputable' (Benson and Hughes 1983: 193). The way forward was seen to lie in as close an alignment as possible with the success of the natural sciences and their hallmarks of rigorous empiricism, quantification, causal reasoning and predictive power. This alignment had considerable implications for what was considered appropriate methodology. Sociology, particularly in North America, became predominantly empirical, and the method which above all came to be associated with it was the social survey. The survey drew on empirical data, produced quantifiable results amenable to statistical analysis and, its advocates claimed, was free from subjective bias.

In the applied field of education, those seeking 'scientific' accounts of the learning processes looked to psychology, the established science of the mind (or rather, of behaviour), to provide them. The close alliance of education with psychology was to have lasting effect, and the model to which almost all psychologists in the early decades of this century aspired was again that of the natural sciences. The earliest institutional organization of psychology had been at the Vienna laboratory of Wilhelm Wundt in the 1890s (Danziger 1990: 396–409). Wundt's methods, depending heavily on introspection, were soon to be criticized as 'too metaphysical' in the academic departments of psychology subsequently established, often by his pupils, in North America. Here, it was claimed, *scientific* psychology was carried out, which distanced itself from the liberal arts and sought to capitalize on the success of physical science. In practice this ideal translated into a concern with method and technique, with 'the means of achieving objective description and measurement of mental content and capacities' (Smith 1990: 411). Outside pressures on psychologists to produce useful knowledge about what people do and how that could be altered coincided with inside pressures to maximize the objectivity of experimental technique by recording only physical variables. The ensuing movement, known as behaviourism, deliberately chose to forgo any attempt to deal with 'inner' mental processes in favour of what was observable, and its core topic became the 'stimulus–response' relation.

If educationalists were interested in psychology, the latter discipline, increasingly behaviourist dominated, was certainly interested in education — or rather in learning theory. Learning theory, which has been described as the 'heartland' of earlier forms of behaviourism, derived its methods almost exclusively from work with animals in laboratories freely extrapolated to man. A leading psychologist, E. C. Tolman, wrote in 1938:

I believe that everything important in psychology (except such matters as the building up of a super-ego, that is everything save such matters

as involve society and words) can be investigated in essence through the continued experimental and theoretical analysis of the determiners of rat behaviour at a choice point in a maze. Herein I believe I agree with Professor Hull and also with Professor Thorndike (Tolman 1938: 34).

Museums opened their doors to evaluation of their practices in the 1920s — a time when some were under pressure to demonstrate their utility in order to justify funding. Particularly in North America, stress on the museum's *educational* role had begun to feature large in their rhetoric. Given that education was widely perceived in behavioural terms, it is hardly surprising that behaviourist psychologists led the way in professionally evaluating the museum experience. It is no accident that E.S. Robinson's often cited paper of 1928 was entitled 'The *Behavior* of the Museum Visitor' (Robinson 1928: 1). A professor of psychology at Yale, Robinson quantified temporo-spatial visitor behaviour as a means of evaluating museum exhibition. He cited leading behaviourists in support of his view that the public museum was 'essentially a psychological institution' whose 'future development ought to be guided by the results of formal, psychological investigation' (Robinson 1931: 122). Robinson's concealed observers, with stopwatch and notebook in hand, recorded for example how long visitors to art galleries spent in front of particular paintings. His research assistant, A. W. Melton, became a research associate of the American Association of Museums in 1930, identifying the so-called 'right turning' tendency of visitors and the 'distraction effect' of exits, which he included amongst determinants of 'routing behaviour' (Melton 1972: 393). Robinson and Melton persuaded other museums to make 'experimental changes in their exhibits for the purposes of psychological measurement' (Robinson 1931: 122). Amongst these was the experiment of creating a second exit in a gallery. From this Melton concluded that:

> The exit . . . acts as an extremely interesting object and competes with the art objects for attention. This has been shown by the marked decrease in the total time visitors spend in a gallery when a new exit is opened. Visitors spent, on the average, 73 seconds in a period room before the a new door was opened, and they spent only 23 seconds in the room after the door was opened. Even the removal of all the paintings or all the furniture from this room before the new door was opened failed to decrease the average room-time of the visitors below 52 seconds . . . (Melton 1972: 400).

Melton made many similar experiments on the presumed rat-like visitor by altering the museum maze. Focus on temporo-spatial behavioural change alone led him not to differentiate between attraction to an exit

and to an object. Similar studies of visitor behaviour, together with discussions of how best to observe and record it, form the bulk of the small number of museum exhibition evaluation studies published prior to 1960. Explicit citations of the behaviourists Thorndike and Hull were still to be found as the 1960s progressed. So were studies which took the behaviourists' preoccupation with objective measurement of physical variables to its logical, reductionist conclusion. In order to measure the effect of the 'individual elements' such as pictures, sounds and objects in a Prague exhibition of 1961, visitors were fitted with electroencephalo-grams (machines which record change in the brain's electrical activity). The researchers thought it could be assumed that, with some technical improvement, these measurements would prove to be 'the most reliable aid in objective measurements of the effectiveness of artistic and didactic influence on the spectator' (Malík 1963: 264).

Survey research, designed to elicit visitor parameters, attitudes, and sometimes learning by questioning, rather than observing, individuals, made a somewhat later appearance on the museum scene. The first large-scale survey was that at the Royal Ontario Museum in 1959, still a model for much museum work (Abbey and Cameron 1959). Survey work was estimated, by the mid 1970s, to comprise two-thirds of all evaluative work done in museums (Alt 1983: 15). In the late 1960s, and in the mid 1970s, two bibliographies of museum evaluation were published. The first, in Eric Larrabee's *Museums and Education*, was entitled 'Chronological bibliography of museum visitor surveys' (Larrabee 1968) and the second *Studies of Visitor Behaviour in Museums and Exhibitions* (Elliott and Loomis 1975). Many entries appeared in both listings. The difference in titles reflects the two preoccupations of museum research — behaviour and survey — but also draws attention to important similarities between the two methods. Both are empirical, and both seek to make generalizations, preferably predictive and causal, from the study of individuals.

Behaviour and survey had indeed been the twin methodological preoccupations of the human sciences community, especially in North America, for the first half of the twentieth century. In the 1950s, however, new ideas had begun to gain influence. In psychology, behaviourism was attacked by those who turned to theorizing central processes — those processes between stimulus and response which the behaviourists had deliberately neglected or denied in their pursuit of objectivity. By the 1960s, there had been a so-called 'cognitive revolution' in psychology (Gardner 1985: 28–35; Baars 1986). Behaviourism was not dead but from then on had to contend with strong challenges to its model of simple associative chains between stimulus and response, which cognitive psychologists considered were utterly inadequate to account for serially ordered behaviour, especially language. Their models for central pro-

cesses drew on computing, mathematics, information processing and cybernetics. They still studied behaviour, but for the purpose of theorizing about the unobservable constructs — ideas, motives and other conscious elements — which might explain it. This change, great as it was, did not involve a rejection of empirical methods of objective observation and causal generalization.

In sociology, there was a much more fundamental attack on empiricism *per se*, which some have gone so far as to label a paradigm shift (Argyle 1978: 247–50). Alternative movements had long been stressing the inappropriateness of using methods modelled on those of the natural sciences to study social phenomena. What had been mere rumblings of discontent with the kind of 'facts' that empirical sociology was producing turned, in the early 1970s, into a full-scale revolt. 'The arrival of symbolic interactionism, phenomenology and ethnomethodology, and the ensuing methodological pluralism constituted an attack from which empirical sociology was never to recover its former overall supremacy' (Armstrong 1989: 116). These new movements, sometimes known as the 'interpretative sociologies', all rejected the positivist, empiricist paradigm as the proper one for the social sciences. The founders of symbolic interactionism, introduced at the University of Chicago in the 1920s and 1930s, maintained that meanings were 'social products formed through the activities of people interacting'. Efforts to reduce social research to routine and rule according to the accepted canons of scientific method 'distorted the social world and glossed over the character of the real operating factors in group life' (Benson and Hughes 1983: 44–5).

Questionnaires, interviews and scaling methods all served to distance the researcher from the real social world in the name of objectivity. The only adequate method was immediate experience obtained by participant observation. Researchers lived in and learned the social world constructed by groups — in street gangs, dance halls, or wherever social action occurred. They produced qualitative, detailed descriptions, often including large amounts of transcribed speech. Symbolic interactionism remained a fringe tradition in sociology in the 1950s and 1960s, always problematic. Exactly what degree of objectivity should the participant observer retain, since complete success involved the complete subjectivity of 'going native' and losing any analytical potential? The movement did, however, serve to maintain a concern with meaning in social life and with its construction by social actors. This concern was fundamental to the later movement of ethnomethodology, which took as its programme 'the investigation of the intersubjectivity of practical reasoning, and action' and was committed to 'the particularities of phenomena' (Benson and Hughes 1983: 194, 197). The theoretical basis of ethnomethodology was informed by many of the phenomenological ideas of Alfred Schutz.

For movements like these, *meaning* was the central problematic.

Subjectivity, not objectivity, was their concern. They stressed the socially constructed, negotiated character of meaning and its absolute contextual dependence, and they subjected the social survey in particular to a sustained critique. The conversion of social phenomena into variables to allow for statistical analysis and often causal inference, and the method of information gathering — the interview — were especially attacked (Marsh 1982: 53). The relevance to understanding everyday life, of gathering information in a situation 'designed to minimize the local, concrete, immediate circumstances of the particular encounter . . . and to emphasize only those aspects that could be kept general enough and demonstrable enough to be counted' and coded was called into question (Benney and Hughes, 1978: 180). It was pointed out that sociologists using surveys were often not interested in the answers to interview questions themselves, but merely took them as indicators about the respondents', say, aspirations, political views or social class. The interview was like 'a calibrated dipstick' — the sociologists presumed that what adhered to the stick itself was not important, except for what it indicated about something else. Furthermore, the interview was not an impersonal exercise in objective 'fact gathering' but a social situation like any other.

These critiques led to efforts among those who still supported the survey as a useful tool to try to eliminate what were regarded as previously unrecognized 'sources of error', rather than fundamental theoretical objections. Such technical 'improvements' have gradually been incorporated into survey work in the museum field. They include circumventing the expected tendency of respondents to give 'socially desirable' answers by offering 'equally respectable alternatives', avoiding the 'danger of fabrication' by the use of filter questions and tackling 'the problem of misunderstanding' by the use of pilot studies (Argyle 1978: 249). I shall return to the use of some such techniques in museums below. More radical movements in sociology regard such 'improvements' as doing little to remedy fundamental problems with the survey, and advocate descriptive methods closer to those of the humanities. Few areas of applied sociology have failed to be affected. In media studies, for example, the former emphasis on empirical surveying of 'effects on' individual members of the audience (often to make predictive generalizations) was replaced by descriptive studies of the content of programmes, and of programme genre. Concern was with how meaning got made, with messages, often symbolically coded, with the embodiment of dominant cultural assumptions, with issue of ideology and ultimately of power and social control. A special issue of *Journal of Communication* (*33*, 3) in 1983 was aptly entitled 'Ferment in the Field' and media studies has never returned to its earlier, atheoretical, empiricist-dominated form.

In education, from the late 1960s, fierce controversy was also engendered by criticism from the new movements. Key works, such as *Life in Classrooms* (Jackson 1968) or *Education and Social Control* (Sharp and Green 1975), which took ethnographic or descriptive approaches, stressed the centrality — not just the influence or relevance — of context. Their concern was not so much with what was taught and intended but with what was 'learnt and unintended', with what Jackson termed the 'hidden curriculum'. They took issue with the 'transmissionist' view of education, 'namely that the point of teaching is to transmit knowledge to pupils that they do not already know, that this knowledge pre-exists the lesson, that it is composed of propositions and that its transmission is under the control of the teacher' (Hammersley 1987: 236). Knowledge was *produced*, not transmitted, in the classroom. Schools were not neutral arbiters of knowledge and culture. Such stress on qualitative study of learning and the production of meaning in schools could hardly be further from the empiricist psychology of behaviourist-based learning theory. Their incompatibility became most obvious in the area of evaluation. Traditional methods, using quantitative behavioural indices, came under intense criticism. By 1977, readers in educational evaluation had titles such as *Beyond the Numbers Game*. An alternative title considered by the editors of this particular volume was 'Evaluation on the Run' (Hamilton *et al.* 1977: 3).

When we come to consider applied research in museums in the 1970s, however, ferment and radical revision are not words which spring to mind, although there is certainly evidence of an increased *interest* in evaluation. In Britain, evaluation of pre-set objectives was integral to the 'new' school of exhibition led by Roger Miles at the Natural History Museum (Miles and Tout 1978: 48). In the United States, Harris Shettel and C. G. Screven were prominent advocates of rather similar 'new' approaches (Shettel 1973; Screven 1986). It is at once apparent, however, that all three depended heavily on the traditional empirical tools of observation, survey interview, or structured questionnaire to evaluate exhibitions. All three shared a somewhat pragmatic approach to theory. Miles, for example, writing of the problem of validity that attaches to the use of questionnaires and the like, clearly considers it of little import, since 'evaluation research . . . is usually concerned with practical issues independent of theory' (Miles 1988: 164). It was apparently J.M. Keynes who once said that those who claimed to get along better without theory were simply in the grip of an older one (Eagleton 1983: vii). In its assumptions, this work is indeed rooted in the traditions of older, empirical sociology and older, often behaviourist, educational psychology. The Americans, Shettel and Screven, whose work is based in curriculum development studies, explicitly advocate the use of pre-set behavioural objectives in museum evaluation. In a very recent review,

Screven provides a graphic example of what the behaviourist approach to meeting behavioural indices means in practice. Because visitors enjoy, for example, discovering the effects of pushing buttons, the task according to Screven is 'to make such intrinsic rewards dependent on attending to exhibit content'. Pressing the right button in answer to a question about the exhibit might, say, light up an otherwise invisible 'extra' object. If visitors choose a wrong answer, however, Screven suggests that 'making all the buttons inoperable for three or four seconds is an "aversive" experience for most people' (Screven 1986: 114). Miles, though less strident in his advocacy of behavioural indices, considers it to be a 'prima-facie case' that psychology and education are the proper disciplines to underlie exhibition design (Miles 1988: 20). Those works which Miles and his associates most often cite — R. M. Gagné's *The Conditions of Learning* (Gagné 1970) is a favourite — reveal what kind of psychology and education are implied. The work of Gagné, writing in the 1960s and 1970s, is centred on the very model of curriculum development and evaluation — that of Ralph Tyler in 1949 — which made the behavioural objective the dominant concept in the field (Hamilton *et al.* 1977: 27–8).

There has been one detailed critique of the assumptions underlying this 'new' exhibition movement to date. It is contained in the work of Michael Alt, a psychologist closely involved in setting up the Human Biology exhibition with Miles (Alt 1977, 1983; see also Alt and Shaw 1984). Alt recognizes the continuing positivist, empiricist and behaviourist domination of exhibit evaluation studies, reserving particular criticism for Shettel's exclusive concentration on the didactic/pedagogic functions of museum exhibits, his preoccupation with defining their effectiveness in terms of measurable behaviour change and his operationalism in using abstractions of supposed actual behaviour (such as knowledge tests and attitude questionnaires), to measure this (Alt 1977: 241–3, 251). Historically, Alt's views can be located in the cognitive revolution in psychology which discredited much behaviourist teaching. Shettel's functionalism (he considers visitors have a need to learn), operationalism and general disregard for cognitive elements in museum visiting are among the now traditional grounds on which cognitive psychology successfully demolished behaviourism. Alt's criticisms are perceptive and telling. They do not, however, challenge the pre-eminence given to psychology *per se* in the study of exhibit effect. Alt seeks to substitute the cognitive for the behaviourist form of that discipline.

It has been remarked that in order to learn about a child's reading ability, a reading test — the behaviourist method — is not enough, we must know if the child wants to read and here the cognitive psychologists psychologists would certainly agree. But we must *also* know, for example, what it means in that child's social class to read well (Lévy-

Leboyer 1986: 34). The discipline of psychology, which seeks to natur-alize meaning by locating it in universal properties of human minds, uses explanatory factors such as these only in circumscribed areas, usually designated as 'social psychology'. It is striking that questions of this order are simply not addressed in the cognitive psychologists approach to museum evaluation. And yet the meaning of being a 'good' museum visitor in a certain class or other social group may crucially affect the response to exhibits. To illuminate this question, some have turned to that other large body of museum research, survey work. Determining who visits museums may certainly offer suggestions for further research but, in the light of the interpretative sociologies' criticisms of survey, we might seriously ask how close to an answer pursuing this issue through further survey research is likely to get us. The question is probably not answerable by asking individuals *why* they visit museums, or even why they don't — though this may be more promising. Some recent work on museum visiting stands out from a vast number of arid empirical studies by showing itself crucially aware of the need for adequate theory underlying the design and interpretation of results (for example, Merriman 1989a, b), but largely fails to take into account more radical doubts cast on the ability of the survey interview/questionnaire to elicit social meaning at all. Thus Merriman, though perceiving and criticizing extensive reliance on 'the cognitive psychology approach' advocates instead a synthesis between this and the more 'sociological' accounts of Bourdieu and others (Merriman 1989b: 164). Such a synthetic approach has led him to correlate museum visiting with, for example, opinions on the importance of knowing about the past, obtained by survey. However, Merriman's account of Bourdieu's theory of 'habitus' and of cultural capital tells us that in many senses museum visiting may not be 'about' the past at all, and it is hard to see how conclusions such as these can be meaningfully related to cognitive accounts of individual visitor's opin-ions. The view that survey research is 'poorly suited for analysing social structure' is now relatively commonplace among sociologists. Some go further, rejecting the traditional view that survey research remains 'an excellent tool for studying attitudes and behaviour' (Wilner 1985: 2). This work suggests there are considerable limitations as to what the empirical tools of observation and survey will ever reveal about the world of museum visiting. The relationship between attitude and behaviour has been notoriously problematic in the human sciences (as is acknowledged by some sophisticated users of museum surveys, see Alt 1983: 135). For more radical practitioners, the notion of attitude or opinion itself is questionable (Plowman 1978: 91–103). For many interpretative sociologists, technical improvement in survey design is no solution. Many consider that there is no theoretical basis for assuming that what people say correlates with whatever else they may do. Furthermore,

'attitudes or opinions thought fit for the world at large may not be thought fit for work, friends or family' (Plowman 1978: 95).

We might also note that the widespread adoption in museum surveys of providing 'equally respectable' or socially desirable alternative responses precludes us from ever hearing a socially undesirable one. Did nobody ever put two fingers up, make a rude reply, a personal comment, a joke even, when asked a question by a museum researcher? Perhaps not, but if they did, such a response is presumably coded as a 'no reply'. And on the subject of 'no replies' generally, Bourdieu has pointed out in his much-cited paper entitled 'Public opinion does not exist' that analysis of this category, the 'no replies' or the spoiled ballot papers, 'offers information about the meaning of the question, as well as the category of people questioned, the category being defined as much by the *probability of having an opinion at all* as by the conditional probability of having a favourable or unfavourable one' (his italics) (Bourdieu 1972: 125). This insight is apparently not shared by a determined museum evaluator such as Borun, who, noticing that some visitors apparently have difficulty verbalizing feelings and ideas about their experience, partially solves the problem by getting them to indicate which, of a series of faces in which the mouth line changes from upturned to downturned, best indicates their opinion (Stansfield 1981: 48). This, in effect, fabricates opinions. It might also leave the visitor who experienced hysterical derision at the exhibit in question somewhat at a loss. Elsewhere in the social sciences, the interpretative sociologies *have* had a direct impact on evaluation studies, though reference to this in published work in the museum field is very rare. A recent book entitled *Fourth Generation Evaluation* (Guba and Lincoln 1989) represents an attempt to derive a methodology for evaluation from the constructivist paradigm which underlies the method of the interpretative sociologies. It is one which is 'iterative, interactive, hermeneutic, at times intuitive'. Amongst other things, it involves avoiding pre-set objectives, with 'open ended' design allowing for consideration of issues important to interested groups but not originally raised by sponsor or evaluator, and allowing the various 'stakeholders' to confront and deal with the constructions of other groups (Guba and Lincoln 1989: 55). These authors assert that evaluation outcomes are 'not descriptions of some true state of affairs but represent meaningful constructions that . . . actors form to make sense of the situations in which they find themselves, that these constructions are inextricably context and value-linked and that they may well serve to enfranchise or disenfranchise stakeholding groups' (Guba and Lincoln 1989: 8–9). Guba and Lincoln are not alone in their rejection of the methods of empirical science as the appropriate ones for evaluation. 'In programme evaluation methodology today' concludes another author, 'there is a vigorous search for

alternatives to the quantitative–experimental approach' (Campbell 1978: 184).

Why has the museum world been offered, and why has it chosen to accept, evaluation practices which social scientists have themselves begun to question and, in many instances, to reject? Some answers are not difficult to suggest. Advocates of methodological pluralism in the social sciences were well aware that 'anarchy is difficult to sell, and . . . a lot of sociology is being bought and sold in the market place'. They knew that 'A loss of confidence in positivism (would) almost certainly make consultancies harder to obtain, make sociology less demonstrably useful and make the information thus obtained less amenable to forming a basis for social control by elite groups' (Bell and Newby 1977: 29). Older style evaluation — and that encompasses virtually all museum work to date — serves some interests better than others. The 'hard' data it produces is directly useful to administrators, rhetorically and otherwise. More than that, its focus — the issues addressed and questions asked — is likely to reflect management concerns directly. Particularly for science museums, the managerial and the wider audience for evaluation contains strong positivist expectations. 'It is legitimate to expect some behavioural change after a visit to a museum. Otherwise we could franchise them to Disney. If we want people to carry away something, we ought to be able to define what that is and measure it' was a typical view expressed by a discussant at a 1987 conference on communicating science to the public (Ciba Foundation 1987: 125).

There is now, even in museums, a 'softer' school of evaluation, one which discourages the pre-setting of objectives, behavioural or otherwise, which advocates paying as much attention to visitors' talk and visitors' accounts, preferably obtained by open-ended interviews, as to survey data. It is clear that newer thinking and more recent techniques in the social sciences have had some influence. Wolf and Tymitz of the Smithsonian Institution have been advocating a more 'naturalistic' style of evaluation for several years (Wolf and Tymitz n.d.). Workers in museums on both sides of the Atlantic have reflected the new preoccupation in the social sciences with actual speech — the analysis of discourse. And in a perceptive and sensitive appraisal of the state of the art in North American museum evaluation Mary Ellen Munley, referring to behaviourist methods, concludes that 'Museum evaluators must not fall victim to using research tools originally developed for other settings simply because they exist' (Munley 1987: 127). And yet this appearance of rapprochement is perhaps not all it seems. In the hands of museum evaluators, these newer techniques, with potentially radical findings, somehow have a tendency to become less radical, less subversive of the old order, just more grist to the mill for an enterprise whose theoretical assumptions have not really changed. Wolf and Tymitz, those 'natur-

alistic' evaluators, still speak of the impact of exhibitions *on* the consumer, using the older model of communications theory.

Mary Ellen Munley certainly advocates concentration on the meanings constructed by exhibition, but suggests pluralism and the adoption of methods 'already employed by phenomenologists and cognitive psychologists', seemingly untroubled that the theoretical bases of these two groups are irreconcilably different (Munley 1987: 125). It is striking that, when workers in museums analyse recorded speech, neither their methods nor their theory really approximate to that form of discourse analysis which is having such an impact elsewhere in the humanities and the human sciences. Just as earlier approaches in the sociology of science used scientists' discourse as a basis for their own conclusions, and failed to explore how scientists used such discourse as an interpretive resource (Mulkay *et al.* 1983: 171), museum studies of visitors' recorded speech are used to evaluate the effectiveness of message communication (e.g. McManus 1989). Analysts and participants categories are treated as equivalent and 'the assumption is made that if enough participants seem to say the same thing then the analyst can take their statements as providing sociologically adequate descriptions' (Mulkay *et al.* 1983: 175). There is a failure here to appreciate that 'the first step in discourse analysis is rather like a natural history of social accounting', which might provide a wide-ranging description of the contextually variable methods which scientists, museum visitors or any other group use to *construct* versions of their action and belief (Mulkay *et al.* 1983: 199). The 'discourse analysis' used in museum studies to date brings us little nearer to a sense of what is actually going on in those institutions. How strange it is that in published accounts visitors always seem to be talking about the exhibits — never the weather, their love life or even the location of the tea bar. McManus in fact asserts that it is rare for visitors *around an exhibit* to deviate from the exhibit topic (McManus 1989: 181), but we have nothing resembling a full-blown ethnomethodological account of museum visiting, or one from a discourse analyst, to date, both of which might be expected to be rather less selective in their assessment of what constitutes relevant data. The overall enterprise is a far cry from 'the common focus, elsewhere in the human sciences upon how "reading" "accounting" and "talk" are *achieved*' (Pinch 1990: 95). For ethnomethodologists, the constraints constructing the social world reside *in* these accounting features themselves. Others, who do not wholly share this premise, still work with sophisticated forms of discourse analysis using the constructivist paradigm.

Recent work, for example, of particular relevance to museums has involved the study of collective remembering. 'Psychology, with its tradition of theory and method derived from the experimental study of individual memory, is no longer accorded a monopoly of interest in the

topic' say the editors of a recent volume on the subject, and they make the key point that 'issues currently approached as the property of individual cognition require relocation within a broader epistemological framework' (Middleton and Edwards 1990: 2-6). If Michael Alt seeks to replace behaviourist accounts of learning and related processes such as remembering with those based in cognitive science, contributors to this volume go much further. They explicitly seek a 'non-cognitive' approach to remembering and forgetting and a recovery of their social and institutional determinants. Such an approach takes it that it is *not* the primary function of all our talk to represent the world. 'We speak in order to create, maintain, reproduce and transform certain modes of social and societal relationships' (Shotter 1990: 120-1). These constructivist criticisms of conversational remembering are particularly relevant to museum evaluation work since it is conversational remembering which often forms the basis of cognitive testing used in exhibit evaluation and of 'feedback' mechanisms for 'improving' exhibits. Here, as in experimental psychology, 'meaning and context are defined as variables, factors whose effects on the accuracy of recall are manipulable' (Middleton and Edwards 1990: 42). Discourse analysts argue that 'people's accounts of past events, before they can be taken as data on the cognitive workings of memory, need to be examined as contextualised and variable productions that do pragmatic and rhetorical work . . .' (Middleton and Edwards 1990; 37).

Psychology, the science of individual mind, has found generalizing from the empirical study of individuals largely unproblematic. For sociology, however, it has been a lasting and largely unresolved paradox that the bulk of its methodology seeks knowledge about societies by analysing knowledge about individuals. Societies clearly have qualities which are hard, if not impossible, to get at in this way. Aggregates of data given by respondents to questionnaires or in interviews, which form the bulk of museum evaluation work, are particularly vulnerable to this criticism. To take an extreme position, how might these techniques ever reveal, for example, the existence of 'false consciousness' in a society? It has rightly been maintained that 'issues of power and self determination are rarely . . . at issue when social scientists attempt to study the process of memory and forgetting' (Cole 1990: viii). These issues are rarely at stake either when evaluators, using the traditional empirical methods of social scientists and psychologists, attempt to make generalizations regarding the 'effectiveness' of museum exhibition. For, ultimately, these are issues to do with values.

It is perhaps no coincidence that in Britain at least the 'new' school of exhibition, to which evaluation was integral, had its origins in a museum of natural history. Empiricist evaluation can pursue its claims most effectively in supposed 'value free' endeavours. Of all museum subject

matters natural history is perhaps the easiest to mistake as value free. It is widely accepted that art museums deal with values, increasingly appreciated that science and technology are not the value-free preserves they were once considered to be. But natural history? — nature study? with its disinterested classification of what is simply observed in nature? Of course the interpretation of those observations may well be a matter of *scientific* contention — evolution is a prime example. But in the educational displays of a natural history museum, in the dioramas of animal life, the food chains and the dinosaur displays, could there really be a hidden agenda — dominant cultural assumptions embodied, value judgments incorporated? Of course the answer must be, as for any cultural production, a resounding yes, and we are fortunate in having at least some work which makes this abundantly clear. Donna Haraway's piece on the creation of the New York Natural History Museum's famous dioramas in the 1920s is an obvious example, revealing how these 'windows on nature' selectively portrayed a sexist and racist account in many ways directly attributable to the social Darwinism prevalent among the museum's trustees and 'white hunters' who stocked it (Haraway 1984–5). Older style evaluation, by its very nature, will never reveal a hidden agenda. Evaluation which predicates itself on what is said will never speak of what is not said, of what is swallowed by Borge's little black monkey with a curious taste for indian ink, who when an author has finished writing, drinks what is left of the ink, and in so doing drinks:

> What has been left unwritten by the writer or what has been undisplayed by the exhibitor, unrecorded by the archivist or unclassified by the metaphysician. He swallows, as well, all trace and knowledge of the programme which instigated the endeavour to do these things which can be 'seen' to be done (Shelton forthcoming).

I am quoting here from a paper on the possibility of a post-modernist museography. This is critical analysis of a very different kind, as far from exhibit evaluation as, for example, contemporary media studies are from the empiricist audience surveys of broadcasting research in the 1940s. It is a form of analysis which, like contemporary media studies, owes much to the academic subdiscipline known as cultural studies, institutionalized in Britain since the 1960s. Stuart Hall has outlined the origins of cultural studies and its paradigms, arguing that it emerged as a distinctive problematic in the mid 1950s (Hall 1980: 57). Among others, Richard Hoggart, Raymond Williams and E. P. Thompson, working in diverse historical traditions, forced on their readers' attention the proposition that 'concentrated in the word *culture* are questions directly raised by the great historical changes which the changes in industry, democracy and class, in their own way, represent, and to which the changes in art are

a closely related response', and these authors placed 'the politics of intellectual work squarely at the centre of Cultural Studies from the beginning' (Hall 1980: 58).

Work within the cultural studies tradition, broadly encompassing fields such as media studies, art history and theory and non-narrative and sociological approaches to historical and contemporary studies generally is, slowly but increasingly, being carried out on museum exhibition. Practitioners do not use the term 'evaluation', with its connotations of measurement and judgment. Their work does not involve generalizing from visitor observations (except perhaps in the 're-analysis' of survey findings such as carried out by Bourdieu and others). It is characterized by reflexiveness on its origins and by awareness of its theoretical base. It is a prime intention of this type of research to make clear *how* social meaning gets made in museums or elsewhere. Just as evaluation research does, it may focus on precise details of exhibit design to do this, but its analyses are very different in character (see, for example, the essays in Lumley 1988).

It was during the 1960s and 1970s that more radical thought in the human and social sciences finally broke with the model of positivist, empiricist science that had been their paradigm for most of the century, turning, along with the post-Saussurian humanities, to a concern for meaning and its cultural *production*, for subjectivity and *intersubjectivity*, for textuality and *intertextuality*. The parent disciplines of museum evaluators, however, remain those large areas of psychology and education which stayed within the empiricist paradigm. The gap between these workers and those who view museum exhibition as a cultural production, amenable to analysis as any other cultural production, is so wide that the concerns and problematics of one side are virtually meaningless from the point of view of the other. In the face of the death of the author, how relevant is it to speak of the effectiveness of message communication? If there is a judgmental or evaluative comment to be made on the exhibition as text, it might be to the effect that a move towards what Barthes has called the 'readerly' text and others refer to as the 'interrogative' text, or the 'open' text, is the desirable one (Real 1989: 129).

A large number of museum evaluators, however, remain largely preoccupied with the accurate observation of behaviour. One factor which undoubtedly acts against any degree of rapprochement between the two 'schools' is the lack of reflexiveness in the work of the majority of those who practice or advocate evaluation in museum settings. This is perhaps attributable to the fact that 'methodologists are traditionally uninterested in the history of their subject, or its theory' (Marsh 1982: 9). I have already commented on the atheoretical nature of much evaluation work. One is reminded that professional practitioners of survey research have often considered it to be 'a discipline in its own right, standing

outside any of the social sciences, in a direct relationship to the policy maker' (Marsh 1982: 2). How aptly this would seem to apply to professional museum evaluators, most of whom seem reluctant to acknowledge, still less explore, theoretical assumptions derived from parent disciplines, or examine how those assumptions relate to other critical traditions active in museums. It simply will not do to suggest, as Miles does, that those who do not accept his 'prima-facie' case that the proper disciplines to direct exhibition are psychology and education, and those who know 'almost nothing about psychology or education but have nevertheless convinced themselves that these disciplines are a monumental waste of human effort and are, in consequence, best ignored' (Miles 1988: 20). In attempting to trivialize the opposition, Miles misses the point. Unravelling the specific historical reasons as to *why* education and psychology have come to be advocated for this role in museums, examining the theoretical assumptions they bring with them and then questioning whether these are in fact the most appropriate ones for museum analysis has nothing to do with considering them a monumental waste of effort, or with ignoring them. Those working in or sympathetic to what I have termed the 'cultural studies' tradition *have* shown themselves willing to consider how alternative ways of studying museum exhibition, including 'evaluation', differ from their own approach. Some have reached similar conclusions to those expressed in this paper. Roger Silverstone, for example, in considering the appropriate research methodology for museum practice, and advocating 'ethnographies', concludes that 'if the bottom line for research . . . is evaluation, then I wish to suggest that evaluation be seen not as a matter of measurement but of understanding, and as a matter of the study not of individual visitors but of the whole communication process in which all who are involved, both as producers and consumers are implicated' (Silverstone 1989: 147). We are reminded here of the significant insights gained in recent years from the sociological approach to art history, whose practitioners stress that production (in the sense of the apparatus interposed between culture creators and consumers), as well as ideology, has been largely neglected in their field (Wolff 1982: 65).

Practitioners of evaluation in museums resolutely igore certain aspects of what is inevitably included in any exhibition. Paradoxically, these are the aspects which are of greatest interest to the 'cultural studies' approach, which seeks to decipher 'the codes of connotation, constructed over and above the denoted sign', codes which are 'necessarily cultural, conventionalised, historical' (Corner 1986: 54). Evaluation, concerning itself solely with what is denoted, advocates, for example, changes in typography on the grounds of legibility, ignoring the connotations carried by different typefaces. The 'correct' placing, framing or colouring of illustrations and whether these should be line drawings or photo-

graphs, involves no consideration of the meanings conveyed by these factors about the subject matter (such as are considered, for example, in Jacobi and Schiele 1989). The validity of 'attracting power', a concept derived from behaviourist work, is considered self-evident, even by those who take a cognitive rather than a behaviourist approach, because 'if a visitor does not look at an exhibit the exhibit cannot be effective' (Alt 1983: 30). But without reading a word or deciphering an image on an advertising hoarding, certainly without stopping, most of us would have no difficulty deciding whether a black and white photo overlaid with bold red capitals was an advert for baby clothes or a warning about Aids. The reasons are historical — the connotations of the 'agitprop' style are borrowed to convey urgency and gravity in the 'fight' against Aids. Every convention used in the museum medium is likewise a borrowed one — including the components of so-called neutral and unobtrusive design styles. The very wallpapers and carpets carry meaning and we certainly do not need to stop at them to apprehend it.

'Hard line' evaluators such as Harris Shettel nevertheless maintain that the museum experience consists of a series of encounters with individual exhibits. There are of course individual exhibits which Shettel and other evaluators regard as unsuitable for evaluation, such as dioramas and period rooms. Some workers have evaluated dioramas (Peart and Kool 1988) but almost everyone draws the line at evaluating what is referred to as 'aesthetics'. It is interesting to pursue this point, together with the closely related claim that evaluation is intended to apply only to *educational* exhibits. Would we be correct in suggesting that recent exhibits such as the 'Blitz Experience' at the Imperial War Museum, or the modern fitted kitchens which form part of the Food for Thought gallery at the Science Museum were intended to be *non*-educational? Of course not. We are reminded that what the behaviourists could not measure — that is what went on between stimulus and response — they chose to isolate and ignore. Consequently, the significance of what they *were* measuring was increasingly called into question. Evaluators, it seems, define educational exhibits as those for which they have a language for describing and a method for estimating whether they 'work' — and what they have no language for describing and certainly no methodology for estimating, is the carriage of meaning by connotation. It is largely to the types of exhibit most obviously carrying meaning by connotation — the 'art' object, the room setting and so on — to which they apply the term aesthetic'. They are quite right in asserting that the carriage of meaning by such exhibits cannot be 'evaluated' by their methods. They are wrong, however, in assuming that didactic exhibits do *not* carry such connotations or that it is possible to isolate and measure transmission of didactic elements, usually referred to as 'messages', which are to be independent of aesthetics. There are of course no exhibition

media, from typefaces to videos to brown paper mock-ups that are free of 'aesthetics'.

It is striking that in all the areas where empirical sociology and psychology have been challenged — in education, media studies, and in newer schools of evaluation, commentators have independently suggested that precisely those methods used for analysing 'aesthetic' productions — the methods of art, literary, film or historical criticism might be more appropriate (for example, Eisner 1979: 227–59; Harré 1978: 52). Other methods advocated include those akin to ethnographic or anthropological fieldwork. More radical sociologists, however, have reservations even over these methods if used in an evaluative context, suggesting that 'in accepting the assignment of evaluating the effects and effectiveness of a programme the anthropologist or sociologist has lost a significant freedom and has re-entered the more traditional scientific arena of causal inference' (Campbell 1978: 199).

It is controversy regarding the appropriateness of this 'traditional scientific arena', with its underlying positivist assumptions, to the study of cultural and social processes which has formed the main theme of this paper. It seems essential that practitioners in the museum field should appreciate, first, that there has been, and still is, intense controversy on this issue — something which proponents of evaluation in museums seem reluctant to discuss, wishing evaluation simply to be accepted as a useful applied technique largely free of theoretical assumptions. Second, it is important to understand where, in the main, those assumptions come from. The critique of positivism is so well known that it scarcely needs reiterating. But as Roy Bhaskar puts it 'Although "dead" in philosophy, positivism lives in the sciences: as a tendency of thought in the natural sciences; and as very much more than that in many of the human sciences' (Bhaskar 1981: 335). It has further been suggested that 'the logical positivists perhaps achieved their greatest influence on a science in neo behaviourism' (Smith 1990: 415). We should remember too that the behaviourist view of society was essentially functionalist — that of a consensus with little conflict of interests and with behaviour seen as functional to this organic system. Sociologists owe this insight to the 'new deviancy' theorists of the 1960s, who substituted for this model of society one in which there was a pluralism of values, with consensus a mystification serving certain interest groups (Worsley 1987: 410–15). Useful as typical museum evaluations based on behavioural, cognitive or survey work may be to administrators, we may wish to think extremely carefully about whether or not they really do illuminate the processes by which meaning is produced in our museums, or whether they rather serve to perpetuate, largely by ignoring them, society's obfuscations about cultural processes.

BIBLIOGRAPHY

Abbey, D. S. and Cameron, D. F., 1959. *The Museum Visitor: I Survey Design*, Royal Ontario Museum, Toronto.

Alt, M. B., 1977. 'Evaluating didactic exhibits: a critical look at Shettel's work', *Curator*, 20 (3): 241–58.

Alt, M. B., 1983. *A cognitive approach to understanding the behaviour of the museum visitor*, unpublished PhD dissertation, University of London Institute of Education.

Alt, M. and Shaw, K., 1984. 'Characteristics of ideal museum exhibits', *British Journal of Psychology*, 75: 25–36.

Argyle, M., 1978. 'An appraisal of the new approach to the study of social behaviour', in Brenner, Martin, Marsh, P. and Brenner, Marylin (eds), *The Social Contexts of Method*, Croom Helm, London.

Armstrong, D., 1989. *An Outline of Sociology as Applied to Medicine* (3rd edn), Wright, London.

Baars, B. J., 1986. *The Cognitive Revolution in Psychology*, Guildford Press, New York.

Bell, C. and Newby, H., 1977. 'The rise of methodological pluralism', in Bell, C. and Newby, H. (eds), *Doing Sociological Research*, George Allen and Unwin, London.

Benney, M. and Hughes, E. C., 1978. 'Of sociology and the interview', in Denzin, N. (ed.), *Sociological Methods* (2nd edn), McGraw-Hill, New York.

Benson, D. and Hughes, J. A., 1983. *The Perspective of Ethnomethodology*, Longman, London.

Bhaskar, R., 1981. 'Positivism', in Bynum, W. F., Browne, E. J. and Porter, R. (eds), *Dictionary of the History of Science*, Macmillan, London.

Bourdieu, P., 1972. 'Public opinion does not exist', in Mattelart, A. and Siegelaub, S., *Communication and Class Struggle; vol. 1, Capitalism, Imperialism*, International General, New York.

Campbell, D., 1978. 'Qualitative knowing in action research', in Brenner, Martin, Marsh, P. and Brenner, Marylin (eds), *The Social Contexts of Method*, Croom Helm, London.

Ciba Foundation, 1987. *Communicating Science to the Public*, John Wiley and Sons, Chichester.

Cole, M., 1990. 'Preface', in Middleton, D. and Edwards, D. (eds), *Collective Remembering*, Sage Publications, London.

Coleman, J., 1978. 'Sociological analysis and social policy' in Bottomore, T. and Nisbet, R. (eds), *A History of Sociological Analysis*, Heinemann, London.

Corner, J., 1986. 'Codes and cultural analysis', in Collins, R. *et al.* (eds) *Media, Culture and Society: A Critical Reader*, Sage Publications,

London.

Danziger, K., 1990. 'Wilhelm Wundt and the emergence of experimental psychology', in Olby, R. C., Cantor, G. N., Christie, J. R. and Hodge, N. J. (eds), *Companion to the History of Modern Science*, Routledge, London.

Deutscher, I. and Ostrander, S., 1985. 'Sociology and evaluation research: some past and future links', *History of Sociology*, 6 (1): 11–32.

Eagleton, T., 1983. *Literary Theory*, Blackwell, Oxford.

Eisner, E. W., 1979. *The Educational Imagination*, Macmillan, New York.

Elliott, P. and Loomis, R. J., 1975. *Studies of Visitor Behaviour in Museums and Exhibitions: An Annotated Bibliography of Sources Primarily in the English Language*, Office of Museum Programs, Smithsonian Institution, Washington DC.

Gagné, R. M., 1970. *The Conditions of Learning*, Holt, Rinehart & Winston, New York.

Gardner, H., 1985. *The Mind's New Science*, Basic Books Inc., New York.

Geertz, C., 1980. 'Blurred genres: the refiguration of social thought' *The American Scholar*, 49 (2): 165–79.

Gordon, D., 1988. 'Education as text: the varieties of educational hiddenness', *Curriculum Inquiry*, 18 (4): 424–49.

Griggs, S. A., 1984. 'Evaluating exhibitions', in Thompson, J. M. A. (ed), *Manual of Curatorship*, Butterworths, London.

Guba, E. G. and Lincoln, Y. S., 1989. *Fourth Generation Evaluation*, Sage Publications, London.

Hall, S., 1980. 'Cultural studies: two paradigms', *Media Culture and Society*, 2 (2): 57–72.

Hamilton, D., Jenkins, D., King, C., MacDonald, B. and Parlett, M. (eds), 1977. *Beyond the Numbers Game*, Macmillan Education, Basingstoke.

Hammersley, M., 1987. 'Heap and Delamont on transmission and British ethnography of schooling', *Curriculum Inquiry*, 17 (2): 235–7.

Haraway, D., 1984–5. 'Taxidermy in the Garden of Eden, New York City', 1908–1936, *Social Text*, II: 20–64.

Harré, R., 1978. 'Accounts, actions and meanings — the practice of participatory psychology', in Brenner, Martin, Marsh, P. and Brenner, Marylin (eds) *The Social Contexts of Method*, Croom Helm, London.

Jacobi, D. and Schiele, B., 1989. 'Scientific imagery and popularised imagery: differences and similarities in the photographic portraits of scientists', *Social Studies of Science*, 19: 731–53.

Jackson, P. W., 1968. *Life in Classrooms*, Holt, Rinehart & Winston, New York.

Larrabee, E., 1968. *Museums and Education*, Smithsonian Institution Press, Washington DC.

Lévy-Leboyer, C., 1986. 'Applying psychology or applied psychology', in Heller, F., *The Use and Abuse of Social Science*, Sage Publications, London.

Lumley, R. (ed.), 1988. *The Museum Time-Machine*, Routledge, London.

Malík, M., 1963. 'Principles of automation in museum exhibitions', *Curator*, VI (3): 247-67.

Marsh, C., 1982. *The Survey Method*, George Allen and Unwin, London.

McManus, P., 1989. 'Oh yes, they do: how museum visitors read labels and interact with exhibit texts', *Curator*, 32 (3): 174-88.

Melton, A. W., 1972. 'Visitors behavior in museums: some early research in environmental design', *Human Factors*, 14 (5): 393-403.

Merriman, N., 1989a. 'The social basis of museum and heritage visiting', in Pearce, S. M. (ed.) *Museum Studies in Material Culture*, Leicester University Press, Leicester.

Merriman, N., 1989b. 'Museum visiting as a cultural phenomenon', in Vergo, P. (ed.), *The New Museology*, Reaktion Books, London.

Middleton, D. and Edwards, D., 1990. 'Conversational remembering: a social psychological approach', in Middleton, D. and Edwards, D. (eds), *Collective Remembering*, Sage Publications, London.

Miles, R. and Tout, A., 1978. 'Human biology and the new exhibition scheme in the British Museum (Natural History)', *Curator*, 21: 36-50.

Miles, R. S., 1988. *The Design of Educational Exhibits* (2nd edn), Unwin Hyman, London.

Mulkay, M., Potter, J. and Yearley, S., 1983. 'Why an analysis of scientific discourse is needed', in Knorr-Certina, K. and Mulkay, M. (eds) *Science Observed*, Sage Publications, London.

Munley, M. E., 1987. 'Intentions and accomplishments: principles of museum evaluation research', in Blatti, J. (ed.), *Past meets Present*, Smithsonian Institution Press, Washington DC.

Peart, B. and Kool, R., 1988. 'Analysis of a natural history exhibit: are dioramas the answer?', *International Journal of Museum Management and Curatorship*, 7: 117-28.

Pinch, T., 1990. 'The sociology of the scientific community', in Olby, R. C., Cantor, G. N., Christie, J. R. and Hodge, M. J. (eds), *Companion to the History of Modern Science*, Routledge, London.

Plowman, D. E. G., 1978. 'Public opinion and polls', in Bulmer, M. (ed.), *Social Policy Research*, Macmillan, London.

Real, M., 1989. *Supermedia*, Sage Publications, London.

Robinson, E. S., 1928. 'The behaviour of the museum visitor', *Publications of the American Association of Museums*, New Series, 5: 1-72.

Robinson, E. S., 1931. 'Psychological studies of the public museum',

School and Society, 33: 121–5.

Screven, C. G., 1986. 'Exhibitions and information centers: some principles and approaches', *Curator*, 29 (2): 109–37.

Sharp, R. and Green, A. 1975. *Education and Social Control*, Routledge and Kegan Paul, London.

Shelton, A., forthcoming. 'In the lair of the monkey: notes towards a postmodernist museography', *New Research in Museum Studies*, 1.

Shettel, H., 1973. 'Exhibits: art form or educational medium', *Museum News*, September: 32–41.

Shotter, J., 1990. 'The social construction of remembering and forgetting', in Middleton, D. and Edwards, D. (eds), *Collective Remembering*, Sage Publications, London.

Silverstone, R., 1989. 'Heritage as media: some implications for research', in Uzzell, D. (ed.), *Heritage Interpretation. Volume 2: The Visitor Experience*, Belhaven Press, London.

Smith, R., 1990. 'Behaviourism', in Olby, R. C., Cantor, G. N., Christie, J. R. and Hodge, M. J. (eds), *Companion to the History of Modern Science*, Routledge, London.

Stansfield, G., 1981. *Effective Interpretive Exhibitions*, Countryside Commission, Cheltenham.

Tolman, E. C., 1938. 'The determiners of behavior at a choice point', *Psychological Review*, 45: 1–41.

Wilner, P., 1985. 'The main drift of sociology between 1936 and 1984', *History of Sociology*, 5 (2): 1–20.

Wolf, R. and Tymitz, B., n.d. *A Preliminary Guide for Conducting Naturalistic Evaluation in Studying Museum Environments*, Office of Museum Programs, Smithsonian Institution, Washington DC.

Wolff, J., 1982. 'The problem of ideology in the sociology of art: a case study of Manchester in the nineteenth century', *Media, Culture and Society* 4: 63–75.

Worsley, P. (ed.), 1987. *The New Introducing Sociology*, Penguin Books, London.

3 *Making sense of exhibits*

PAULETTE M. MCMANUS

Making sense of exhibits

PAULETTE M. MCMANUS

In examining how sense is made of museum exhibits, I shall first examine the behaviour which visitors can be expected to bring to the exhibition environment. It is within this behavioural context that any sense is made of the museum's communication. I shall then examine the communication situation in a particular museum, in order to identify the fundamental elements involved. A communication model appropriate for the use of those preparing exhibitions in museums will be proposed.

Finally, I shall explore the theme 'making sense of exhibits' illustrating factors which influence failure and success in the way messages are formulated for the visitor.

WHAT ARE MUSEUM VISITORS LIKE

Visitors Attitudes and Motivations

People choose to visit museums out of interest, for pleasure and because museums are places that can be visited with family and friends (Hood 1983). Consequently, the social aspect of visiting is very influential on the communication situation in museums (McManus 1988). Being able to have a relaxed time in social contact with family group members is very important to many visitors – often as important as the exhibits they will see.

Relaxation, pleasurable anticipation of a warm social quality to that relaxation, the opportunity of 'find out' and the expectation of pleasure associated with the reception of information, work together to colour the visitor's view of what will happen to them in the museum, even before they

Table 3.1 Motivation to visit the museum

Family visit with children	20%
Recreation	20%
Reputation of the museum	18%
Interest in science	17%
Revisiting the venue/an exhibit	17%
Museuming	8%

Source: Science Museum, 1989. Quota sample (n = 100)

cross the threshold. Such feelings affect the manner in which visitors are 'open' to any communications presented to them so it is essential that those who prepare exhibitions are aware of them before they begin work. Fortunately, surveys of visitors entering museums are broadly similar in their reporting of visitor motivations and attitudes so it is possible to look at a particular survey as representative of a general trend in behaviour. During 1989, it was decided to conduct an entry survey of visitors' views of the Science Museum, London, to help in the preparation of a major new exhibition. One hundred visitors, chosen as a quota sample which mirrored the visitor age and sex distribution reported in the last major visitor study in the museum (Heady 1984), were interviewed as they began their visit. Two out of every five visitors interviewed were making a repeat visit.

Table 3.1 summarizes the visitors' motivations in planning their visits. It can be seen that the responses centre around general interest in science and social relaxation. Around one-fifth of the audience at the Science Museum can be expected to be focusing on making an enjoyable family outing, while a further one-fifth is prompted to visit for recreational reasons. Slightly over one-third visit because of the reputation of the museum or because they have a general interest in science. As the Science Museum is in the South Kensington 'museum district', a small percentage of the visitors at any particular time can be expected to be in the building because they are 'museuming' and making many museum visits that day.

The team preparing the exhibition also wanted to focus on what the visitors' expectations were of them so that they could build their communications around these as much as possible. A visit to a museum is more than a visit to an exhibition, or exhibitions, so a general question was posed to the same quota sample asking what they hoped to get out of the time they spent in the museum. Table 3.2 reports the attitudes visitors brought with them to the museum with regard to the 'museum side' of the communication situation. It can be seen that more than a quarter of visitors hoped to gain information or understanding about *unspecified* scientific subjects, while a further one-fifth visited to satisfy and feed a general interest in the subjects presented in the building. That is, almost half of the visitors to the Science Museum can be expected to hold, as a first priority, hopes related to the educational mission of the

Table 3.2 Expectations of visit

Finding out/learning	26%
Fun	22%
General interest	21%
Specific aspect of museum	18%
No structured plans	7%
No	6%

Source: Science Museum, 1989. Quota sample (n = 100)

Table 3.3 Visitor constituencies: Social groupings in a sample of 1,572 visitors attending the Natural History Museum in 641 groups, 1985

Constituency	Visitor Groups %	Individuals %
Groups with children	46.3	68.2
Singletons	31.5	12.9
Couples	13.9	11.9
Adult groups	8.3	7.6

museum. This group is bolstered by a further one-fifth of visitors who came wishing to see specific exhibits or exhibitions of which they are fond or have learnt about recently. In all, around 65 per cent of the sample reported that the main hopes for their visit were related to satisfactory communication from the displays presented in the museum. A further 22 per cent of visitors hoped to get fun and enjoyment from their visit — an aspiration not incompatible with good museum communications.

Generalizing away from this particular survey, and noting that its findings are broadly in line with surveys conducted in other museums (for example, Alt 1980), we can say that visitors are highly motivated to attend to exhibit communications within a social recreational context. Their interest is general and not focused in a studious, academic style.

Visitor Behaviour Patterns

It is possible to categorize visitors according to the patterns of behaviour they show when they interact with exhibits (McManus 1987; Diamond 1986). In a study I conducted in the Natural History Museum, London, the behaviours of reading, talking to companions, interacting with exhibits and spending time at exhibits were particularly considered. Styles of behaviour within these categories were closely related to specific types of social groupings amongst the visitors to the museum. I call the social groupings constituencies (Table 3.3). I believe that exhibits must cater for the four distinct styles of making sense of exhibits shown by these constituencies, described below.

Groups containing children The largest constituency was of groups

containing children. Such groups were very likely to play at interactive exhibits, had long conversations and tended to have longer visits. It was not easy to observe reading behaviour unless there were adults in the group and then it was likely to be brief glances at text. The characteristic style used in engaging with exhibit communications displayed by the Groups Containing Children Constituency involves lots of talking and discussion and active participation and play, where this is possible.

Singletons The next largest constituency was composed of people visiting alone. Males outnumbered females two to one in this social grouping. Singletons tended to pay brief visits to exhibits and read the labels in great detail. They were 50 per cent more likely to read labels thoroughly than any other constituency. When compared to females, male singletons were twice as likely not to play at interactive exhibits. The characteristic style used in engaging with exhibit communications employed by the Singletons Constituency involves a focus on the text of labels, rather than on artefacts or games in the display.

Couples This, the next largest constituency, was characterized by a lack of conversation in comparison to other constituencies containing companions. Nearly 50 per cent of couples did not talk at all. On the whole, couples tended to stay at the exhibits for a longer time than members of all the other constituency groupings and were, in general, likely to read the labels comprehensively. The characteristic style used in engaging with exhibit communications displayed by the Couples Constituency involves much reading and browsing with a tendency to process communications independently before, perhaps, drawing together for discussion.

Adult social groups This constituency appeared to pay the least attention of any constituency to exhibits as they read less than other adult constituencies and spent the least time at exhibits. The characteristic style used in engaging with exhibit communications displayed by the Adult Social Group Constituency involves rather rapid browsing. This may be because such groups are skilled processors or, alternatively, because the main focus in such groups is social interaction within the group, so leaving less attention time for displays.

The categories of behaviour displayed by the four constituency types are brought to the museum as a part of the social context of visits. They are natural behaviours, dependent on the companions with whom one comes to the museum. That is, a particular individual will be very likely to process communications in the museum differently, on differing occasions, depending on the type of constituency in which he or she visits. We see that there is no single type of visitor audience and exhibits have to cater for the variety of behaviours shown by visitors.

The Effects of Social Intimacy

The analysis of the data collected in the Natural History Museum also showed that groups of visitors which had good social relationships and moved around the museum in closed units were more likely to engage in behaviours which would allow them to process information from exhibits satisfactorily. Groups who communicate well with each other also communicate well with museum staff via exhibits. Museums cannot choose their visitors for the quality of their social interactions, but they can encourage intimate social behaviour by designing exhibits which lead groups to cluster about while they sort out what is happening within the exhibition. Exhibits can be organized so that face-to-face communication or equal status interaction within the group are possible.

COMMUNICATION IN THE MUSEUM

Language Is The Key

As a part of the large study conducted in the Natural History Museum, 168 conversations between visitors were recorded at various exhibits. The recordings were transcribed and subjected to a very rigid linguistic analysis, using all the words spoken in the conversation, in order to examine the structure and patterns of talk in the museum (McManus 1989a) and behind that structure, the thinking processes of the visitors (McManus 1989b). The analysis illustrated two points of great importance when we reflect on how sense is made of exhibits.

Dependency on language Visitors are very dependent on the language provided by the presentations. Labels have had a bad press, with many people discounting their importance and relevance to the visitor. However, when reading labels the written word stands in for the presence of the person who prepared the exhibit interpretation. Label text can be thought of as rather like a speech bubble in a cartoon which happens to hold the words of the person who prepared the exhibit. Great care should be taken in the choosing of words as they will be dealt with in the museum when interpreters are not there and in a very real sense they are a substitute for their speaking presence.

Of course, label texts are not the only items which help people to make sense of exhibits. Graphs, diagrams, models, audio-visuals, photographs and artefacts of all sorts also contain propositional information necessary for the building and sharing of information between visitor and museum staff. However, in nearly all the cases that I have examined, language is the key to the visitor making sense of these media.

Conversational nature of visitor-text interaction The nature of the visitors' engagement with the words in labels is conversational in style and in a psychological sense. The recordings showed that visitors speak as if 'someone' is talking to them through the labels. Visitors also talk back to the 'someone' who wrote the labels. In their conversations, all the visitors in the large sample kept to the text topic established by the label writer. It is a socio-linguistic principle that one cannot introduce a topic and not be a party to the discourse — a partner in the conversation. If one exerts topic control one is a leader in the conversation. Clearly, visitors see the person employing the words and expressions in labels as a party to, and in control of, the communication situation at exhibits. Throughout the transcripts, it was a curious state of affairs to find that the words of the label writer, and by proxy the writer, became a part of the conversations between visitors. In a very real sense, the visitors invoked the presence of the label writer so that the meanings he or she expressed became a contribution to social group discussion even though the writer was not present.

How Visitors use the Museum Language Contribution in the Interaction They Have With an Exhibit, Display or Interpretation

The transcripts of conversations recorded in the Natural History Museum indicated that seven out of ten visitor groups showed 'text-echo' in their conversations. That is, they repeated the exact phrasing of segments of label text in the conversations they had with each other. Visitors were also observed while recording were being made. In all, eight out of ten visitor groups showed evidence of looking at text and/or looking and using text-echo in their talk.

In most social groupings, one person in the group reads aloud for the other group members. When we look around an exhibition it may not look as if many people are reading. In fact, more people than can be expected just by looking at them have direct access to the text of labels because of the establishment of 'reader for the group' behaviour. Adults usually read for groups containing children. Couples read more than other adults in social groups and this may be because some couples process exhibition communications independently before swapping impressions — as if they were sharing the task of processing the exhibition between them. Singletons cannot rely on other people to help in making sense of exhibits and so, as expected, they tend to spend the largest time of all the identified social groups in reading exhibit labels. Male singletons tend to spend longer reading than females, perhaps because female singletons are more likely to supplement their reading with direct physical interaction with exhibits where this is possible.

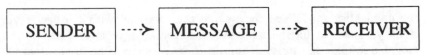

Figure 3.1 The traditional three-unit model of communication

An Appropriate Communication Model for those Working in the Museum

It is very important that those working on exhibit communications centre their efforts on putting sense *into* them. Without this effort, we cannot be sure that visitors will be able to *make* sense of the exhibits at all. The primary, overriding focus of putting sense into exhibits during exhibition preparation means that all the work involved — researching content, finding artefacts, discussions with designers, construction of exhibits — must be done with a sense of purpose in a controlled, organized, informed manner. The pace of exhibition preparation inevitably becomes frenzied at certain points because each exhibition is a unique 'one-off', prepared within rigid time constraints. If, amid conflicting demands on attention, those responsible for informing an audience do not maintain an inner certainty that the imperative behind their work is communication with people they can very easily become 'de-centred'. When this happens the focus can move away from the visitor to one concerned with, say, getting the job done come what may (see Bud 1988 for a concrete illustration), or putting everything known in the department into the exhibition, or becoming fascinated with dazzling design effects, or whatever activity it is that is dominant when the pace of work takes over.

The only way to keep the primary focus of the work on good communications with visitors is, surely, to hold at all times to a model of communicative behaviour which is relevant to the museum communication situation. The traditional linear, three-unit model of communication is the one most likely to be known to museum communicators (Figure 3.1). It is, unfortunately, not at all helpful when we are thinking about visitors making sense of exhibits from the sense that we, the producers, put into them.

It is an inappropriate model, first, because the 'message' is depicted as an 'object' with an identity of its own, separated from the human participants in the communication situation. It is inappropriate, second, because the line of action in the model is 'one way' that is, linear in direction. Once the 'sender' has put the 'message' on its way he or she can turn away from it and, in so doing, give up responsibility for it. We all know of curators who do just that. Once the exhibition has opened, they are not really interested in their exhibits and any messages they represent as long as the exhibition containing them appears attractive or popular. The conceptualization of the line of action as linear in the traditional

communication model also means that the 'message', with its object-style identity, is seen as 'hitting' a passive 'receiver'. The 'receiver's' part in the model is to take the 'message bundle' in its entirety. If he or she doesn't, or cannot, it is not the fault of the sender or the message — the receiver is in some way in error in not 'getting the message'. The model is inappropriate to the museum situation, third, because when an individual working in a museum wants to use it to guide his or her work, he or she must analyse each unit separately. This will lead to all sorts of confusing tangles because communication is a process taking place between people. It cannot easily be examined as a string of isolated items with singular objectified identities.

A more appropriate model of communication for use in the museum situation is provided by Sless (1981) (see Figure 3.2). This model, which I have developed slightly, is more appropriate than the linear model for use in museum situations because it can incorporate linguistic and psychological understandings of how human beings go about communicating with each other. It does so because it focuses on the process of communication. In the process model, the 'message' does not have an independent existence. It is forged and comes to life as a transaction between minds at the moment of communication. In order to ensure that the communicative transaction takes place, *both* parties, in our case the exhibition team and the museum visitors, must be able to participate and work actively in the same direction. The person with whom one wishes to communicate is certainly not in a passive role. It is now easier to think of the sender in the traditional model as an author and the receiver as the audience for communications. Both human parties must work on the message with a series of questions which crystallize their relationship as author and audience respectively.

In forming an author/message relationship a communicator must work to answer three questions:

- What do I want to say?
- Who am I saying it to?
- Am I reaching out to them?

In forming an audience/message relationship a person must engage in the work involved in answering three questions:

- Who is talking to me?
- What are they talking about? (What is the topic framework?)
- What are they saying about the topic?

We all engage in the work involved in these two sets of questions when we talk to each other. However, when we prepare distance communica-

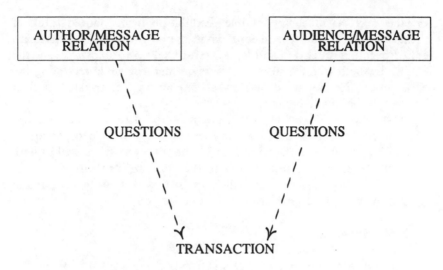

Figure 3.2 The process model of communication (after Sless, 1981)

tions, it is very easy to become involved in the task as a task and neglect to ask ourselves the questions supporting the author/message relationship. When this happens, the people we wish to communicate with cannot satisfy themselves with the answers they are trying to get to the questions they must ask to form a satisfactory audience/message relationship. This leads to frustration and miscommunication — in fact, to a failure to achieve the communicative transaction. It can be seen that both relationships to the message — the author's and the audience's — become the indivisible unit of study if we wish to analyse a communication situation in an academic manner.

How to Work Within the Process Model of Communication to Encourage 'Conversational' Interaction with Visitors

When working within a process model of communication, it is possible to use the feedback from studies into visitor reading behaviour to improve the layout and style of exhibit label texts (McManus 1990). Two features of label texts need to be concentrated upon:

(a) the conversational aspect of language use;
(b) the ease with which visitors can select the most important part of the exhibit texts for inclusion in their conversations.

As has been discussed above, the reader is inclined to form a conversational relationship with exhibition teams and this tendency should be encouraged. Those preparing exhibit texts should use the pronoun 'you'

in label texts as much as possible. Exhibition teams should think of themselves as talking to someone when they write labels. If the team editor becomes stuck for words, a useful trick is to explain what the exhibit is about to a friend or fellow team member while recording the explanation. The key words used when explaining face-to-face can then be used in the final label text.

Those who write label texts will not be allowed to hog the language space when interaction takes place in front of the exhibits; people want to talk with and relate to the people with whom they visit, as well as with those who prepare communications in the museum for them.

The following golden rules will help to ensure that the maximum amount of written communication is attended to:

- Don't overwrite.
- Break the text up so that it is accessible.
- Use subheads to help the visitors skim texts.
- Above all, use an accurate orientation heading: that is, do not wander off the topic. The objectives of the exhibition should be articulated. Headings should relate to these.

Remember that when visitors first encounter an exhibit they want to know two things. First, what the exhibit maker is talking about. Accordingly, they need to be given headings and subheadings. Second, visitors need to form an early impression of the general line you are taking on the topic you are talking about. In order to help the visitor in this regard, orientation sentences should be provided before launching into detail. If visitors are not given reference and orientation to the exhibition topic they get angry or confused and miscommunications are likely to ensue.

Making Sense of Exhibits: Failure and Success in Working on the Author/Message Relation

We all have our favourite 'bad' and 'good' exhibits. It can be instructive to look at such exhibits in the light of the process model of communication.

Some of the exhibits which provoke most amusement among professionals are those where the perpetrators of the exhibit are seen to be transparently sticking to their own concerns, oblivious of the need to envisage an audience or an author/message relationship. This is most obvious when 'curator jargon' comes into conflict with 'street language'. Dr Roger Miles of the Natural History Museum has a favourite slide of an exhibition which used to be in that museum under a large heading of 'Boring Sponges'. For a short time in 1989, I noticed a similar *faux pas* in

the Science Museum with an exhibit entitled 'Boring Machines'. Mr. Terry Suthers of the Science Museum has a favourite example of an exhibit seen some years ago which perfectly illustrates a curator letting the job of putting objects on display take over from communicative behaviour. A large case carries the label 'these four shelves contain many thousands of fragments of pottery from the 12th to the 17th century'.

It is important to be on the look-out for missing questions in the author/message relationship. When visiting exhibitions, watch out for exhibits where exhibition teams have under-interpreted the display because they feel that they don't have to say anything but just let the objects speak for themselves. Watch out for cases of over-interpretation where a mass of text can lead to loose communication. Watch out for forms of display which fail to integrate text and artefacts so that the intended communication is not articulated coherently. Look out for exhibits, especially games, where the ways we handle concepts have not been thought through.

Favourite 'exhibits' are likely to show evidence of thinking about subject matter *and* the character of the visitor. Watch out for skilful use of visual analogies. The use of teaching points to structure communications is likely to be reflected in appropriate subheadings which guide visitors through the exhibit communications. Notice the levels of communication used in exhibits, a range of appropriately signalled levels of differing weight can cater interestingly for the wide range of visitors to museums in ways which do not offend either 'browsing' or 'serious' members of the audience. I am very interested in the use of language in exhibit texts but some of my favourite exhibits have little text. However, they show obvious traces of a prior high use of language skills by exhibit teams for they embody explanations and descriptions in a visual form which leaps straight into the imagination. They are visual communications of the highest order because they are well rooted in the unity of the author/message and audience/message relationships. They really do help visitors to make sense of exhibits.

BIBLIOGRAPHY

Alt, M. B., 1980. 'Four years of visitor surveys at the British Museum (Natural History) 1976–79', *Museums Journal*, 80 (1): 10–19.

Bud, R., 1988. 'On the social production of visual difference', in Law, J. and Fyfe, G. (eds), *Picturing Power: Visual Depiction and Social Relations*, Sociological Review Monograph 35, Routledge and Kegan Paul, London.

Diamond, J., 1986. 'The behaviour of family groups in science museums', *Curator*, 29 (2): 139–54.

Heady, P., 1984. 'Visiting museums', in *A Report of a Survey of Visitors to the Victoria and Albert, Science and National Railway Museums for the Office of Arts and Libraries*, HMSO, London.

Hood, M. G., 1983. 'Staying away. Why people choose not to visit museums', *Museum News*, 61 (4): 50–7.

McManus, P. M., 1987. 'It's the company you keep . . . the social determination of learning-related behaviour in a science museum', *International Journal of Museum Management and Curatorship*, 6: 263–70.

McManus, P. M., 1988. 'Good companions . . . More on the social determination of learning-related behaviour in a science museum', *International Journal of Museum Management and Curatorship*, 7: 37–44.

McManus, P. M., 1989a. 'Oh yes they do! How visitors read labels and interact with exhibit texts', *Curator*, 32 (3): 174–89.

McManus, P. M., 1989b. 'What people say and how they think in a science museum', in Uzzell D. (ed.), *Heritage Interpretation, Vol. 2: The Visitor Experience*, pp.156–65, Belhaven Press, London.

McManus, P. M., 1990. 'Watch your language! People do read labels', in Serrell, B. (ed.), *What Research Says About Learning in Science Museums*, Association of Science — Technology Centres, Washington, DC.

Sless, D., 1981. *Learning and Visual Communication*, Croom Helm, London and John Wiley, New York.

4 *A new communication model for museums*

EILEAN HOOPER-GREENHILL

A new communication model for museums

EILEAN HOOPER-GREENHILL

HOW MEANING IS STUDIED: SEMIOTICS AND ITS RELEVANCE

In recent years, studies of meanings within cultural contexts have been carried out under the broad umbrella of 'semiotics'. Semiotics has been defined as 'the doctrine of general theory of signs . . . (which) . . . deals with meanings and messages in all their forms and all their contexts' (Innis 1985: vii) and as 'the systematic and "scientific" study of all those factors that enter into semiosis, that is, the production and interpretation of signs' (Innis 1985: viii).

Semiotics, then, according to this definition looks at signs and signifying practices and analyses them. All observable socio-cultural phenomena are studied as signifying systems that constitute and are constituted through hidden social logics. These hidden agendas might be kinship systems, myths, ritualized behaviours and so on. In many, if not most, instances, the analyses of sign systems and signifying practices seek to uncover the (often hidden) ideological messages that are carried.

What studies can be found that analyse museums, or museum practices such as exhibitions, from this standpoint? How useful are such studies? I want to look very briefly at one such analysis, of an exhibition.

One chapter in Roland Barthes' well-known *Mythologies* is called 'The great family of man' (Barthes 1973: 100–2). Barthes analysed a photographic exhibition held in Paris during the 1970s, in which he discussed the way in which the objects (the photographs) were put together, the choice of content, division and section subtitles, and the stylistic manner in which the exhibition texts were written. In doing this, he demonstrated how myths may be constructed through exhibitions. The exhibition sought to establish a mythical 'human community'. Universal values were

constructed through such subtitles as 'birth,' 'death,' 'work,' 'play'. An essential humanism was posited. The photographs were accompanied by texts in the introductory leaflet and the catalogue (statements such as 'the Earth is a Mother that never dies'). Together the objects and the texts established a discourse which celebrated a timeless ahistorical harmonious 'human condition'.

'What is the use of this essentialism?', asks Barthes. An eternal lyricism about birth masks the true social facts that reveal whether a child was born with ease or with difficulty, whether the mother was caused harm by the birth, whether it was in an area of high mortality, and so on. The meaning of the photographs, Barthes is telling us, is constituted through ideology, and taken as a whole the meanings of the objects and the exhibition construct an essentialist myth of human harmony, as opposed to the social reality of conflict and competition. This myth serves to maintain the *status quo*, and preserve the definitions of the world made by existing power groups.

The analysis reveals how exhibitions construct values and how these values are construed through a hidden ideological agenda. Barthes analyses a meaning hidden in the way in which the objects (photographs) are assembled, contextualized, and presented.

Other analyses of museums and museum practices tend to operate in a similar way. Hodge and D'Souza (1979), for example, used a semiotic analysis to analyse the Western Australian Museum's Aboriginal Gallery. Where the display purported to celebrate the culture of the aborigines, the researchers discovered quite another message, that of the power of curators to define the world on their own terms. A similar analysis of the exhibition at the Natural History Museum 'Man's Place in Evolution' (dubbed 'Adam's ancestors: Eve's in-laws'), discovered that the three-dimensional images and the texts used in the displays revealed very Victorian assumptions about the social roles of men and women (Anon 1980). Duncan and Wallach (1980) state that the museum's primary function is ideological, and that its task is to impress on its visitors society's most revered beliefs and values. They analysed the Louvre as a ritual experiential agenda that incorporates the unaware visitor as an ideal citizen of the state. Earlier, Duncan and Wallach (1978) had analysed the Museum of Modern Art in New York. They described the architectural script and the iconographic programme established by the arrangement of the collections and showed how the experience of the museum as a labyrinth is a metaphor for spiritual enlightenment and apparently universal values which act to reconcile us to the world outside the museum, as it is.

USES AND PROBLEMS OF SEMIOTIC ANALYSIS FOR MUSEUMS

These analyses of museums and their meanings work from the outside in: that is, they analyse the experience and significance of the museum from the point of view of the consumer of the museum as a cultural artefact, rather than from the point of view of the producers of such an artefact. The researchers claim to speak as though for the visitor, rather than on behalf of the museum worker.

The studies I have discussed also work with analyses which are theoretical rather than practical, by which I mean that the researcher has built a theoretical model which he or she then seeks to prove through a personal analysis which, as we have seen, can include the museum building, the arrangement of the collections, the labels and other texts, and so on. A hypothesis is proposed, and an examination of the visible aspects of a museum or gallery is then carried out to prove the hypothesis. Most of the hypotheses concern the hidden curriculum, or the underlying ideological agenda of museums and galleries.

It is quite clear from the various studies that have emerged, that it is extremely easy to discover and document the ideological functions of museums. It is all too easy to prove that museums as a whole, and separate aspects of museum practices, act to construct values, to represent images, all of which have class, gender, and ethnic biases. In a sense, what else would one except?

However, this is not to deny the validity of these studies. On the contrary, the studies demonstrate that museums and galleries have a role in representation in exactly the same way as other social and cultural institutions and that the representations of museums have political and ideological functions. This is something which cannot be disputed and it is useful that we, as museum professionals, know and acknowledge it. Without these studies, it would be difficult to begin to understand and work with these complex functions of museums. They illuminate the various alternative and sometimes fragmented meanings that may be construed from the experience of the museum.

But how does this help the museum professional in the production of cultural meanings? For a practising museum worker, these studies can make very discouraging reading. In relation to actually doing museum work, they help by alerting us to areas of difficulty, and enable us to analyse the finished product, but they don't help too much in the design of exhibitions, or museum posters, or in the rearrangement of the building.

There are critiques that can be made of the analyses that I have discussed. In terms of the meaning that is made of the museums and the displays, meaning is posited rather than demonstrated. Visitors to the exhibition were not interviewed. The 'meanings' of the photographs (for

example) are those that Barthes found supported his own viewpoint. These meanings certainly present an alternative way of reading the exhibition from that intended by the curator, but we don't know how many other people read the exhibition as Barthes did, nor how many other ways of interpreting the exhibition there were, nor even if anyone went. Theoretically, the idea is beautifully constructed. Practically, it tells us very little.

These analyses have a further problem, in my view. The studies imply that individual subjects (individuals) do not construct their own messages, but are themselves constructed by the messages implicit in the experience of the museum. Barthes, for example, assumes, in so far as he is interested, that visitors are automatically deceived by the messages of the exhibition. Duncan and Wallach assume that visitors to MOMA are carried away by the ceremonial agenda and the iconic programme and are not themselves actively constructing and reconstructing the experience to suit their own needs. Visitors are assumed to be passive and uncritical, incapable of making their own meanings, and manipulated by the hidden social and ideological functions of the museum.

A further aspect of these studies is useful to bear in mind. These analyses set out to analyse the unintended rather than the intended effects of signifying systems. The researchers are interested in the revelatory power of their hypothesis, in showing how museums and galleries, unwittingly, make certain social statements, or represent certain beliefs and values. These analyses of communicative acts as signifying systems do not help in the *production* of cultural meaning. This is not their intention. We, as museum workers, and as those who are charged with the production of systems in which meanings are made, are not offered guidelines to produce, for example, exhibitions that work with non-essentialist values, nor are we assisted in working out new forms of museums that relate to the conflictual fragmented world in modes other than those of reconciliation.

How can we analyse cultural meaning in such a way as to illuminate and develop actual work practices in museums? How is meaning construed by individuals from the continually shifting flux of experiences of the world? How do these two questions relate?

Museum professionals work in a number of different ways, according to their functions (as designers, curators, educators, outreach workers, public relations people and so on), to communicate messages. These messages relate to the museum, the collections, and the interrelationship of people with the museum and its practices. These messages are intentioned messages. Exhibitions are evolved with specific teaching points or ideas that they intend to convey. Museum posters or leaflets deliberately present particular bits of information and specific images. Yes, they will also have hidden ideological messages, as we live within

and are constructed through ideologies. It is not possible to live in a social world without partaking of that social world, and there is no finite truth 'beneath' an ideological 'distortion'.

The semiological studies that we looked at earlier do not offer any analytical method for the analysis of intended messages. However, I know a man who does!

SEMIOLOGY OF SIGNIFICATION, SEMIOLOGY OF COMMUNICATION

I have recently come across the work of George Mounin, a French semiotician and linguistic theorist. His work has been little known in England, but recently a book of collected essays appeared under the title *Semiotic Praxis: Studies in Pertinence and in the Means of Expression and Communication* (1985). Mounin has developed some ideas that may be useful to us.

Mounin proposes that Saussure, the founding father of present-day semiotics, opened up two theoretical avenues (Mounin 1985: 21). One of these avenues, which Mounin calls the semiology of signification, has been followed by such writers as Barthes and Kristeva, and has been particularly influential in American developments. This avenue has led to the exploration of the hidden or unintended logics of signifying systems. The studies we looked at above fall into this category.

The other avenue, followed by writers such as Prieto, Martinet and Mounin himself, follows the lines of a semiology of communication. The semiology of communication deals with purposeful and conventional communicational systems. Mounin identifies two important character-istics of systems of communication: first, they involve a conventional code that is acquired through social learning; second, that there is an intention to communicate which is recognized by at least two people.

The semiology of communication studies, therefore, intended mess-ages, and the semiology of signification studies unintended messages. Methodologically, the difference in the two semiologies lies in their different understanding of signs and indices.

The semiologists of communication make a sharp differentiation between an indice and a sign (or signal). The translators had a problem over the word 'indice' and have used this expression as it enables a clarity of distinction. An indice is an observable fact (an indicator) which carries information about another fact which is not observable (something which is indicated). For example, the presence of a particular type of distant smoke indicates the presence of a fire. On the other hand, a sign or signal is an artificial indice, produced and expressed by a sender with the intention to send information about another non-observable fact. Thus the smoke from a forest fire is an indice, but the smoke from a fire

lit by an Indian to announce an enemy approach is a sign or signal. The semiology of communication studies communication systems that are known and understood as such through social learning. One of Mounin's papers, for example is called 'An analysis of Indian sign language'.

In contrast the semiology of signification posits, without explicitly proving, that all socio-cultural phenomena that can function as indices can also function as signs and are therefore communication facts. This is justified by stating that all aspects of all socio-cultural phenomena have signification, and analyses have been undertaken which show how this works. The task is to decode the sign systems, or signifying systems, using the general structural-linguistic model (Mounin 1985: 24). The studies we looked at above adopt this approach, by insisting, for example, as Duncan and Wallach do, that the architectural code of the Louvre or of MOMA had a signifying effect, even though we do not know and are not told, which visitors noticed which parts of it.

From the point of view of the analysis of intended communication, the distinction between indices and signs is crucial, because it enables the obsevation of the selection of indices. In other words, it enables the making of a methodological distinction between that which is intended by the communicator to be meaningful (a sign) and that which may become meaningful to the viewer because of some relationship that they perceive between themselves and the phenomenon (an indice). Mounin points out that indices are not in themselves necessarily signifying (*signifiant*) but that they do have the potential to signify if selected to do so by someone. Indices are 'signicative' (*signicatif*). They may come to mean something to the observer through a process of interpretation. All socio-cultural phenomema, including museums, exhibitions, posters, and objects, are saturated by indices, which are 'signicative': they may become 'signifying' if relevant to and selected by the observer through a personal process of interpretation.

For example, recently I went to the British Museum and walked, without any particular intention, into a display entitled 'Archaic Greece'. The display contained a series of *signs* that patently made up an intended communication system. This consisted of introductory text panels, headlines, object labels, photographs, maps, diagrams, objects of various sorts, and so on, all admirably consistent and intentionally designed to convey information about some aspects of Archaic Greece. Alongside this system of intended messages, there were also many *indices* which had the potential to interest observers, or which might have remained virtually invisible. I ignored the intended messages (the signs) about the cultural and historical context of the objects, and looked instead at the form of some large pots. I observed how they stood up, if they had legs or feet, where their handles were, and how big they were. A secondary

interest was how they were decorated and which materials had been used. The indices relating to the sculptural aspects of the objects (form, size, texture, decoration) became, for me, signifying indices through the relationship I made with my own interests in making sculpture. I interpreted a gallery with pots from Crete in it, in the same way, for the same reasons.

Museums and exhibitions are saturated with indices, but are also constructed through an assemblage of signs and signals, which in Mounin's terminology means that they carry intentioned messages. I think we could legitimately claim that museum exhibitions and posters, for example, operate within a system of communication that can be socially learnt. There is certainly an argument to be made about who has access to such social learning, and how effective this social learning is, but at the moment I want to put this to one side. It we accept Mounin's approach to the semiology of communication, and if we can for the moment accept that museum communicative practices fall within a communicative system that can be socially learnt, then we can proceed to say that all communicative acts in museums will consist of: first, signs and signals, which carry intended messages: and second, signicative indices, which may or may not become signifying through a process of interpretation.

Mounin points out that it is sometimes difficult to differentiate between the two semiologies, that is between the semiology of signification and the semiology of communication, because some socio-cultural phenomena can participate in both. His examples of such social-cultural phenomena are literature, film and theatre, but I think we can definitely add museums to the list. Museums clearly can be part of both the semiology of signification, as we have seen from the analyses I have cited, and I propose to demonstrate how museums can be approached through, and can usefully use, the semiology of communication.

However, before we go on to consider the semiology of communication, we should first ask how communication as a process is understood in museums at the present time.

COMMUNICATION MODELS IN MUSEUMS TODAY

I am not at all sure that we can in fact be very clear about how communication as a process is understood in museums today. If we look back a few years we can discover quite a debate about how museum communication should be understood. Thus Duncan Cameron in 1968 in an article entitled 'A viewpoint: the museum as a communications system and implications for museum education', posited a communications model which was drawn from the then contemporary information theory.

transmitter ‑‑‑> medium ‑‑‑> receiver
(exhibitor) (real things) (visitor)

Figure 4.1 Basic communications model from Cameron, 1968

He dismissed a simple communications model of transmitter, medium and receiver in favour of one with a variety of transmitters, many media and many varying receivers. However, a schematic diagram of this model will reveal its basic structure (Figure 4.1).

It is of course based on the original Shannon and Weaver model of communication, one of the most influential models of communication, developed to assist in the construction of a mathematical theory of communication which would apply to any situation of information transfer, whether by people, machines or other systems (Figure 4.2; McQail 1975: 21).

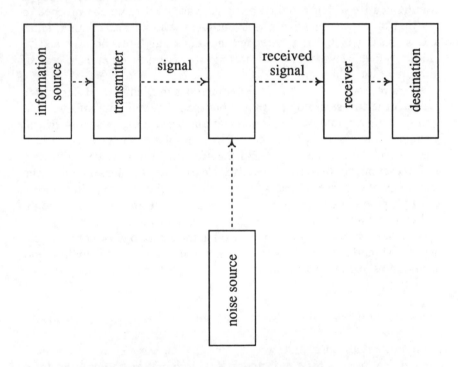

Figure 4.2 Shannon and Weaver model from Duffy, 1989

Cameron added the notion of the feedback loop. 'The addition of feedback to the museum communications system is the basis of exhibit effectiveness reearch', he wrote. This will enable the transmitter to

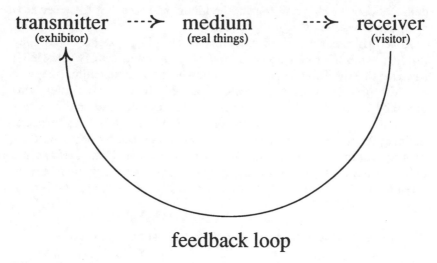

transmitter ---> medium ---> receiver
(exhibitor) (real things) (visitor)

feedback loop

Figure 4.3 Cameron's model with feedback loop

modify the transmission. Alternatively, feedback loops allow the visitor to compare his or her understanding with the intended message, that is to see if the message has been received correctly (Figure 4.3).

This model has been relatively influential in museum thinking. Borun (1977) states, for example, that 'the museum visitor can be seen as part of a special communications system in which he is the recipient of messages from the staff through the medium of the exhibit. In order to know whether or not the message has been received and understood, the museum must complete the communication process by providing feedback channels for visitor response'. Steven Griggs points out that one of the most often-cited reasons for evaluation in museums is to provide feedback to the process of developing exhibits (Griggs 1984: 413). This suggests that where people are thinking about how useful their exhibitions are, they are taking this basic communication model as a given.

It is, in fact, extremely difficult today to find out what, if any, model of communication underpins the communicative efforts of museum professionals. I am not sure how far people are thinking about it in this way. However, I think it is fair to say that most museum workers are thinking in terms of the messages of the display, and thinking in terms of how messages may be transmitted effectively, which suggests that the model I have cited is still in operation.

There are recognized problems with this model of communication to which we should pay attention. These are as follows: first, the model proposes a linear view of communication; second, the model suggests that the communicative act begins with a sender; third, the model suggests that the intention of the communicator defines the meaning of a

communicative event; and fourth, the model assumes that the receiver is cognitively passive (McQuil 1975: 1–3).

Roger Miles has described museums as 'disabling systems' where they produce exhibitions based on this model of communications (Miles 1985: 31). One of Miles' major critiques is that where communication is seen as a linear process, with the message defined by the transmitter, this generally means that the transmitter is the curator, and that curators therefore become what he calls the power-brokers in this process, defining the themes, approaches and processes of exhibitions from their own viewpoint. The meanings of the exhibition and its artefacts are defined by the curator according to his or her agenda, without paying attention to the interests, desires, needs of visitors, or indeed non-visitors.

SEMIOLOGY OF COMMUNICATION AND THE CONCEPT OF 'PERTINENCE'

How can the semiology of communication help to modify the communications model, or help to moderate a disabling process? One of the most fruitful concepts used by this school of semiotics is the concept of 'pertinence'. 'Pertinence' is a fairly broad concept which can cover the point of view, the approach, the set of questions, or the general theoretical outlook that guides either observation or expression of communication systems (Mounin 1985: xvi).

In linguistics, for example, communicational pertinence both determines that structural function of the elements of language and leads to an identification of these elements. Mounin suggests that this concept can be borrowed by other fields of semiotics. 'By determining which elements in a given phenomenon will become indices, the concept of pertinence allows for an interplay between a point of view on the one hand and the specificity of a given phenomenon studied on the other, because indices are at the same time materially part of the phenomenon and abstracted from it into a conceptual scheme' (Mounin 1985).

We might apply this to museums by saying that the concept of pertinence allows us to study how a given set of objects are related for the purposes of, say, an exhibition; the study would include an identification of which elements of the material phenomenon (the object) had become indices, and which approach to display had been followed for what reason.

The concept of pertinence is relevant to both observation (the study of something) and expression (the making of something). Thus we can use the concept of pertinence to help make relationships with audiences. Pertinence implies that although reality is inexhaustible, it is not elusive. Pertinence determines which elements of a given phenomenon will become meaningful. Relevance and meaning in relation to objects will

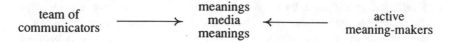

Figure 4.4 A new communication model for musems

ensue with a congruence of pertinence between communicator and interpreter, between the messages of a given exhibition and the meanings construed from this exhibition by individual visitors.

From a material socio-cultural phenomenon (an artefact or specimen, an exhibition, a museum) people will select (imperceptively) those indices that are pertinent to their own agendas at that time. Things will become of meaning if relevance if found between the phenomenon and the viewer. When Mounin was asked 'What makes a linguistic statement a poem?', his answer was the effect on the readers. The moment of reading is as important as the moment of creation. Thus for the success of any communicative act, both the expression and the interpretation need to be in a dynamic relation. For an exhibition to be a success, the effect on the viewer is as important as the work of the museum workers in setting it up.

A new communication model for museums must be proposed which would look something like Figure 4.4. The 'communicator' is replaced by a team which would include the interests of the curator, the designer, the conservator, the audience. The 'receiver' is recognized as an active maker of his or her own meanings for experiences, an interpreter with previous knowledge, attitudes and values which will inform any interpretation; and the 'medium' is reconceptualized as the middle ground between the communicators and the interpreters where many, varied, and possibly conflictual meanings will constantly be made and remade. This middle ground is never still, but always in flux. Each new interpreter brings a new interpretation to both the intended communication and the potential indices. The middle ground includes all the communicative media of the museum; the building, the people, the exhibitions, the objects, the café, the toilets and so on. Museum meaning is not confined merely to an interpretation of the exhibitions or displays. A good experience in the café, or at the information desk, will influence the meaning of the artefacts, as we all know.

Mounin's distinction between the semiology of signification and the semiology of communication enables us, as museum workers, to make several distinctions. We can understand that museums as cultural and ideological artefacts may be analysed as signifying systems, as Barthes and others have done, and we can grasp the strengths and weaknesses of this analysis. We can also understand, through the semiology of communication, that museums can be analysed as intentional communication systems, with a use of intended signs and signals that may be both

socially learnt and socially taught. The semiology of communication also enables us to understand what we always knew, that people will make their own sense of experiences, in other words that indices will become signifying according to personal meaning systems. We can also realize that indices can be manipulated as part of the system of intended meanings.

There are several tools here that are of use to museum workers. Clearly if museums do operate as systems of intended communication which can be socially learnt, this system can be studied, analysed, improved, modified, taught and so on. Museum workers would benefit from such studies.

Maybe we should assume that museum audiences have not in general been taught the communicative system of museums, and we should develop ways of enabling people to grasp the system quickly. Some museums are finding ways of working together with audiences to produce communicative systems. This acts as training for both museum worker and audience member.

How can we make the museum pertinent to the lives of audiences? Can we interest new audiences by finding new ways of approaching the collections, new questions to ask, new indices to become significant? How do we know when an indice has shifted from being 'potentially signifying' to 'significant' if we don't ask? How would the answers change the intended communication systems?

I feel that many museums are already beginning to explore these avenues and are beginning to find ways to develop the dynamic relation between expression and interpretation. This dynamic relation is the way forward for museum communication.

BIBLIOGRAPHY

Anon, 1980. 'Adam's ancestors: Eve's in-laws,' *Schooling and Culture*, 8: 57–62.

Barthes, R., 1973. 'The great family of man', in *Mythologies*, Paladin, England.

Borun, M., 1977. *Measuring the Immeasurable: A Pilot Study of Museum Effectiveness*, The Franklin Institute, Philadelphia, USA.

Cameron, D., 1968. 'A viewpoint: the museum as a communications system and implications for museum education', *Curator*, 11: 33–40.

Duffy, C., 1989. 'Museum visitors – a suitable case for treatment', (unpublished paper for the Museum Education Association of Australia conference, 1989).

Duncan, C. and Wallach, A., 1978. 'The Museum of Modern Art as late capitalist ritual: an iconographic analysis', *Marxist Persepctives*, Winter: 28–51.

Duncan, C. and Wallach, A., 1980. 'The universal survey museum', *Art History*, 3(4): 448–69.

Griggs, S., 1984. 'Evaluating exhibitions', in Thompson, J. M. A. (ed.), *Manual of Curatorship*, Butterworths, London.

Hodge, R. and D'Souza, W., 1979. 'The museum as a communicator: a semiotic analysis of the Western Australian Museum Aboriginal gallery, Perth,' *Museum*, 31(4): 251–66.

Innis, E., 1985. *Semiotics: An Introductory Reader*. Hutchinson, London.

McQail, D. 1975. *Communication*, Longman, London and New York.

Miles, R. 1985. 'Exhibitions: management, for a change', in Cossons, N. (ed.), *The Management of Change in Museums*, National Maritime Museum.

Mounin, G., 1985. *Semiotic Praxis: Studies in Pertinence and in the Means and Expression of Communication*, Plenum Press, New York and London.

5 Boredom, fascination and mortality: reflections upon the experience of museum visiting

ALAN RADLEY

Boredom, fascination and mortality: reflections upon the experience of museum visiting

ALAN RADLEY

The title of this paper emerged out of a series of interviews with people who had been museum visitors. As mundane descriptions, its terms are familiar to everyone who is concerned with the display of material culture in museum environments. Boredom is what some visitors feel (this is a bad thing); fascination is what others experience (generally a good thing), and mortality — well, by this I mean a sense of what has gone, been lost, the past itself. The second part of the paper's title refers to people's recollections of visits which they had made to museums, sometimes many years previously. I was interested to know how they remembered the visits which they had made, and how their memories were shaped by experiences related to particular objects which they selected. As these people demonstrated, boredom, fascination and mortality often appear together as elements in their recollections of museum visits. What is less tangible, I suspect, and what I shall have to make an effort to show, is how the original experiences were premised upon a different form of remembering, of sensing the past. In this case, boredom and fascination are not encapsulated experiences, so much as indicators of different ways of grasping mortality, of sensing what is absent from the display.

People's recollections of their museum visits are constructed out of their experiences, whatever they may be; and people's experiences of museum objects emerge through their grasping a past which is culturally formed. To understand what visitors make of museums, one needs to understand what museums made of them. More precisely, one needs to know something of their encounters with particular objects at a particular time. This can be done during the visit itself, by observing and talking to people in the actual museum setting (Cone and Kendall 1978; McManus 1987). In this case, I chose to do it by speaking with

individuals some time (in some cases, years) after they had made their visits.

The Social Appropriation Of The Past

Before beginning with the main body of the paper, it might be useful to set this work in a wider context, and to show the connections between the approach which I shall adopt – social psychology — and museum and material culture studies. Perhaps the clearest point of contact presently visible is work on collective memory. Traditional literature still concerns itself with memory as an aspect of individual cognition, a process that resides somewhere in each person's brain. However, new lines of research see remembering as very much a product of social discourse, having significance both in what is shared by people and in how they share it (Middleton and Edwards 1990). For example, a community preserves, or rather it remakes its collective past through commemorative acts, which include oral accounts making up what is termed 'popular memory'. This remaking of the past provides communities with their identity, establishing a continuity which is the basis for approaching the future. This does not mean that people are engaged in trying to replicate what actually happened. Social remembering includes many instances of people whose reputations have undergone change as they are transformed into epic heroes, of families who recall together something that did not quite happen but, in the telling, makes them all into the family which they want to be. To study collective memory is to realize that the past is the subject of discourse and debate, in which competing and discontinuous elements are present.

The past is not a passive object for the community. It is often embellished or purified in people's attempts to render it either amenable to modern concerns, or else to render it distant and mute (Lowenthal 1985). It is sometimes used by the present as its own critique, the argument that our todays could benefit from being more like our yesterdays (Billig 1990). And more directly, we arrange our todays so that they shall be remembered in the future, as pasts consistent with our present interests. The album of wedding photographs, the unveiled plaque and the twenty-first birthday party celebrate today partly by putting a marker on tomorrow (Radley 1990).

These comments are equally true for the way in which we arrange the physical environment in which we live. Both the urban and the natural landscapes, and the ways in which they are represented, provide this continuity. Perhaps more than anything else, however, museums are expressions of the ways in which societies represent their own, and

others' pasts to themselves. In a sense, all of the comments which I have just made about social remembering are applicable to museum studies. The ways in which artefacts are displayed, in which locations, who selects them, who is encouraged to view them, the issue of information versus entertainment, are each an aspect of an ongoing debate about the present ends which the past should serve. Where these issues remain implicit in everyday discourse, they are made explicit in the work of students of museum and cultural studies (Lowenthal 1985; Lumley 1988; Shanks and Tilley 1987).

Having made this connection between social psychology and museum studies, I can now rely upon it to turn my attention to what I believe is missing from this kind of analysis. In psychological terms it is the way in which moments become significant for individuals, so that a specific point in time becomes a particular standpoint in discussions of what is or has taken place. From the position of social remembering, these moments are taken to be the products of people's actions and discussions. And yet this cannot be wholly true. People do have experiences which either lack the support or the confirmation of others' reports. There are also experiences which they are unable or choose not to share with other people. Just because one is not expected to see certain things, does not mean that they will not be experienced. Just because the social group declares some perception outside its interests, does not mean that a particular person must forgo it. Commemorative occasions are themselves remembered by occurrences which are out of place; when someone dropped the Christmas pudding, or when the car broke down on the way to the wedding reception. In spite of our best efforts to arrange that an occasion will be remembered in a certain way, events have a certain way of erupting 'from below' as it were, in the more mundane arenas of experience.

With this point I arrive at this paper's focus on museum studies. For museums are institutions of cultural memory, selecting, legitimating and interpreting the past for its visitors. However, museums are also arenas of mundane experience, through which the preferred categories of curator and visitor are often levered open. This occurs because the museum is full of objects which appeal to or resist the appetites, as well as the senses. Arranging the social and cultural setting of an object does not, as Durrans (1988) has pointed out, exhaust an appreciation of the object itself. But what is the 'object itself'? Psychological theory cannot help us here because it is itself a product of Cartesian thought. It lays its claim to mental life by forgoing any interest in the material world except as an object of thought. I think that this is a gross error. To show this I want to use the study which I made to address the issue of how things are remembered in museums, linking the apparent ordinariness of objects to the asserted significance of visitors' memories.

THE MUSEUM AS CONTEXT

The material from which I shall draw examples for discussion was based upon questionnaires completed by two groups, one of 44 middle-aged adults attending evening classes and one of 62 undergraduates. They were asked about their background of museum visiting, their views on museums in general, significant objects which they remembered, and what they thought and felt when viewing a number of artefacts which they selected. I shall restrict myself in this paper to talking about their views on museums and their memories of significant artefacts.

Clearly, these two groups are not representative of visitors or non-visitors, and one cannot generalize from what they said. This, however, is not the purpose of the analysis. The intention is to use the replies of the respondents to examine the structure of their various experiences, in order to discern the different ways in which particular objects or museums (a) were made significant, and (b) were made memorable for them. While it is clearly important for museums to estimate the parameters of their client populations, the survey technique associated with this task is inappropriate to understanding the situated and concrete experience of particular people. Therefore, rather than count responses, I shall use selected examples to illustrate differences in patterns of experience, as part of the wider task of examining how people use artefacts when constructing a sense of the past.

The respondents were given a list of episodes, and asked to compare these with a visit to a museum. Included in the list were such items as 'going on a family outing'; 'watching a television documentary'; 'being in school'; 'going to the theatre'. However, the majority of both groups saw the visit as either being like 'looking around a stately home' or 'going into a church or cathedral'. Among the students, these categories were sometimes coupled with rather negative judgments of the setting. For example:

Stately homes are similar to museums in that both generally contain a clutter of objects, most of which are far less interesting than they are supposed to be. There is a sense that one is supposed to be taking an interest, and that it is a sign of being cultured/educated to do so . . .

This opinion was less common among evening class respondents, many of whom saw the stately home as a model for the museum.

Stately homes are museums with the displays ready set out.

Comparisons with stately homes and with cathedrals were made in terms

of the fact that both evoke the past through containing valuable or sacred objects. For example:

> *The grandness of a cathedral is similar to the grandness of the upper class in history.* (Undergraduate)

> *Sense of oldness, history and even decay.* (Undergraduate)

> *Because of the way most museums are laid out with the walk round from one room to another, and because items are displayed, but you can't touch or feel them. The atmosphere of it being a hallowed, hushed place. The feeling of looking at dead history.* (Evening class member)

In these comparisons questions of boredom or fascination are subordinate to an attitude of reverence, in which the objects displayed in museums are to be treated like *sacra*. It is not their value but their uniqueness which marks them out, as well as the form of display, which separates them from contact with the visitor. In passing, one might note that museums are the only place, apart from the church setting, where the public is likely to come across human relics. Skulls of Maoris, hands of thieves and shrunken heads from Southern America, evoke the twin responses of awe and disgust which, in many cultures, are associated with the corpse and what it touches. Perhaps it is not surprising, therefore, that in one survey nearly half of the *non*-visitors chose 'a monument to the dead' to be their image of what a museum is like (Merriman 1989).

I do not want to labour this interpretation of museums, but would make one particular point. For a visitor to see a museum, stately home or cathedral in this way is to appropriate the past directly. By this I mean that the past is given in the marks of ageing of the building and is there to be seen in the decay of its contents. The building and its contents are of the same form; the artefacts are not so much in the building as *of* it; the building is not so much a container as the connective tissue of the displays. Within the terms of this approach, the idea of a modern museum is virtually a contradiction in terms.

Other images of museums were offered by both groups of respondents, including, among the younger undergraduates, the idea of the museum as being like a department store. What was emphasized here was the freedom of visitors to wander around until something catches their eye. The museum becomes the support for a kind of 'visual buffet', for the benefit of its consumers. Without exploring this particular metaphor further, one notes the manifestation of this viewpoint in the development of the museum shop. This offers, at the end of one's tour, the one thing

that the older museum did not provide — the opportunity to acquire some semblance of the past in commodity form.

Now these two images which I have just described are but selections from others which people will use if given the chance. They are chosen because they offer the advantage of seeing what might lie behind the use of such metaphors. The museum as cathedral and as department store differ, I believe, on three main counts:

- the status of the artefacts on display;
- the scope or potential for the visitor to perceive and perhaps to touch the objects;
- the sense of the past associated with each one.

By the status of the artefacts I mean the degree to which they are seen as being excluded from the exchange process. Kopytoff (1986) has used the term *singularization* to capture this condition whereby artefacts are removed from the world of trade and accorded special status (e.g. a painting by Monet, a vintage car). He speaks of *commoditization* to refer to a condition in which an object is freely exchangeable in the market-place, acquiring a monetary value which marks its accessibility to all who can afford to purchase it. These two terms form the poles of a continuum, which can be adapted for use in relation to museum artefacts.

In one sense, all museum objects are singularized in being set aside, just in the act of being collected. There is a difference, however, between the object or collection which is singled out as unique and one that may be removed, added to, placed in a relation to others, or be part of a travelling display. The singularized object, exemplified by a tomb in a church or by a body preserved in peat over centuries, is displayed in and of itself. By comparison, objects which are exchangeable — and this might account for the majority of most museums' items — form part of a repository on which curators can draw in order to construct displays of their own devising. Apart from the physical restrictions imposed, tombs and human relics do not lend themselves to this form of creative exchange. My point is not that there are two kinds of item in the museum world, but that to view a museum *as if* it were a cathedral is to know it as a locus of singularization, in which all it contains has meaning in being excluded from the things of the everyday world. It is a site of purity, and, arguably, of danger too.

The difference between the singularized and the exchangeable can be appreciated in terms of the relationship of the artefact to the visitor. In the case of the singular object, many visitors come to view it as pilgrims to a shrine; the eyes of many fall upon the one thing at the same time, and their presence together, their collective gaze adds to its particular significance. We think of national treasures in this regard, or certain

paintings. Notice that where these objects travel, special arrangements are made for their security which reinforces their status. This has a different effect upon different sections of the population. Let me conjecture about non-visitors, I suspect that it is they who see museums as monuments to the dead. In this case, singularization of artefacts means exclusion from their life world, the commerce of everyday things which celebrate the present day.

In contrast to the non-visitor, singularization can enhance the attraction of the exhibit for the cultured (and usually middle-class) person. Berger (1972) has argued that, in an age of reproducible objects, it becomes very important to remake the original artefact as unique, if necessary through what he terms its mystification by academics. One of the evening class students, when asked about an object she remembered, said:

> *The painting of the Mona Lisa by Leonardo,* adding *possibly the most well-known painting in all the world.*

When asked to say what came to mind about it now, she remarked:

> *It is much smaller than I imagined it to be and not the best painting in the world.*

This quote shows that singularization can also raise expectations of the object's significance. It implies that the meaning of the object will, like sacred artefacts in medieval times, somehow be given *in* it. Two students who were less than enthusiastic about museums described them as 'dimly lit', and as 'dark places'. One can imagine the space of these museums, like that of a gothic church, to be penetrated by the illumination from the precious artefacts which they contain. This is the reverse of the modern conception of throwing light upon objects in order to see their qualities more clearly.

The modern eye reads the meaning *upon* the object, which it scans actively. Consistent with this, the department store metaphor is based upon the idea of a freely moving visitor who scans the array of artefacts, choosing to stop here or to wander there. Among respondents, those who used this image spoke of 'looking in your *own* time', as well as objects competing 'to attract attention' and to catch the visitor's eye. In this case the relationship between visitor and artefact is quite different to that contained within the cathedral metaphor. The latter evokes a collective attitude of reverence before the object; by comparison, the department store indicates the free movement of individuals around objects grouped, illuminated and displayed to meet this interest or that appetite. The correlate of this is the reconstructable and portable display, through

which, as Berger notes about reproduced paintings, the meaning of objects 'multiplies and fragments into many meanings' (Berger 1972: 19).

Let me turn, briefly, to the different senses of the past which these two metaphors convey. I have already said that the museum as church bears the marks of the past upon it directly, in the age and condition of the artefacts. Removed from the present — by which is implied here the world of the living — the artefact embodies certain continuities for the visitor who believes in it. These continuities, I suggest, are partly to do with knowing *where* one is in the world (not *what* one is, but one's location). As one evening class student said, justifying the museum as a church:

> *A cathedral can reflect a national history, particularly if well-known figures in history are buried there.*

Crown jewels, the regalia of power and of wars won, the battered helm and broken sword, are all examples, like stately homes in graceful decline, of objects which help people to know where they stand in the world. In Britain, people may know that the past is dead, but it is glorious none the less. As Lowenthal (1989) has pointed out, museums can play an important role in keeping the past dead, and in consequence, free from being tampered with by those who would reinterpret it. (For critical discussions on this point, see the volumes edited by Pearce (1989); Lumley (1988); and the recent book by Vergo 1989). The more one examines the church metaphor, the more one sees that words like *sacra* and reverence are not misplaced in trying to understand the museum experience.

The image of the museum as a department store produces different possibilities for how the past will be perceived. This difference can be appreciated in terms of the fact that the store is a modern edifice, compared with a cathedral or church. This comparison is not just between two buildings, but between two material expressions, reflecting on the one hand a society in which hierarchy and status are key concepts, and on the other a society in which the rights and obligations of individuals (consumers) are paramount. The idea that people can walk around at will, sampling this and leaving out that, implies that the past is capable of being reconstructed. The past does not lie in the objects contained in the museum, but needs to be read out of them by means of a created display. In addition, providing a text helps visitors to see in the objects the curator's interpretation. While visitors do not purchase the artefacts themselves, they acquire knowledge of the items they inspect, as a kind of cultural commodity.

It is important to note that what has been discussed in these metaphors are two *ideal forms*. I am not suggesting that museums can be divided up

into those like churches and those like department stores; nor can visitors be grouped according to this particular difference. I am suggesting, however, that these loose comparisons reflect real and important differences in the ways in which people approach museum artefacts. However, these two approaches need not appear separately. It is not unusual for the two attitudes to be evoked together in a single display, such as when an important painting (like the *Mona Lisa*) attracts visitors through their having seen one of its many reproductions.

This comparison of images of museums has shown that the status of the artefact, the scope for perception of objects and the sense of the past attaching to these are related together. I now want to go on to examine in more detail the way in which these things work together in people's experience of memorable museum artefacts.

SIGNIFICANT OBJECTS AND A SENSE OF THE PAST

The respondents were asked to think of a museum object (or display) that had caught and held their attention. They were asked to describe it, say why it was significant for them, and to write down what came to mind when they thought of the object now. Among the responses were the following:

> *A large doll's house belonging to a queen/princess (Victorian) in a palace in London. I was about eight and had my own doll's house, but nothing so large and detailed as this one. I wanted to play with it.*
>
> *It was much larger than me. It was enclosed in a lit-up glass case whilst the rest of the room was dark. I would like to go back and examine it more, but I wouldn't be able to see it through a child's eyes again.*
>
> (Undergraduate)

> *An old railway steam engine . . . in working action with an old man telling its history. He fed the fire with coal, and happily answered any questions.*
>
> *[I remember] mainly the noise, heat and shining metal — also the old man!*
>
> (Undergraduate)

> *The 'Mallard' at the Railway Museum. It was big and quite frightening to look at — not like the trains of today, I remember it towering above me like a large animal. The front of the train — its 'face' — had character and it seemed as though it were almost alive.*
>
> (Undergraduate)

These responses all relate to things which those individuals found fascinating, and are selected to highlight two particular points. The first is that the qualities which originally made the objects interesting are significant in how the visit is remembered today. I shall have some clearer examples of this later on. The second point concerns the fact that what made these objects significant was partly their size in relation to the visitor (they are memories of childhood). They called out a sense of awe which was manifested, not merely as a size difference in physical terms, but in the imagination of the visitor. As one student said, the size of the dinosaurs in the Natural History Museum are evidence that such creatures really did live on earth, even though to a child they might seem only a fantasy.

Size is perhaps the simplest example of the fact that we confront museum objects with our senses, senses which are constituted by our bodily existence. The giant steam engine or the towering dinosaur are not simply there as bigger, they become so in the course of being approached and looked at. This involves the visitor not just in comparing the relative sizes of things from a distance, but in craning his or her head to look up, walk round the object, and sense its weight. The perception of these kinds of things can readily be appreciated as bodily perception, and we can extend the idea easily to the ways in which people respond when entering cathedrals, as well as some museums and art galleries. The museum is in part an experience of space, where distance and size are always relevant features. This applies to the small as well as to the large; the miniature painting, and the intricately worked handtool must be approached, leant towards and focused upon.

I want to make central this idea that the body is a key feature of the perception of museum objects. This might seem a strange proposition in a culture where the visual sense is dominant, to the point where to know something is almost synonymous with seeing it. Even the body itself has become an object of visual perception, something which can be dissected and understood as a machine. And yet the lived body cannot be confused with this machine-like entity, for it is the ground of our sensing of the resistance of the material world, its shape, size and texture.

It is not just in their spatial arrangements that artefacts are sensed but in their use. They are sensible in what they call out in us as we would touch, lift, wear, or stand upon them. To perceive a 'handle' I must not be just a thinker, but a handler with a hand that is substantial enough to grasp the cup, as it withstands my grasp (Wertz 1987). Heavy objects are sensible as limitations to one's lifting, softness is perceived within the scope of a delicate transgression of the fingers, sharpness in terms of the yielding of one's own flesh to the blade. This way of perceiving objects depends upon the body's material aspect for penetrating the world of things. Following the phenomenologist Merleau-Ponty (1962), we can

say that the body also has an intentional aspect, in that it adopts an anticipatory attitude towards the world. Just as we might say that the handle of the cup invites us to lift it, so it can be argued that the body forms itself in anticipation of the style of use of the objects or settings in question. These styles of use are not merely to do with motor actions; they are elaborated into habits, capabilities, and limitations taken up by us in the course of our cultural experiences. Take the following examples:

> *The mask of Agamemnon discovered by Schliemann. It is a beautiful gold mask — the features are very clear and very finely carved. They show a middle-aged man of noble rank, someone who looks as if he was used to being obeyed without question and yet the face is kind. The features are — to coin a phrase — aristocratic.*
>
> (Evening class student)

> *A Victorian household. I compared my way of life today with that of a Victorian equivalent. Would I be a servant or employer? I imagine myself as a weak servile servant. Low status or lady of the house? High status but still servile and subordinate to husband and men of equal standing to him. Could I be so passive?*
>
> (Evening class student)

In these quotations the visitors' grasp of the objects is given in their different 'attitudes' to the settings. Just as the physiognomy of Agamemnon's mask is understood through his powers to bend people to his will, so the Victorian household is seen as a potential space in which men and women enjoyed different powers to act in the world. In front of these objects the two respondents (both women) adopt, respectively, a shape of potential strength and weakness. This is embodied in them as feelings, and discerned upon the object and in the display as qualities which gave the artefacts their meaning.

The perception of objects is not merely a seeing of things, a timeless inspection of the present. We reach out with our potentialities in a unity which embraces the senses and also the points of culture which we embody, as man, woman, labourer or scholar. The body has what Merleau-Ponty calls 'historical density'. To accept this is to be able to take a further step towards understanding the museum visitor in terms of gender and of class, because these are grounded in bodily differences. Out of one of the earliest divisions of labour, men came to create enduring symbols, while women reproduced perishable bodies (Turner 1984). This is one reason why women are less represented in museum displays. Particularly in the case of the poor and those living as servants, the objects which they owned and with which they worked were few and were rendered down or decayed with use. (See Porter 1988 for a critical

discussion of the way in which the past worlds of men and women have been differentially constructed out of the availability of historical artefacts and the press of modern assumptions.)

The relationship of men and women to members of their own and to the opposite sex are mediated by the ways in which they relate to the world with their bodies. As examples of this tradition, male and female visitors bring different body-schemas, lived orientations if you like, to museum displays. In spite of recent changes, many women do not know the sensation of taking apart and mending a piece of machinery, the pleasure of overcoming a problem to make something work. Fewer men, I expect, know the feeling of silk on their skin, or the pleasures to be derived from choosing and using clothes, jewellery and make-up in their daily lives.

When it comes to social class, the relationship of people to objects cannot be appreciated without some understanding of ownership, of differences in the alienation of people from their products (Marx 1959). Also relevant is the way in which people of different classes and cultural backgrounds use their bodies in different ways in the pursuit of pleasure and relaxation (Bourdieu 1984). Terms like taste, culture and style refer to ways of life appropriated by privileged people in the course of living in a world whose material form they are relatively able to control if not shape.

As museum visitors, what people bring to the display is an orientation which expresses their cultural and personal biography. They reach out to the object from the basis of personal pasts which remain tacit in their sensing of the object. It is into this tacit personal past that a sense of cultural past is taken up. For example:

> *A dress worn by Emily Brontë which was shown in the Haworth Museum. I have remembered it so vividly because it was on a model, and seemed to bring Emily Brontë to life. It was wonderful to think that I was standing next to something which she had actually worn.*
>
> *The picture in my mind is just as vivid, as I feel the dress belonged to someone I could identify with and therefore really brings history to life.*
>
> (Evening class student)

This does not mean that there is a mere matching of bodily capabilities with object potentialities, or else men would all head for the steam engines while women would go to see the jewellery. While cultural categories exercise limitations upon experience, they do not wholly contain it. If visitors were only travelling thinkers this might be the case. However, the unity of perception with the body makes it possible (as nothing else does) to apprehend the whole through its sensory particulars. By this I mean that conceptual labels do not inevitably hold

sway over sensation and sensuality. It is possible for our participation in the object's form or colour then to form and colour our grasp of it. This is what I meant by saying earlier that our senses can, as it were, erupt from below. Here is one example:

> *When I first saw the collection of Saxon jewellery in the British Museum, including the Sutton Hoo Treasure, I was stunned by the colour — gold, garnets and various blue stones — probably because it was so unexpected after looking at stone and wooden artefacts. It was my first glimpse into Anglo-Saxon art: not the crude people we had been led to believe in!*
>
> *I try to imagine the craftsmen at the time, working in difficult conditions, surrounded by simple mud and thatched houses, etc. but with an ideal of splendour which they gave their work; such rich simplicity which we have yet to improve on.*
>
> (Evening class student)

What this shows, if we did not know already, is that objects are perceived aesthetically and morally, as well as functionally or nostalgically. This can involve a sensory experience, a shock, a disruption to expectations, which indicates a qualitative reconstruction in our perceiving. As significant perceptions they can be of the following form:

> *A display of jewelled fans, pillboxes and combs, the colours and intricacies of the objects. I remember being fascinated by the patterns, feathers and jewels used to decorate the glass case in which they were displayed.*
>
> (Evening class student)

> *Van Gogh display in the Musée d'Orsay. The particular painting I remember is of a haystack. The feeling I had when I looked at it was that I was there, or looking through a window into another world. It's that feeling that I remember because it was so strange and magnetic.*
>
> (Undergraduate)

In these cases, the artefact is not just given but, to use Merleau-Ponty's words, is 'internally taken up by us, reconstituted and experienced in so far as it is bound up with a world' (1962: 326). These moments of reconstitution, that discontinuity, opens up a world of experience which poses new questions; who made this, what sort of people were they, when exactly did Van Gogh paint this picture?

However, at the very same moment that a fascinating object opens up new potentialities, asks new questions of us, it simultaneously makes a

difference to the museum visit itself. It is to this question of 'the memorable visit' that I would finally like to turn.

MEMORIES OF VISITS TO THE MUSEUM

When people wrote about their memories of museum objects, they often included detail about the context within which it was seen. This concerned the museum as a whole, and the people with whom they made the visit. Sometimes all three were found together, as in the following description:

> *At the Natural History Museum. Huge dinosaur skeleton. First thing seen when I walked in. Significant because I was only young at the time and due to the size and the detail. Never seen one before.*
> *Now the whole museum comes to mind, when I think of the object. The whole day out as well. The museum comes to mind because the dinosaur symbolized the other contents to me. I couldn't believe the content and the detail. I remember wanting to stay the whole day.*
> <div align="right">(Undergraduate)</div>

or in a different mode,

> *As I remember Monet's 'Waterlilies', I think of a trip to the National, and Jackie who couldn't see it because of the lousy design of the building (she's in a wheelchair) — and of Paris.*
> <div align="right">(Undergraduate)</div>

> *The Egyptian man in the British Museum . . . The object seems still quite clear in my mind, and the difficulty of finding it (or anything else) in the British Museum is a strong part of my memory.*
> <div align="right">(Evening class student)</div>

All three quotes underline what I have already said about the body as a key term in understanding the museum experience. In these cases, either a particular object or painting, or the work necessary to find and see it, come to frame the memory of the day. The significance of an artefact is in part a biographical event; it might be an object one has read about and especially wanted to find, or something brought to one's attention by a child or grandparent, or something stumbled on quite unexpectedly, a kind of bonus from fate.

Sometimes the relationship of the object to the museum setting can provoke interest. Why are they showing this, or how did it come to be here? Here are two examples:

A Viking Town in Germany was constructed on wooden stakes so it was above water. I was fascinated about how it was built, how long ago, etc.

[I remember] leaning over the fence inside the village and staring down to the water where the tide was in, wondering if they built the bridge to the town after they built it, or before. If after, how did they get to the town, etc.?

(Undergraduate)

A periscope of a World War Two U-Boat at the Science Museum. The eye-piece is on the ground floor and it looks out on to the third floor.

How the hell did they get it into the building? [I remember] the trip to London when I first saw it. I would still look through the eye-piece if it was still there.

(Undergraduate)

These memories tell of artefacts which both invite participation of a multisensory kind, and provoke questions about their setting in the museum context. Rather than making the museum context opaque or non-problematic (such as in a display aiming at authenticity), highlighting the context, showing the discontinuities seems to enrich rather than to detract from some people's experience (Durrans 1988).

Once people have experienced an object or a display, that episode now becomes part of their own personal history, so that what is being remembered is an occasion when their sense of the past was extended or deepened. For example:

Roman mosaics and the underfloor heating system used by the Romans, seen at Fishbourne Roman Palace . . . the care taken to make a mosaic (each little stone) amazed me. The engineering and technology behind the heating system also fascinated me. It seemed so near to modern day technology.

[I remember] the enjoyment of that day. It was part of a three day history trip when I was a first year at school. It brings back memories of enjoying a hot day with friends. I am still astonished now by what I saw, in the same way that I was then. It is all very comforting and comfortable.

(Undergraduate)

This last quote reminds us that how people approach the museum is shaped by the outing, the people whom we are with, and the reasons for being there. The last comment about the comforting nature of the visit I found echoed in statements from parents who remembered going to museums with their children, as well as from young people who

remembered going with grandparents. The museum is, to borrow the title of Robert Lumley's (1988) book, a kind of time-machine, and not only for our cultural pasts. It keeps on working after the visit is over in the realm of personal and family recollection. It does this by signifying a day enjoyed or perhaps an afternoon of utter boredom.

It also signifies, for regular visitors, a kind of experience in which their personal capacities and interests can be informed by the potentialities which lie within material artefacts. This might result in a wider appreciation of past lives or else it might be a rehearsing of experiences with the familiar, as occurs with displays of nostalgia. Whatever the case, the museum experience is a meeting of our personal and cultural pasts, recovered together through the senses in the widest meaning of that word. To grasp something of another past, or the form of historical change through experiencing objects, is to be able to symbolize something of one's own personal past with that item. Collected artefacts are significant not only because curators say they are, or because they are in museums, but because they have done what we might call 'cultural work' for the person concerned. The object's significance lies in it symbolizing a tying together of cultural and personal pasts in a particular moment during a visit. It can be discussed, if you wish, in terms of either of these 'pasts' taken separately; we might study people's memories of their museum visits, or else the historical importance of the artefact for understanding a particular period or culture. What I hope to have shown, however, is that a full understanding of either requires that we take both of them together.

CONCLUSION

The aim of this paper has been to show some of the different ways in which visitors remember museum visits, partly because of differences in how they approach museums and partly because of their experiences of particular objects. The approach which I have taken has been social psychological, in that I have focused upon the experience of people rather than upon the qualities of visitors. Doing this has meant bracketing out the concerns of curators, particularly those to do with 'getting across the message' of the display. While it is clear that the experience of visitors is formed by the interpretation embedded in displays, no analysis of curators' intentions — expressed in material or textual form — can alone provide an understanding of what makes a visit to a museum significant for particular individuals. In this paper I have tried to show, by implication, that theories of communication which are premised upon the visitor as interpreter cannot embrace experiences of artefacts which differ in modality (the 'cathedral/store' metaphor), and in their ground-

ing in bodily life. The transience of life itself is reflected in museum artefacts, and the material aspect of our bodies is that upon which our knowledge of objects depends. From this perspective, boredom and fascination are not just passing frames of mind; they are instead clues to the ways in which cultural pasts and individual biographies engage, and are sometimes mutually transformed.

BIBLIOGRAPHY

Berger, J., 1972. *Ways of Seeing*, BBC and Penguin Books, London.
Billig, M., 1990. 'Ideology and the British Royal Family', in Middleton, D. and Edwards, D. (eds), *Collective Remembering*, Sage, London.
Bourdieu, P., 1984. *Distinction: A Social Critique of the Judgement of Taste*, Routledge and Kegan Paul, London.
Cone, C. A. and Kendall, K., 1978. 'Space, time and family interaction: visitor behavior at the science museum of Minnesota', *Curator*, 21: 245–58.
Durrans, B., 1988. 'The future of the other: changing cultures on display in ethnographic museums', in Lumley, R. (ed.), *The Museum Time-Machine*, Routledge, London.
Kopytoff, I., 1986. 'The cultural biography of things: commoditization as process', in Appadurai, A., (ed.), *The Social Life of Things: Commodities in Cultural Perspective*, Cambridge University Press, Cambridge.
Lowenthal, D., 1985. *The Past is a Foreign Country*, Cambridge University Press, Cambridge.
Lowenthal, D., 1989. 'The timeless past: some Anglo-American historical preconceptions', *Journal of American History*, 75: 1263–80.
Lumley, R., (ed.), 1988. *The Museum Time-Machine*, Routledge, London.
McManus, P. M., 1987. 'It's the company you keep: the social determination of learning-related behaviour in a science museum', *The International Journal of Museum Management and Curatorship*, 6: 263–70.
Marx, K., 1959. *Economic and Philosophic Manuscripts of 1844*, Progress Publishers, Moscow.
Merleau-Ponty, M., 1962. *Phenomenology of Perception*, Routledge and Kegan Paul, London.
Merriman, N., 1989. 'The social basis of museum and heritage visiting', in Pearce, S. (ed.), *Museum Studies in Material Culture*, Leicester University Press, Leicester.
Middleton, D. and Edwards, D., 1990. *Collective Remembering*, Sage, London.

Pearce, S. M. (ed.), 1989. *Museum Studies in Material Culture*, Leicester University Press, Leicester.

Porter, G., 1988. 'Putting your house in order: representations of women and domestic life', in Lumley, R. (ed.), *The Museum Time-Machine: Putting Cultures on Display*, Routledge, London.

Radley, A., 1990. 'Artefacts, memory and a sense of the past', in Middleton, D. and Edwards, D. (eds), *Collective Remembering*, Sage, London.

Shanks, M. and Tilley, C., 1987. *Social Theory and Archaeology*, Polity Press, Cambridge.

Turner, B. S., 1984. *The Body and Society*, Basil Blackwell, Oxford.

Vergo, P., 1989. *The New Museology*, Reaktion Books, London.

Wertz, F. J., 1987. 'Cognitive psychology and the understanding of perception', *Journal of Phenomenological Psychology*, 18: 103–41.

6 *How language means: an alternative view of museums text*

HELEN COXALL

How language means: an alternative view of museums text

HELEN COXALL

My research in museum text is primarily an exploration into how the use of language in museum labels, information panels, guide books and catalogues conveys meanings. A large part of the research consists of critical linguistic analyses of texts from selected galleries and museums, with regard to social and ideological implications. Assumptions that are embedded in language are all-pervasive and cannot be ignored. Madeleine Mathiot makes this point in the preface to her collection of essays on the sociology of language, saying that 'referential meaning manifests itself as a culture's categorization of "the world" through language' (Mathiot 1979). My interest is in the way that a writer's choice of language, and the issues that he or she chooses not to address in the final text, transmit both the official policy of a museum and the personal 'world view' of that writer.

This is not intended to imply that an exhibition's message is not also communicated in non-verbal ways. Meanings can be conferred by the way an object is placed with respect to other objects, or by the positioning of an object in a commanding place in a gallery. A display with very few objects in a large space assumes greater significance than a display with a large number of objects packed into a smaller area. Also, objects highlighted by modern technological methods (a series of slides activated by the visitor, for example) would have more attention drawn to them, thereby suggesting that they have greater significance. Photographs accompanying an object have a similar effect. The context of the exhibits as regards the museum itself is also significant as are the location of the information and notices, the size of the lettering, the lighting and the content of the text (see Hodge and D'Souza 1979: 354).

While acknowledging that all of these aspects, and many more,

contribute to the construction of meaning, for the purposes of my research and for this paper, I am concentrating specifically on the neglected aspect of the language and content of the text.

Several people have already written upon the general subject of museum text. Although Beverley Serrell's well known book *Making Exhibit Labels* concentrates specifically on legibility, readability and design, rather than on semantic implications, she does make a rather disturbing observation in her introduction which has direct bearing on this issue.

> Museum labels have small amounts of copy compared with books, yet people expect them to last for years, often under adverse conditions. Museum labels are also unique, unfortunately, in that although the number of people expected to read them is large, the amount of time spent on their preparation is often very brief and the amount of editing very little. With an annual attendance of 10,000 visitors, a museum exhibit on display for 5 years may draw at least 25,000 potential readers. A book prepared for such a market would undergo far more rigorous and numerous editing stages than the average exhibit label (Serrell 1983: 1).

This alone points to a very valid reason for the need for more investigation into museum text. It is an accepted fact that not every visitor reads the texts provided, or reads them to the same extent. There has been a considerable amount of valuable study devoted to visitors' responses to text, and to methods of increasing the percentage of those who read the information provided. A substantial amount of this work has been done by Paulette McManus, who has published papers about visitor reading behaviour in Natural History and Science Museums (McManus 1988, 1989a, 1989b, 1990). However, while acknowledging this work and always bearing it in mind while doing my own work, this aspect is not the focus of this paper.

Other professionals in the field of museum communication have advocated the use of readability formulae in order to ensure that language is aimed at a specific age group's level of reading ability. To mention just a few: the Communication and Design team of the Royal Ontario Museum have, in the past, recommended that museum staff use the Fog index (Gunning 1952) or the Flesch readability formula (Flesch 1948) to match the language with the reading ability of the target audience. In this country, Sorsby and Horne's article in the *Museums Journal* (1980) discussed the advantages and limitations of the applications of the Fry test (Fry 1968) to museum texts. In 1989 the National Maritime Museum in London published a book by Eric Kentley and Dick Negus called *The Writing on the Wall*, in which they described and

recommended the use of the Fry test and the Cloze procedure (see Bormuth 1966) as measures of language that aid accessibility.

There are three problems with this line of approach. The first is the difficulty of targeting a specific group when the majority of large museums are visited by a cross-section of the public including schoolchildren, students, family groups, adults, specialists and visitors to whom English is a second language. The second is that even if a museum considers its collection sufficiently specialist to justify targeting only one of these groups, by aiming its interpretive labels at a correspondingly restricted audience they will automatically exclude a wider potential audience, who although not specialist, would visit if the presentation was accessible to them. The third and most fundamental problem caused by relying primarily on readability formulae to assess museum text, is that they are measures of style rather than content. Readability formulae are almost exclusively concerned with such restricted features as word and sentence length, but not with meaning.

George Klare, who is probably the greatest authority on readability formulae and who has written extensively on the subject, still feels unable to recommend any of them to writers in general. He comments rather wistfully: 'I wish I could be more certain of how to tell writers what to do to change readability effectiveness' (Klare 1976: 148). However, although it is obviously of undeniable importance that texts should be comprehensible to visitors, this should not be permitted to exclude the issue of how the text communicates its message and whether or not this approach is both appropriate and relevant to the potential audience. As Norman Fairclough points out in his book *Language and Power*:

> We ought to be concerned with the processes of producing and interpreting texts, and with how these cognitive processes are socially shaped and relative to social conventions, not just with the texts themselves (Fairclough 1989: 19).

Jakobson's communication model is used by linguists because it is concerned both with the meaning and the internal structure of the communicated message (see Fiske 1988: 36–9). It therefore ensures that the user never forgets the contribution that the reader makes to the constructed meaning of a text and as such can be usefully adapted to museum use.

The 'addresser' in this model (see Figure 6.1) is the exhibition organizer, the 'context' is the museum itself and the many non-verbal signs such as those discussed in paragraph two. The 'message' is, at best, an embodiment of the aim of the exhibition. The 'code' is the medium of communication, be it text, film, photograph or object. The audience is the 'addressee' and the 'contact' is that which engages the audience's

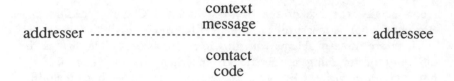

Figure 6.1 The constitutive factors of communication (Fiske, 1988)

attention, which will vary tremendously with its accessibility and relevance for them. It will be obvious that an exhibition's design and presentation will operate visually and textually on different levels according to different audiences. By using such a model, the writer is forced to identify the audience at the outset and to ensure that the form and content of the communication is both appropriate and relevant to that audience. It subsequently forces the writer to consider how a text communicates its meanings.

To summarize, the purpose of this analytical approach is to raise awareness of the way our choice of language reflects current socio-political perspectives as well as our own way of seeing. The intention is to suggest alternative ways of saying that are accessible and relevant, and that avoid unintentional bias.

ACCESSIBILITY AND RELEVANCE

The following text has been taken from Oxford University's Natural History Museum to illustrate the issue of accessibility.

> Primates may be described as plantigrade placental mammals, primarily arboreal, typically with nails or claws on some of the digits, possessing clavicles, having the orbits encircled with a bony ring and usually directed somewhat forward; the innermost digits of at least one pair of the extremities opposable; radius and ulna not fused, allowing free supination and pronation of the manus; separate centrale almost always present in adult; brain well developed with some hypertrophy of the neopallium and reduction of the olfactory lobes typical.

This text was obviously written for zoology scholars as it contains nineteen technical Latin terms, unaccompanied by definition. It takes the form of a factual list of descriptive features presented as one extremely long sentence. The sheer length (83 words) of this sentence and the fact that after the first semicolon the syntax changes abruptly to verbless sentence forms, make it extremely difficult to follow. It could be argued

that, as this text would be accessible to the specialist academic audience for whom it was written, there is no necessity to alter it. However, first it is debatable how accessible this text would be to first-year undergraduate students and second, the assumption that specialists prefer reading highly complex text has been contradicted by research. Funkhouser and Maccoby found in 1971[1] that although knowledgeable scientists found little difference in the comprehensibility of more and less readable versions of science articles, they disliked the less readable versions. Third, this line of argument completely disregards the fact that the museum is visited daily by the general public and subseqently has another, non-specialist audience.

Inevitably, it is necessary to employ technical terminology in science museums. However, there is no reason why technical terms could not be defined, sentences shortened, lists presented as annotated points and unnecessarily complex language modified. All this could be achieved without losing the intended meaning. It is also worth pointing out that textual complexity sometimes results when factual information has been transposed from source documents, without due regard to the different nature of the original reader and that of the museum audience.

Another obvious way to ensure that a text communicates with a wider audience is to provide translations into languages other than English. This is not only applicable to the large national museums whose visitor numbers are boosted by an annual influx of tourits from overseas, but to the local community museums where English is a second language to many of the local people.

The next text has been selected to foreground the issue of textual relevance. This example also illustrates the importance of taking care when choosing evaluative words to qualify meanings and when deciding which information to leave out. Such choices have caused the writer unconsciously to create rather than to relate history. The text is taken from the eighteenth-century section of the Geffrye Museum, a decorative art museum whose aim is to record and show the history of urban home life, interiors and the development of English furniture from 1600 to the present day.

Expensive oil paintings could now be copied and mass produced in a variety of ways such as engraving or etching. These prints were cheap and widely available. By the late Georgian period it was fashionable to have an overall decorative scheme. Yellow silk damask was a popular fabric for curtains and chairs.

This is an apparently objective, authoritative-sounding statement of fact — but what does it mean? The three adjectives *expensive, cheap* and *available* are at once evaluative and relative terms. Whose opinion,

therefore, is being expressed? Is this intended to imply that they were considered cheap by people of the time who could afford silk damask furnishings, or that they were considered cheap by the whole population? As the majority of the population at the time could not even afford furniture, how accurate is the qualifying adverb *widely* in 'widely available'? If the availability was restricted to the middle classes (who numbered less than 25 per cent of the population at that time) whose history is being related here? If it is only that of 25 per cent of the population, should that not be made clear?

The *Oxford English Dictionary* defines *popular* as 'liked or enjoyed or used by many people; of or for the general public' and *fashionable* as 'in a currently popular style; used by stylish people'. Thus *fashionable* would appear to be an elitist word reserved for 'stylish people', which would seem to be more correct in the context of a wealthy home. However, *popular* (i.e. of the general public) is hardly an appropriate word with which to describe a taste for silk damask.

In view of the fact that the museum claims to record and show the history of urban home life from 1600 to the present day, the writer could easily have explained the very legitimate reason why they only have access to examples of the kind of furnishings owned by the most wealthy quarter of the population. Because this was not done, the impression given is that the ignored three-quarters of the population have no domestic history at all.

This situation has considerable implications for the museum's audience. After all, anyone who is not used to elegant living could easily feel excluded by this history and feel that it had no relevance to them or their predecessors. This is not to suggest that people cannot appreciate things that are not within their own realm of experience — in fact quite the contrary is true. The issue here is that this text is not just relating an apparently objective message about Georgian urban life; rather, it is implicitly creating a history in which the whole working-class section of eighteenth-century society (over three-quarters of the population) has been marginalized into extinction. If this section of society was not even worth acknowledging by the writer, what is the same section of society looking at the exhibits and hearing this message going to assume?

WAYS OF SEEING

The text from the Geffrye Museum also illustrates that the choice of language can reflect the writer's, often quite unconscious, socially-constructed way of looking at the world. This process of social conditioning continues unnoticed by the majority of us. In their book *Language as Ideology* Kress and Hodge make the following observation:

The world is grasped through language. But in its use by a speaker, language is more than that. It is a version of the world offered to, imposed on, enacted by someone else (Kress and Hodge 1979: 9).

They go on to make the claim that the grammar of a language itself is a theory of reality. Initially this may sound a little far-fetched. Nevertheless, social structures not only determine discourse but are themselves produced by discourse. As Catherine Belsey points out, our system of communication — our language — is already in existence before our children learn it and in learning this language they learn words that stand for concepts which are taken as natural, 'commonsense' concepts but are actually socially determined ones (see Belsey 1987: 1–67).

For example, the word *tree* (setting aside the obvious difference if the word is translated into different languages) carries different connotations for different cultures. It would have a very different meaning to a current inhabitant of the Brazilian rain forest threatened by exploitation, than it would to a current inhabitant of Ethiopia where dead trees are symbols of drought, or to a current inhabitant of Scandinavia where pine trees are grown as a trade commodity. Hence *tree* is not such a straightforward, 'commonsense', term as it first appears to be.

It does not automatically follow that because our language is socially determined, we are unable to escape the unconscious articulation of underlying ideologies. However, it becomes imperative that we are clear as to the nature of these underlying assumptions if it is not our wish to perpetuate them. It also does not follow that each of us has a fixed perspective that can be quickly identified. As Roger Fowler cautions in his book *Linguistic Criticism*, 'it would be incorrect to think that each individual possesses one single monolithic world view or ideology encompassing all aspects of his or her experience; rather the (representational function of language) provides a repertoire of perspectives relative to the numerous modes of discourse in which a speaker participates' (Fowler 1986: 149).

If writers are articulating perspectives that have hitherto been regarded as commonsense concepts, they may be implying meanings of which they are unaware. Critical linguistic analysis can serve as a valuable tool with which to uncover a text's hidden agenda in order to 'see reality in a new light' (Halliday 1971: 333). Furthermore, with its assistance it should be possible for a critically-aware writer to draw on other discourses in order to create a new perspective. And this applies as much to writers of museum text as to any other writers. This is not meant to imply that complete impartiality is possible, as this would not be realistic. Nevertheless, a greater awareness of the way all discourses are socially constructed would be of great benefit to any writer involved in the publication of so-called facts.

However, museum text is not only influenced by individuals but by the policies and aims of the museums, and museums themselves are influenced in turn by outside forces. The way that specialist museum staff write about their collections is conditioned by many factors including new research in the field, the present socio–political climate, and the interests of their funding bodies. For example, if a geological museum had mounted an exhibition about earthquakes in response to the recent ones that hit Armenia and San Francisco, they could have given detailed information about geological fault-lines and about the problems of accurately predicting an imminent earthquake (which was so graphically illustrated by the failure to predict the two earthquakes just mentioned). It would not be unreasonable to expect such a museum to include information about construction methods that enable buildings, such as the ones built in Tokyo, to withstand shock waves. It would also not be too politically insensitive to discuss the enormous death toll in Armenia being partially due to lack of finance available to erect such houses.

How easy would it have been, however, for the same museum to have mounted an exhibition about nuclear explosions after the events of Chernobyl? Could the museum candidly have discussed the implications for humankind in the face of what could have developed into a far worse nuclear disaster? Exploring this theme further, could the museum have illustrated the purposes to which nuclear power is put without mentioning the numbers of nuclear weapons that are kept to maintain the balance of power? This would obviously be a very sensitive topic for any country owning nuclear weapons. In addition, the feasibility of such an exhibition would be even more problematic if the museum received its funding directly from central government. This is, of course, a very extreme example of political circumstances affecting what museums are and are not able to say, but it does serve to illustrate the point.

To summarize, the choice of language and the avoided subjects in museum text are closely associated with implicit or mediated meanings, but the interpretatation of a collection is also indirectly influenced by other forces, such as the museum's policy, the socio–political climate and the funding bodies.

THE MUSEUM AS MYTH

Objects in a museum's collection need interpretation in order that the public may fully understand their significance. Although some may be records of the past, meanings do not reside within objects and they cannot speak for themselves. Their meanings are reordered by their method of display and interpretation. An exhibition and the accompanying information form an explicit message to the public about the objects

on display, whatever they may be. However, this message is determined by the way the information has been selected and carries an implicit message about the values of the museum and the staff who curated the exhibition. And value is a judgment, not an inherent property.

The issue of evaluative judgment has implications about the responsibility museums have to their public. After all, a museum is not just a preserver of precious relics but an information link with these objects and the world. The preferred· 'truth' of the objects in a collection is constructed by an exhibition team's selection of objects, by what they choose to say and particularly what they choose not to say about them, as well as by the viewer's reinterpretation of what they see. The display and interpretation of collections not only educates and fascinates, but influences and, in some cases, reinforces current stereotypical attitudes. Museum staff, therefore, have a responsibility to be very clear about which messages they are trying to communicate, and the implications that these might have for their visitors. As has already been observed, it is sometimes difficult to ascertain exactly who the museum audience consists of. It is, however, very important that staff have some idea about the potential audience, because it is not just the museum and the writer that determine the meaning of an exhibition but the interpretation made by the audience which will vary greatly according to who that audience is.

Thus, with their objects and their audience in mind, and the knowledge that the choice and combination of words is crucial to the preferred meaning of the text, writers of museum texts have to question whether or not they are unconsciously perpetuating any stereotypes or myths through their choice of language. They would be well advised to question this because museums are generally regarded by the public as centres of excellence and objective learning, their collections being accepted as assemblages of authentic objects. In other words museums *themselves* have acquired a status of 'myth'. Texts accompanying their permanent collections are automatically imbued with a received aura of unquestioned truth — in Roland Barthes' words, they are 'innocented'. However, no text can be entirely innocent or objective, for the construction of language is itself a construction of reality.

Why is it assumed that museum text is unquestionably objective, and why is the validity of its viewpoint not examined more closely? I think the answer to this lies in the assumption that the object, like the camera, 'cannot lie'. In his essay *The Photographic Message* (1977), Barthes explores this very idea by focusing on the way that a photograph of an object, though obviously not itself the same as the original object, is usually taken as a truthful reproduction of it, and this apparently unmediated, objective photograph transmits its 'innocence' to any text accompanying it. This occurs even though the text may misrepresent the image, take it out of context, or even deliberately mislead the reader (as is

common practice in certain kinds of news reporting (see Hartley 1982: 26–37). If this is the case with a photograph of an object, it is obvious how much more easily the same assumption can be made of the authentic object itself. In the same way, objects in the museum's collection authenticate their texts. This obviously has far-reaching implications which Jeanne Cannizzo articulates very clearly as follows:

> Museums are carefully created artificially constructed, repositories; they are negotiated realities. We need to examine the ideology and cultural assumptions which inform our collection policies, which determine our display formats and influence the interpretations placed upon the objects which we designate as the essence of our cultural and historical identity. In short, museums are amenable to analysis as visual [and spoken] ideologies (Cannizzo 1987: 22).

It is understood that all museum staff, whether teachers, designers, conservators or curators, are committed to a set of values that have been formed through years of training and experience. These commitments are further reinforced by established criteria for professional evaluation and advancement. If curatorial professionalism, for example, is judged on the basis of peer evaluation, it is natural that a curator's primary audience will subsequently be his or her peers. However, unless a public audience is identified and catered for as well, the result will be a 'carefully created, artificially constructed repository' that is neither accessible nor relevant to the visiting public.

Thus, the aim in examining texts to discover the writer's official and personal philosophies is not in order to threaten the museum's staff and their code of practice, but to enable the staff to become aware of their implicit assumptions so that these may be more fully understood. Elaine Heumann Gurian gave a paper at the Smithsonian Institution in 1988, which she concluded with the following observation, made by Stephen Weil of the Hirshhorn Museum and which admirably articulates the points:

> The real issue, I think, is not how to purge the museum of values — that in all likelihood would be an impossible task — but how to make those values manifest, how to bring them up to consciousness for both ourselves and our visitors. We delude ourselves when we think of museums as a clear and transparent medium through which only our objects transmit messages. We transmit messages too – as a medium we are also a message — and it seems to me vital that we understand better just what those messages are.

It is to this end that this approach to museum language is directed — in

order to raise awareness of the way our choice of language reflects current socio-political perspectives as well as our own ways of seeing. The intention is to suggest alternative ways of saying that are appropriate, relevant and that avoid unintentional bias. The method employed is an observation-based approach to the investigation of referential meaning through critical linguistic analysis of text which involves an examination of lexical and syntactical choices and combinations in museum text. The approach is appropriate to all kinds of museums and galleries, whether local or national, independent or publicly funded, with any type of collections from science and natural history to history, ethnology, archaeology, technology and art.

Having said this, it is important to acknowledge that as nobody is free from socially-constructed thought the analyst's own ideological bias will of necessity mediate the way in which such analyses are conducted. However, provided the issue of the analyst's own reflexivity has been sufficiently explored it will be possible to conduct a valid investigation into the linguistic implications in the text, as long as it is not claimed that these are the only possible intepretations (see Hamersley 1983: 14–23).

The last sample text deals with the subject of immigration in the nineteenth century and provides a good demonstration of the process by which a writer's choice of language can result in an unconscious projection of prejudice. The following social history text from the Museum of London was accompanied by photographs and newspapers but no artefacts.

Immigrants

1. *For centuries London had provided a home for immigrants.*
2. *From 1880 onwards thousands of Jews, driven from Russia and Eastern Europe by religious persecution, settled in the already established Jewish community in Whitechapel and spread into the hitherto predominantly Irish districts of Spitalfields and St George's in the East.*
3. *Since over 4000 Jews were arriving every year in London, a large area of the East End was soon a clearly defined 'ghetto' with its own synagogues, religious schools, shops and street markets.*
4. *Numerous Russians and Germans also found lodgings in the courts and alleys of East London while other Germans settled in and around Tottenham Court Road.*
5. *Down in the Docks were colonies of Lascars, Malays, and Chinese who had themselves arrived originally as sailors, but who now made a living looking after the domestic needs of the crews of ships and port.*

Initially, the most striking thing about this text is the title: *immigrants*.

Had the abstract noun *immigration* been used instead, it would have served to describe a process rather than a state of being of persons. As it stands, however, this title acts as a label for all groups of people who were not native to the country, and thereby could imply they were intruders.

The first sentence implies that London's attitude to these people was paternalistic by the use of the verb *provided*. After all, it could just as easily have said 'London became the home of these people'. Also, the use of *London* in a humanizing metaphor actively providing a home for these people reinforces the idea that a favour was being granted to them because they did not really belong.

In the second sentence the vague use of the quantifier *thousands* in 'thousands of Jews were arriving every year' has the effect of maximizing the number. An identified number would have made it sound less like an invasion. *Thousands* could mean 2,000, but could also mean 900,000. The number is left to the reader's imagination, and therefore the implicit suggestion is that it is a very large number indeed. The emotive adverbs *already* and *hitherto* add to this impression by their implicit suggestion that enough people lived there already and that the area had belonged to someone else before they came: thus implying a take-over.

The invasion idea is furthered by an unfortunate use of the verb *spread* which is also commonly used in connection with disease or plagues of vermin. It has been pointed out in the introduction that the meaning of a text is dependent upon the choice and combination of the language used by the writer. If the second sentence were rewritten omitting or replacing the words mentioned above, the result would be a less value-laden message:

From 1880 onwards 30,000[2] Jews, driven from Russia and Eastern Europe by religious persecution, settled in the Jewish community in Whitechapel and also moved into the predominantly Irish districts of Spitalfields and St George's in the East.

In the third sentence the maximizer *large* achieves the same effect as *thousands* did. A large area could be 1 square mile or it could be 10 square miles, depending on whose point of view is being taken. This line of criticism leads to the conclusion that this text was written from the perspective of a current inhabitant rather than from that of a dispassionate historian.

The *clearly defined ghetto* cannot pass without comment. By whom is it clearly defined? The word *ghetto* is problematic as it is uncommonly used nowadays, except in connection with racism. It should be pointed out that this text was written thirteen years ago and would undoubtedly be handled differently now, but that does not change the fact that it is currently still there for all visitors to see. The *Oxford English Dictionary*

defines it as '*Ghetto* 1611. [It.] The quarter in a city, chiefly in Italy, to which Jews were restricted'. This feature of European society which dates back to the 1600s, was recreated during the Second World War as a preliminary to genocide. As a result, it has now come to be directly associated with suffering. The writer is therefore projecting an anachronistic term on to these people, who lived in 1880, with unfortunate results.

The fourth sentence deals with the area of London that Germans and Russians moved to. The fifth talks about Lascars, Malays, and Chinese. The outdated names *Malays* and *Lascars* are again the result of the date of the text, but what is the significance of the phrase *down in the docks*? Apart from being reminiscent of an old music hall ditty — 'Down in the jungle' — it also makes it sound as if they lived underground. The noun *colonies* further adds to the feeling that these people were sub-human, being a term also associated with monkeys or ants.

For those readers who are unconvinced by this line of enquiry, let me conclude by asking a question of this text. What kind of accommodation did the different immigrant groups live in? The answer is that the Jews lived in ghettos; the Lascars, Malays and Chinese lived in colonies; and the Germans and Russians lived in lodgings. I think the inference is very clear.

NOTES

1. This reference is cited in Klare 1976: 145 as Funkhouser, G. R. and Maccoby, N., September 1971, *Report of Study on Communicating Science Information to a Lay Audience: Phase 2, NFS GZ-996*, Institute for Communication Research, Stamford University. Inter-library loan efforts to trace it have been unsuccessful to date.
2. The 30,000 quoted is used to illustrate the linguistic technique of naming and is not intended to be an historically correct number. For more historical information see Charles Booth, 1983, *The Trades of East London Connected with Poverrty in the year 1888*, Vol. 4 of *Life and Labour of the People of London*.

BIBLIOGRAPHY

Barthes, R., 1977. 'The photographic message', in *Image Music Text*, pp. 15–31, trans. Stephen Heath, Fontana, London.
Belsey C., 1987. 'Critical practice', in Hawkes, T. (ed.), *New Accents*, Methuen, London.
Bormuth, J. R., 1966. 'Readability: a new approach', *Reading Research Quarterly*, 1: 79–132.

Cannizzo, J., 1987. 'How sweet is cultural politics in Barbados', *Muse*, Winter: 22-7.

Communication and Design Team, Royal Ontario Museum, 1976. *Communicating with the Museum Visitor: Guidelines for Planning*, Toronto, Canada.

Fairclough, N., 1989. *Language and Power*, Longman, London.

Fiske, J., 1988. *Introduction to Communication Studies*, Routledge, London.

Flesch, R., 1948. 'A new readability yardstick', *Journal of Applied Psychology*, 32 (3): 221-33.

Fowler, R., 1986. *Linguistic Criticism*, Oxford University Press, Oxford.

Fry, E. B., 1968. 'A readability formula that saves time', *Journal of Reading*, 11: 513-16, 575-8.

Gunning, R., 1952. *The Technique of Clear Writing*, McGraw-Hill, New York.

Halliday, M. A. K., 1971. 'Linguistic function and literary style', in Chapman, S. (ed.), *Literary style: A Symposium*, Oxford University Press, New York and London.

Heumann Gurian, E., 1988. 'Covert agendas in the making of exhibits', *The Poetics and Politics of Representation*, Smithsonian Institution Conference, Washington DC.

Hamersley, M., 1983. *Ethnography: Principles in Practice*, Routlege, London.

Hartley, J., 1982. *Understanding News*, Methuen, London.

Hodge, R. and D'Souza, W., 1979. 'The museum as communicator: a semiotic analysis of the Western Australian Museum, Aboriginal gallery, Perth', *Museum*, 31 (4): 251-66.

Kentley, E. and Negus, D. 1989. *The Writing on the Wall*, National Maritime Museum, London.

Klare, G. R., 1976. 'A second look at the validity of readability formulas', *Journal of Reading Behaviour*, 8: 129-52.

Kress, G. and Hodge, R., 1979. *Language as Ideology*, Routledge & Kegan Paul, London.

McManus, P. M., 1988. 'Good companion . . . more on the social determination of learning-related behaviour in a science museum', *International Journal of Museum Management and Curatorship*, 7: 37-44.

McManus, P. M., 1989a. 'Oh yes they do: how museum visitors read labels and interact with exhibit texts', *Curator*, 32 (3): 174-89.

McManus, P. M., 1988b. 'What people say and how they think in a science museum', in Unzell, D. (ed.), *Heritage Interpretation Vol. 2, The Visitor Experience*, pp. 156-65, Belhaven Press, London.

McManus, P. M., 1990. 'Watch your language! People do read labels', in Serrell, B. (ed.), *What Research Says About Learning in Science*

Museums, Technology Centre, Washington DC.

Mathiot, M., 1979. *Ethnolinguistics: Boas, Sapir and Whorf Revisited*, Mouton, The Hague.

Serrell, B., 1983. *Making Exhibit Labels: A Step by Step Guide*, American Association for State and Local History, Nashville, Tennessee.

Sorsby, B. D. and Horne, S. D., 1980. 'The readability of museum labels', *Museums Journal*, 80 (3): 157–9.

7 *Partial truths*

GABY PORTER

Partial truths

GABY PORTER

I have placed theory at the centre of my project to develop a critical practice in museums. I look beyond the content of displays to their production and meaning. I examine the ways in which museums order and interpret, or represent, history: my focus is representation, not history itself.

My approach draws on critical practices applied in other media, particularly in literature and popular culture. I therefore use the terms *text*, *writing* and *reading*. Museums employ a wide range of working methods, and of objects on which those methods are employed — arguably, visitors and employees, as well as collections, resources and spaces. In general, I shall use the term *text* to refer to the permanent public display, as the most enduring and widely-seen part of a museum's activities; *writing* to refer to the work of the curator/interpreter; and the activity of *reading* as being that of a viewer or visitor.

My title, 'Partial Truths', is deliberately ambiguous. It might imply the notion that museums offer only part of the truth and that somewhere, somehow, the whole truth can be found. Rather, I choose 'Partial Truths' in a different meaning, to invoke the post-structuralist and feminist critiques of impartial and objective knowledge and truth. The post-structuralist critique demonstrates that knowledge is positional. The critique is concerned not with essences — whether something is true — but with forms — how, in a text, something comes to be true. The feminist critique further demonstrates that the dominant position from which knowledge 'speaks' — the 'universal subject' of humanist thought — is Western, white, middle-class and male.

I argue that masculinity and femininity are constructed categories which are central to the production of meaning in museums. Femininity

is constructed in a subordinate relation to masculinity, as the 'other' around which masculinity orders itself as the rational and dominant position. In the first part of my paper, I outline the theoretical basis for my argument; in the second part, I use case studies of museum displays to demonstrate my practice.

THEORY AND CRITICISM

Conventional critical practice looks at a text for its truth and expressiveness. New critical practice has drawn attention to the *production* of a text, and has questioned the notion of a single, true meaning. Rather, truth is constructed by position and relationship: truth itself is constituted by meaning.

Fundamental to this new practice is a critique of humanism, the philosophy which is the basis of Western thinking. Humanism presumes the existence of the conscious, rational individual, the unified subject. It urges that 'man' is the origin and source of meaning, of action, and of history. In the words of Michel Foucault, the subject 'founds horizons of meaning beyond which history will henceforth only have to elucidate and where propositions, sciences and deductive ensembles will find their ultimate grounding' (1981: 65).

The humanist desire for a unity of thought and vision in the rational being has its equivalent desire for a universal, objective reality in the material world. This supposes that 'things are already murmuring meanings which our language has only to pick up'; again, in the words of Foucault,

> that at the very basis of experience . . . there were prior significations — in a sense, already said — wandering around in the world, arranging it all around us and opening it up from the outset to a sort of primitive recognition. Thus a primordial complicity with the world is supposed to be the foundation of our possibility of speaking of it, in it, of indicating it and naming it, of judging it and ultimately of knowing it in the form of truth (1981: 65).

This position, which Foucault calls originating experience, offers the empirical view of an external reality 'out there', waiting to be 'discovered'. Objects, as observable, measurable and quantifiable evidence, provide an inventory through which to order and know the world: they come to stand for the world. The ultimate goal is a comprehensive, encyclopaedic archive and repository, which will yield a total knowledge. The empirical view also offers the prospect of a scientific, objective method of collecting and measuring material evidence. That the processes of

collection, selection, ordering and arrangement might themselves con-
stitute meaning is not in question.

Through the unity of the subject and through the reality of experience,
humanism proposes a certainty in its view of the world. Operating on the
simple model of a concept and its referent, the text disappears, or becomes
the transparent medium through which experience can be seized. Cather-
ine Belsey calls this the philosophy of *expressive realism*. Literature and
other texts are seen to 'reflect the *reality* of experience as it is perceived by
one individual, who *expresses* it in a discourse which enables other
individuals to recognise it as true' (1980: 7). Through this mechanism of
transparency, humanist thinking effaces itself as obvious and natural. It
denies the conditions of its own production and presents itself as identical
with reality.

In the new criticism, critics have insisted on a practice of reading which
questions expressive realism and the underlying philosophy of humanism.
They propose that common sense itself is ideologically and discursively
constructed; that the 'obvious' and the 'natural' are not givers of meaning,
but are produced within a specific society by the ways in which that society
talks and thinks about itself and its experience. Those texts which claim
most fervently to be beyond authorship, to tell the truth, are no less
deserving of attention.

This practice of reading derives from structuralism in its approach and
method. Structuralism owes much to the theoretical work of the Swiss
linguist Ferdinand Saussure, in the early part of this century. For
Saussure, 'language is a form and not a substance' (Sturrock 1979: 10). His
linguistic analysis demonstrated that the meaning of signs is not intrinsic
but relational: each sign derives its meaning from its difference from all
the other signs in the language chain. Thus structuralism insists on the
primacy of relations and systems of relations.

Saussure located meaning in the language system, but then saw it
as single, fixed, prior to its realization in speech or writing. Post-
structuralism modifies and transforms structuralism by insisting that
meaning is constantly changing. The meaning of a signifier at any given
moment depends on the discursive relations within which it is located. Its
meaning is open to constant re-reading and reinterpretation.

Post-structuralist criticism disregards the conventional respect for the
authority and intentions of the author, the hierarchy of text and reader. It
destroys the prevailing image of the reader/critic as the passive recipient
of *author*itarian discourse. Post-structuralist critics insist on the auton-
omy of the text, and show how conflict between the reader and the author,
or text, can expose the underlying premise of a work.

The move towards post-structuralism has been associated with the
work of the French philosopher, Jacques Derrida. Shifting from a focus
on speech to a concern with writing and textuality, Derrida sees all

meaning as produced by 'différance', a dual process of difference and deferral. This process is, respectively, spatial and temporal (Derrida 1973: 142). For Derrida, meaning is never truly present, but is constructed through the potentially endless process of referring to other, absent, signifiers: the interplay of presence and absence.

Through the activity of deconstruction which Derrida proposed, post-structuralism works upon the incomplete and contradictory nature of meaning. Deconstruction subverts the dominant meaning and produces new meanings. Precisely *because* meaning is incomplete and con-tradictory, it is open to challenge and redefinition.

Derrida's term 'différance' implies an open availability of texts between which meaning is constituted; it ignores the play of power upon meaning. Others have insisted on the dimension of power. They demonstrate that difference is used by those with power in a range of high-low, self-other, relationships. To quote Christine Weedon,

> . . . the discursive battle for the meaning of texts . . . is a battle in which the legitimation of particular reading and the exclusion of others represent quite specific patriarchal, class and race interests, helping to constitute our common–sense assumptions as reading and speaking subjects (Weedon 1987: 168).

Moreover, the battleground and the rules of engagement are constantly shifting. In his work on colonialism, Edward Saïd has shown how difference is employed by the West over the Orient in a strategy of 'flexible positional superiority, which puts the Westerner in a whole series of possible relationships with the Orient without ever losing him (sic) the upper hand' (Saïd 1979: 3).

Equally, feminism denies neutrality and emphasizes the power dimensions of difference.

THE CONTRIBUTION OF FEMINISM

Feminism is concerned with power. More precisely, it is concerned with patriarchy — the power relations in which women's interests are subordinated to those of men. Patriarchy means, literally, the rule of the father. Patriarchy exercises power not through biology, but through the meanings attached to biological sexual difference in society and in the self.

Feminists since post-structuralism have criticized the whole system of knowledge and thought which underpins expressive realism. In the words of Michèle Barrett, 'one of the major achievements . . . has been to criticise and deconstruct the "unified subject", whose appearance of

universality disguises a constitution structured specifically around the subjectivity characteristic of the white, bourgeois man' (Barrett 1987: 35).

Avoiding any general theory of femininity, because this would essentialize woman, feminists have instead produced a critique which disturbs the logic of the masculine system, its concepts and procedures. In literature, for example, feminist criticism draws attention to the sexual codes of the text. In order to avoid essentializing the experience of women as readers, the *hypothesis* of a woman reader is used to analyse and situate the dominant male critical vision. In doing so, feminist criticism demonstrates that this vision, rather than being potent and full with meaning, is limited and partial. To quote Jonathan Culler,

> . . . [it] reverse[s] the usual situation in which the perspective of a male critic is assumed to be sexually neutral, while a feminist reading is seen as a case of special pleading and an attempt to force the text into a predetermined mould. By confronting male readings with the elements of the text they neglect . . . feminist criticism puts itself in the position that phallic criticism usually attempts to occupy (Culler 1983: 55).

In patriarchal discourse, the nature and social role of women are defined in relation to a norm which is male. For Toril Moi, 'the humanist creator is potent, phallic, and male — God in relation to his world, the author in relation to his text' (1985: 8). The unified subject of humanist thought — knowing, acting, rational — is constituted upon an opposite, against which to define *him*self. Philosophy creates 'its own inner enemy', the feminine within, but repressed.

> By positing woman as the symbol of lack and negativity, [it] turns her into the ground of its own existence: by her very inferiority she guarantees the superiority of philosophy (Moi 1989: 195).

Masculinity and femininity are constructed through a series of hierarchical binary oppositions in which the female is always the devalued, subordinated part.

> Science, philosophy, rationality . . . constantly re-enact the Cartesian mind/body divide in its most basic methodological moves . . . Always and everywhere the rational, active, masculine intellect operates on the passive, objectified, feminized body (Moi 1989: 189).

Drawing on Derrida's deconstructive work, Hélène Cixous has traced a series of hierarchical binary oppositions: activity/passivity; culture/ nature; head/heart; intelligible/palpable; logos/pathos (1985: 90-1). In

these couples, the underlying paradigm is always the hidden male/female opposition with its inevitable positive/negative evaluation.

This dualism acts by making itself inevitable and inescapable. There is no space between or beyond such a pairing. In the positive/negative pairing, the weaker (female) partner is always repressed, silenced or, for Cixous, put to death. She describes a battle for signifying supremacy in which the male, active term must destroy the female, passive term in order to acquire meaning.

How may we escape from the dualism in which woman, the feminine, is tamed and bound; how may we transgress its boundaries? Using psychoanalytic theory, feminists have looked to the unconscious as an instrument in unsettling the unity of the subject — and thus identities of masculine and feminine. Psychoanalysis demonstrates that 'identity' itself is a site of conflict and contradictions. The unconscious undermines the subject from any position of certainty, and at the same time reveals the fictional nature of the sexual category to which every human subject is none the less assigned (Rose 1986: 51–3).

The work of Lacan, following Freud, emphasized the fictional, constructed nature of masculinity and femininity as the results of social and symbolic, rather than biological, difference. For Lacan, the Oedipal experience is never perfected, but remains partial and precarious. Subjectivity is constructed through a process of splitting, division, and is always in the making. Differences exist *within* each subject: the human self is a complex entity, of which the conscious mind is only a small part.

PUTTING THEORY INTO PRACTICE

On the whole, historians have resisted any exploration of the relationship of history and the unconscious. Sally Alexander (1984) and Laura Mulvey (1987) are among the few historians who have done so. Alexander has said that:

> Historians of pre-industrial society have fewer inhibitions about speaking of myth, ritual, magic and their significance in human organisation. Perhaps the fear that by introducing the unconscious and phantasy into social history is to open a pandora's box, to deny the rationale of political and social life, is stalled by the distance of pre-industrial societies from our own. Against these reservations, I only suggest that the persistent problem of femininity and the presence of feminism indicate that the pandora's box is already wide open (Alexander 1984: 134).

Alexander suggests that the unconscious is already at work in history.

This applies equally in museums, in the representation of history and the interpretation of the material culture.

The realist text of the museum works through association, juxtaposition, reference and repetition within a limited repertory. Each museum is different; yet, through 'silent quotation' (Tagg 1988: 99) is related to others and to other realist texts.

Museum practices are formed upon the rigid dualism of subject/object, of active culture working upon the passive body of nature. They are formed upon presence rather than absence. Thus the present materiality of artefacts is privileged over absent or immaterial forms, of thought, speech and emotion. The substance of production for exchange is privileged over the absence, through consumption and exhaustion, of production for use.

Objects are assumed to carry embedded meanings which are universal, transcending locality, class, race, gender, position. Curators read off these meanings from the surface of objects, and group them with other, related, objects and meanings within a classification scheme. Thus the social history classification scheme in general use in Great Britain recommends that a single entry is made for each object (SHIC 1983: vi). It carries an index which tells the user where to place the object within the scheme of things. Such a practice does not acknowledge distinctions of meaning and use over social groupings, time and place. The classification scheme becomes a system for ordering and knowing material, and at the same time a map of all there is to know (Pearce 1989: 8). It is used as a basis for writing a collecting policy and identifying 'gaps in the collection'. It also forms the basis of groupings and arrangements of museum displays.

The active/passive relationship is not only that of subject/object but also that of curator/visitor. Interpretive themes are formed upon narrative closure and happy resolution, rather than upon open forms of possibility and contradiction. The activity of history-making — the production of history — happens behind the scenes, among curatorial staff, designers and decision-makers. Uncertainty is ironed out into a story without seams, folds or creases. This is then offered as a finished product, 'reality itself', to be consumed by the passive spectator.

Fun and pleasure are now encouraged in museums through, for example, demonstrations, interactive exhibits and re-enactments. But these are often available only to limited audiences, mainly children. Moreover, fun and pleasure are offered through games played on the surface of history: they do not disturb museum history, presented in that version which through practice and replication is already institutionalized as 'authentic experience'.

On the stage of history which the museum constructs, only one or two

actors may perform. Almost inevitably, this reduction of history to a tableau becomes a reduction to the masculine and feminine positions of activity and passivity, presence and absence. Thus, for example, at the National Museum of Photography, Film and Television in Bradford, recent displays on the history of popular photography contain a construction of a beach photographer at work. Contemporary photographs show that such photographers often worked with a woman partner or assistant in the photographic studio and outdoors. But only the photographers' names appear on the mounts of studio portraits. Their female partners or assistants remain anonymous and therefore invisible, *immaterial*. Equally, the many women who worked in preparing and packing photographic materials in the factories, or processing, printing, retouching and mounting photographic images, are invisible. The actors on the museum stage play the obvious roles: male photographer and female sitter.

The representation of 'man' and 'woman' in museums is central to the production of meaning. Through limitation, repetition and reference, masculine and feminine categories are constructed in displays, collections and in the very character of institutions.

In the two examples which follow, I have chosen to examine displays in an industrial museum and in a museum of domestic and everyday life: arguably, representing masculine and feminine activities respectively. However, I argue that in both examples femininity is constructed in a subordinate relation to the masculine system of knowledge. I examine two themes: the feminine as the border of male knowledge; and the relationship of gender and technology.

I have chosen these museums as both exemplary and typical of their genre. The first, Kelham Island Industrial Museum in Sheffield (opened in 1982), was among those museums attempting to move beyond technology and transport to present a more integrated story of the history of local industry and the people who worked in it (Silvester 1981). The second, the Castle Museum at York (opened in 1938), is the largest social history museum in Britain. For half a century, it has been extremely popular among visitors and influential among social history and folk life museums (see, for example, Higgs 1963).

'READING' THE MUSEUM: THE FEMININE AS THE BORDER OF MALE KNOWLEDGE

The Kelham Island Industrial Museum in Sheffield focuses on the steel industry. The museum has chosen to represent a narrow range of industries within the locality: those which are most specialized, dis-

tinctive and with a highly developed and differentiated material culture. Further, the displays concentrate on the heavy trades of the late nineteenth and early twentieth centuries, rather than on those trades with a longer history within Sheffield steel. In objects, images and words, the museum celebrates the unfamiliar, exceptional and dramatic.

The massive scale of the technologies — the Bessemer converter, the River Don engine — dwarfs the histories of the people who owned and operated them, and who worked in the associated trades. The balance is created by paying reverence to traditional craft skills and crafts*men*, operating at the other extreme of the technological scale. Women and men working in labour-intensive, poorly-paid and arduous jobs, such as grinding and file-making, do not fit comfortably into this heritage (Porter 1987: 12).

In the displays, we occasionally glimpse women but their roles within this complex group of industries are obscured through their partial treatment. Women are represented in the displays not because their history is held to have intrinsic interest but for another purpose: that of confirming the main/male story.

At Sheffield, the inclusion of women may be seen as *necessary* to the main ordering of physical space and historical narrative in the displays. The position of women is strategic: both space and story are bounded by them. They are necessarily marginal because the *main* story chosen, of technological development of Sheffield's heavy industries, was built upon the exclusion or marginalization of women. Their marginalization as workers anchors and secures male skill in the central functions of the workplace.

A feminist and post-structuralist reading of the displays emphasizes the representation of women as 'the necessary frontier' of the male order; it also stresses the anxieties which surround representations of women. I quote Toril Moi at length because of the relevence of her analysis to the depiction of women in the Sheffield displays:

> from a phallocentric point of view, women will . . . come to represent the necessary frontier between man and chaos; but because of their very marginality they will always also seem to recede into and merge with the chaos of the outside. Women seen as the limit of the symbolic order will in other words share in the disconcerting properties of *all* frontiers: they will be neither inside nor outside, neither known nor unknown. It is this position that has enabled male culture sometimes to vilify women as representing darkness and chaos, to view them as Lilith or the Whore of Babylon, and sometimes to elevate them, as the representatives of a higher and purer nature, to venerate them as Virgins and Mothers of God. In the first instance the borderline is seen as part of the chaotic wildnerness outside, and in the second it is seen

as an inherent part of the inside: the part that protects and shields the symbolic order from the imaginary chaos (Moi 1985: 167).

The main historical story is spatially bounded by women in the displays 'The beginnings of Sheffield industry' and 'The buffer girls'. These two displays are the preface and afterword of the main story of industrial progress.

The introductory panel to this story is entitled 'The beginnings of Sheffield industry'. It shows an illustration from a medieval psalter of a female smith working at an anvil. Below the illustration, in large letters, are the words: 'What lifted Sheffield from such obscurity?'. The very language chosen suggests precisely Moi's 'disconcerting property': women occupied the deep, dark 'obscurity' from which Sheffield was 'lifted'. Sheffield's industry *began* when it was lifted from the chaos in which women laboured into an organized, rational and highly technological industry operating with a clear division of labour and processes.

The interpretive displays end with a small display on the buffing trade, before leading into a courtyard with the 'little mesters', craft workshops. The buffing display shows a woman working alone at a buffing wheel. The buffer girls, too, mark a frontier. They are located neither inside nor outside, but on the edge. On the adjacent graphic panel, a reproduction of an oil painting of buffer girls outside a factory is juxtaposed with an interpretive text. In the text, too, they are described as neither known nor unknown: they harbour those sweet qualities expected of women — fun-loving characters with hearts of gold — but they have the capacity to turn on, and against, men.

The contrasts between working women and middle–class women were, for the nineteenth–century diarist Arthur Munby, 'suggestive contrasts' (Hudson 1974). Working women laboured outdoors, or outside the home; they worked with others; they wore loose, masculine clothing; they were dirty; they drank and smoked and mixed freely with men. By contrast, the middle-class woman stayed in the home and shunned physical labour; she was often alone; her clothing was tight, controlling, feminine; she was clean and sheltered. The most suggestive contrast was that of sexual behaviour: the working woman was seen as active, animal, passionate against the middle-class woman's control and de–sexualiza-tion (Edge 1986: 13; Kitteringham 1975: 127–33). In the panel on buffer girls, the text makes a similar suggestion. The women's warm, friendly characters, their clothing and dirty appearance, and their social class are bound up with their appeal and availability to men:

. . . woe betide any man who stepped out of line in the buffing shop.

The buffing girls had a reputation for giving as good as they got, regardless of whom the offender might be . . .

This ambiguous, teasing statement invites the reader to identify with the 'offender', to 'step out of line'.

'READING' THE MUSEUM: GENDER AND TECHNOLOGY — 'MAN AND MACHINE IN PERFECT HARMONY'

Women are placed in a passive relation to machinery and technology, men in an active relation. This is nicely encapsulated by Alan Radley in this volume (chapter 5). In his example, men have a close and interactive relationship with technology: they experience the satisfaction of working on and dismantling machinery, the smell of engine oil on their hands. In contrast, women are distant, passive, consumers of luxury and exotic goods: *they* experience the feel of silk on their skin, the touch of jewellery.

In museums of science, industry and crafts, the rhetoric is strongly that of activity. Workplace and workshop are shown as places of activity, crowded and scattered with tools, remnants and offcuts of work in progress. The museum may be full of noise, smell, action. The individual display may be situated within a sequence which describes the processes and products of the whole industry. Thus the work is not isolated, but part of a dynamic chain. In interpretive texts, the language venerates and celebrates skill and mastery, pride and achievement. The workers are producers — visually, materially, linguistically. We may be invited to identify further with them through the use of first and second names — of those who worked in the workplaces before their removal and reconstruction in the museum, or those who now occupy the museum's workshops as demonstrators and craftspeople. In museums of housework and the home, on the other hand, the rhetoric is entirely different. The language is that of stasis, silence, cleanliness and tidiness: work is removed.

The first period room settings in British social history museums were reception rooms — parlours, dining rooms. Kitchens were chosen only in the case of cottage households. More recently, the emphasis of room settings has shifted from parlours to kitchens and laundries, but *work* is still absented. This is partly in the nature of housework itself; its very purpose is to render itself invisible, so that it only shows when it is *not* done. Work is also absented through curatorial decisions and devices.

In the Victorian parlour at the Castle Museum, York, the room is shown in its tidied and prepared state, with slippers warming on the hearth — as seen by the breadwinner, ready for his homecoming, his

return. It is not as seen by those who toil and scrub, clean the grate and carry the coal. Direct visual, material and verbal references to work are avoided. The interpretive text for the parlour refers to the 'quiet and improving pastimes' which took place in such a room. It states that 'the ladies of the house busied themselves with embroidery', thereby including embroidery as a pastime: women passing time, busying themselves. The text of a later paragraph distances the labour of housework, referring to the 'housewife's burden [which] was lightened by the presence of her maids'.

In the moorland kitchen, facing the parlour in the same museum, the working tools and equipment of the room are laid out in a display, rather than working, arrangement. The interpretive text refers to household tasks by the use of passive verbs and constructed nouns. These are devices used to avoid naming or implicating the person or people doing the work (Coxall 1990: 18). Elsewhere in the period rooms, decorative styles and makers of furniture are the active subjects of the sentences in the text.

More recently, museums have chosen to deal with the topic of housework through displays on household appliances. Examples are domestic appliances galleries at the Castle Museum (opened in 1985) and at the Science Museum, London; many other museums have equivalent displays. Here, the history of housework is represented as a sequence of technological achievements which reduce or remove housework, liberating the housewife. Such displays are bright, light, modern and colourful. Machines and technologies are shown on plinths and stands, clean and quiet, in splendid isolation, far removed from the context of use. They are backed by colourful illustrations drawn from contemporary advertising. These give the message that the labour of housework is removed by the product, which does the work by itself. The rhetoric is that of supply, not of use.

Active nouns and verbs in interpretive texts are machines, inventors, or progress itself. Again, these render the housewife passive and redundant. For example, in the introductory panel to the domestic appliances gallery at the Castle Museum, York, the machines are humanized:

> The ancestors of our modern machines first appeared as eccentric luxuries. Today they are taken for granted; they give us time to relax and enjoy home entertainments.

This last sentence also illustrates how the home is shown in isolation from the world. Room settings are separated from their context within the whole house, the street, the neighbourhood; from household size, employment and unemployment. Those functions, such as homeworking or shopping, which create a continuum between the home and the world

outside are denied. Thus the home is presented not as a dynamic entity, but as a static haven.

JOKING APART

In historical displays about work, humour is reserved for representations of women. The look and language of museums of industry is serious, dignified, imbued with the weight of tradition and skill. The processes and skills venerated in the museum are almost always redundant in an industrial context and are kept alive, if at all, in museums and heritage industries in Britain. For example, miners' Davy lamps are now made for sale in museum shops such as those at Beamish and Wigan, as ornaments and souvenirs. These are seen as ways of keeping tradition alive, rather than as a transformation or trivialization of former industries and work processes. The contemporary profile of the industries, the processes and effects of de-skilling and de-industrialization, are rarely seen in industrial museums.

In comparison, the look and language of museums of the home and of housework are light-hearted, places to have fun. They insert housework firmly into a framework of progress and liberation, rather than a framework of traditions and skills.

There are two strands to the humour in these galleries. The first rests on the view of the drudge in her dirt, running away from her 'salvation' in the form of a new appliance. This is the form which appeared in the promotional leaflet for the household appliances displays at the Castle Museum, York (Porter 1988: 117). In the second, the smiling woman falls for the new appliance, she embraces it with open arms (and, of course, in embracing *it* she embraces the person who delivers it . . . a man).

The whole rhetoric of such galleries rests on the advertising and marketing of household products. There's a slippage in this process between product and result, in which the *work* of using the tools and equipment is removed. On the contrary, time/use research in housework demonstrates that new appliances do not reduce the amount of time spent on housework, and may even increase it. The effect of the slippage is to cut away the middle ground between drudgery and liberation, in which the museum might address the transformation of housework as an industry: for example, the de-skilling, the fragmentation of tasks, the increasing isolation of the houseworker from others, inside and outside the home.

In this paper, I have explored the construction of femininity and masculinity in museums. These constructed categories come to be seen as real through reference and repetition. Projects to improve the representation of women in museums are often concerned with adding women,

and objects and issues pertaining to women, to existing displays and collections. But this denies the practice of representation: there are no 'real women' in displays but only the fictional category 'woman', constructed in an inextricable relationship with 'man'. The project may therefore be more playful while no less political: to work at the level of construction; to *de*construct and *re*construct to produce new representations.

BIBLIOGRAPHY

Alexander, S., 1984. 'Women, class and sexual differences in the 1830s and 40s: some reflections on the writing of a feminist history', *History Workshop Journal*, 17: 124–49.

Barrett, M., 1987. 'The concept of "difference", *Feminist Review*, 26: 29–41.

Belsey, C., 1980. *Critical Practice*, Methuen, London.

Cixous, H., 1985. 'Sorties', in Marks, E., and de Court, Ivran I. (eds), *New French Feminism*, Harvester, Brighton.

Coxall, H., 1990. 'Museum text as mediated message', *WHAM!* (Women, Heritage and Museums) *Newsletter*, 14: 15–21.

Culler, J., 1983. *On Deconstruction: Theory and Criticism after Structuralism*, Routledge and Kegan Paul, London.

Derrida, J., 1973. *Speech and Phenomenon*, North Western University Press, Evanston, Illinois.

Edge, S., 1986. *Our Past — Our Struggle: Images of Women in the Lancashire Coalmines*, Rochdale Art Gallery, Rochdale.

Foucault, M., 1981. 'The order of discourse', in Young, R. (ed.), *Untying the Text*, Routledge and Kegan Paul, London.

Higgs, J. W. Y., 1963. *Folk Life Collection and Classification*, Museums Association, London.

Hudson, D., 1974. *Munby, Man of Two Worlds: The Life and Diaries of Arthur J Munby 1828–1910*, Abacus, London.

Kitteringham, J., 1975. 'Country work girls in nineteenth-century England', in Samuel, R. (ed.), *Village Life and Labour*, Routledge and Kegan Paul, London.

Moi, T., 1985. *Sexual/Textual Politics: Feminist Literary Theory*, Methuen, London.

Moi, T., 1989. 'Patriarchal thought and the drive for knowledge', in Brennan, T. (ed.), *Between Feminism and Psychoanalysis*, Routledge, London.

Mulvey, L., 1987. 'Changes: thoughts on myth, narrative and historical experience', *History Workshop Journal*, 23: 3–19.

Pearce, S. M., 1989. 'Introduction', in Pearce, S. M. (ed.), *Museum Studies in Material Culture*, Leicester University Press, Leicester.

Porter, G., 1987. 'Gender bias: representations of work in history museums', *Bias in Museums, Museum Professional Group Transactions*, 22: 11–15.

Porter, G., 1988. 'Putting your house in order: women and domesticity in museums', in Lumley, R. (ed.), *The Museum Time-Machine*, Comedia/Routledge, London.

Rose, J., 1986. *Sexuality in the Field of Vision*, Verso, London.

Saïd, E. W., 1979. *Orientalism*, Penguin Books, Harmondsworth.

SHIC, 1983. *Social History and Industrial Classification: A Subject Classification for Museum Collections*, Centre for English Cultural Tradition and Language, Sheffield.

Silvester, B., 1981. 'The genesis of a labouring museum', *History Workshop Journal*, 11: 160–5.

Sturrock, J., 1979. *Structuralism and Since*, Oxford University Press, Oxford.

Tagg, J., 1988. *The Burden of Representation*, Macmillan, London.

Weedon, C., 1987. *Feminist Practice and Poststructuralist Theory*, Blackwell, Oxford.

8 *Exhibitions and audiences: catering for a pluralistic public*

NIMA POOVAYA SMITH

Exhibitions and audiences: catering for a pluralistic public

NIMA POOVAYA SMITH

The race riots of 1981 brought home rather forcibly the point that radical changes of perception, policy and funding were needed to address issues that related to the non-white population of Britain. Inevitably, though somewhat belatedly, this concern extended to the arts. A number of regional and London galleries actively reviewed their exhibition programmes, while a significantly lower number reviewed their collecting and recruiting policies. A few galleries did actually appoint people to deal exclusively with the area of what is often described as the 'ethnic arts'. An unhappy choice of words at the best of times, but one that fully reflects many of the unresolved and perhaps unresolvable aspects of pluralism and the arts in this country today.

This paper will explore the implications this change of policy has had on the art scene in Britain by taking up for study three important exhibitions involving the historical and the contemporary works of Asian and Afro-Caribbean peoples, and examining the public and media response to them. 'A Golden Treasury', an exhibition of jewellery from the Indian sub-continent organized by Bradford Art Galleries and Museums in 1988 and 'Traditional Indian Arts of Gujarat', organized by Leicestershire Museum Services, also in 1988, will be used to explore the dialogue established between the communities and the galleries, while 'The Other Story' curated by Rasheed Araeen for the Hayward Gallery (1989–90) will be used to examine the mixed though considerable media response to the show. The paper will then conclude with a brief examination of whether wittingly or unwittingly exhibitions such as these have helped create changes in the art world which indicate a way forward, or whether ultimately they are isolated and

separate happenings generating a little heat and even less light, and with no perceptible influence on the national scene.

'A Golden Treasury: Jewellery from the Indian sub-continent' showed at Cartwright Hall, Bradford, from September until November 1988 and then at the Zamana Gallery, London, in 1989. The idea for an exhibition on Indian gold jewellery had been suggested as long ago as 1984, been shelved and then resurrected again in 1986. The exhibition, therefore, took nearly two and a half years of organizing. The choice of this particular theme was arrived at through a combination of a strong personal interest in the subject, and the need for exhibitions that had an answering resonance within the Asian community. (Gold has always exercised a complex hold on the people of the subcontinent, a hold that continues with the Asian communities in Britain even today.) It was also another way of introducing one aspect of sub-continental culture to a wider public and last, but by no means least, at a period when attendance figures are one of the main criteria by which a gallery is assessed, gold like death is a theme that is guaranteed success.

In our annual meetings with the communities of Bradford in 1986 and 1987, the strong possibility of putting on an exhibition on Indian jewellery had been discussed and the idea was met with considerable approval and interest. At that point, the exhibition was meant to be somewhat more didactic than it actually turned out to be, for the original title was 'The Darker Side of Gold'. The display of exquisite pieces of jewellery was meant to be accompanied by a fearless examination of the greed, the exploitation, and sometimes murder that underpinned the demand for this metal. For instance, dowry deaths, a tragic phenomenon in the subcontinent caused by the bride's family's inability to pay large sums of money in the form of jewellery and consumer goods, as continually demanded by the bridegroom's family, was one area I thought the exhibition could explore through the display of bridal jewellery. Conscious of the fact that this could cause offence among the local community, I called a meeting with a group of people to pose this question to them. Their response was quite categorical, they viewed the entire system of dowry as totally pernicious, and thought issues such as these should be aired particularly since it was being perpetrated by Asian families in Britain as well. They did, however, caution that they would be extremely unhappy if this was the only facet that was highlighted in the exhibition. They pointed out that bridal jewellery was originally regarded as *stridhana* or woman's exclusive property over which the husband or his family had no control. It was a form of economic security for the woman if she fell upon hard times.

As it so happened, this title did not get used in the end because the Victoria and Albert Museum, from whom we were borrowing the bulk of

the material for the exhibition, thought it would be a difficult idea to sustain consistently with the objects we were borrowing. Besides, as someone remarked rather wittily, it could be construed as referring to the V&A's own mode of acquisition of the material, rather than anything else. But since they were right about the problems of sustaining such a strong element of didacticism, we compromised to the extent that my contribution to the catalogue explored this particular theme in some detail, while the exhibition adopted a more general approach.

But what is interesting is that the members of the communities I had spoken to had expressed no qualms about the exposition of an idea that would not show their culture in a consistently favourable light. This was in interesting contrast with the experience of the then Assistant Keeper of Indian Crafts at Leicestershire Museums, Julia Nicholson, when she was discussing the same issue with the Leicester community while organizing 'Traditional Indian Arts of Gujarat'. Nicholson had involved the community in different stages of the exhibition, starting with the selection of the material and their interpretation. To quote from her Museums Association Diploma dissertation:

(The) meeting (was arranged) for refining ideas on how the sections could be presented and it stimulated a very interesting debate. For example, there was a long discussion about how the issue of dowry should be presented in the exhibition because the abuse of the dowry system had made it into a very controversial and newsworthy topic. In Britain, as well as in India, there have been instances of maltreatment and even murder of young wives by in-laws because of the failure of dowry payments to meet the expectations of the in-laws. This inevitably reflects badly on Indian communities and the advisory group decided that an exhibition which is targeted at the wider community as well as the Indian community should not dwell on an 'exposé' approach to the dowry system.

On the other hand they did not feel that such an important part of their marriage system could be ignored. They therefore decided that an interesting contribution to this area could be to use the objects to illustrate the original function of the dowry system of giving a woman some economic security and acting as a form of portable inheritance. This also fitted in well with the collection which included many 'trousseau' items of embroidery made by hand by the bride and her female relatives (Nicholson 1990).

This was, as is clear, a far more guarded response than that of the Bradford groups. Nicholson does not mention the age range of the group she consulted, but one can speculate as to whether this was a factor. Perhaps due to a subconscious motivation, I had consulted a group of

Asians who were all below 35 years of age and had grown up in this country. They were also regarded as a 'radical' group in the sense that they were relentless in their pursuit and exposure of institutional and individual racism within Bradford Council. But their reaction indicated that they were not afraid to expose injustices within their own cultures either. If Nicholson's advisory group on the other hand were, as I suspect, somewhat older and were Asians with clear memories of growing up in Uganda, Kenya or India, then the dowry system would be a far more sensitive issue. The obvious point however, is that 'consultations with the community' can have different connotations and responses, depending on who you approach and why you approach them.

This point was again highlighted recently when Bradford Art Galleries and Museums commissioned a market research survey on boosting Asian audiences. Up to this point, the question of translating exhibition labels had come up several times, both in community consultation meetings and indeed in Bradford Art Galleries and Museums' own internal survey, and the answers, though couched in somewhat ambiguous language, had always been roughly the same. To quote:

> Translations would be nice rather than useful. They were a good psychological ploy, for when leaflets and posters and even notices within the gallery used Asian languages people had a sense of being welcomed. But on the other hand very few Asians who did not know English would venture into a gallery without being accompanied by a friend or relative who was fluent in English. And finally, Asians who could not read or write a single word of English tended to be illiterate in their own language as well.

But when our market researcher stopped and asked the man on the street outside Cartwright Hall's own gates, which is situated in the heart of the Asian community, the response was unequivocal:

> My parents and other relatives of their generation will not come to the Gallery even if there is an exhibition on Asian art because they cannot speak, read or write English. If the labels and information panels were translated into Bengali, Punjabi, Urdu or Hindi they would definitely consider visiting the Gallery.

The change of exhibition title from 'The Darker Side of Gold' to 'A Golden Treasury' met with a degree of ironic humour from the community, and they commented on its Edwardian overtones. Asian booksellers said the accompanying book was difficult to sell, even though people were passionately interested in the subject and there was a paucity of

information on the area, because the title 'A Golden Treasury' misled them into thinking it was an anthology of English poetry.

But, gentle irony aside, the community continued to extend much needed moral and financial support towards the exhibition. As mentioned earlier the majority of the historical material, some dating to the second century BC, came from the Victoria and Albert Museum, and the rest came from the British Museum, the Royal Collection, the Ashmolean and Pitt Rivers Museums in Oxford. It was felt, however, that in order to demonstrate the continuing importance of gold in the social, religious and economic ethos of the Asian community, and also the fact that craftsmanship in gold in the twentieth century could still be of an extraordinarily high quality, the exhibition needed a contemporary component. This was exclusively supplied by generous loans from the Asian community. The fact that they had agreed to loan material that often had a combined religious, sentimental and monetary value indicated how far they had gone along the road of accepting Bradford Art Gallery as an institution that could serve as a platform both to display and interpret their cultural heritage.

By January 1988, the exhibition seemed to have run into insurmountable financial difficulties. In spite of having found a publisher for the catalogue and funding from the Arts Council, and money for part of the installation and design from Yorkshire Arts and the Crafts Council, there was still a deficit of several thousand pounds. None of our sponsorship appeals to the various multinational and national companies had worked, apart from a contribution of £300 from Shell UK Ltd. In despair, we turned to the Asian businessmen of Bradford and their response was immediate. They promised a donation of £6,000. This, in conjunction with a collaboration agreement with the Zamana Gallery, London, who had decided to take the show, meant that there was now sufficient money for 'A Golden Treasury' to become a reality. But the community contribution did not end there. A visit by two master goldsmiths from India to demonstrate filigree techniques had been organized, through a grant awarded by Visiting Arts. The community set aside a house for them and worked out a rota system amongst themselves to extend hospitality towards them. In the event only one goldsmith managed to come and instead of isolating him in a house all on his own in a strange country, one of the Asian jewellers put him up for the duration of his stay.

There was, however, fierce criticism from an unexpected quarter over two aspects of the exhibition. The co-ordinator of one of the women's centres objected to our plans of bringing over a goldsmith all the way from India, when there were so many practising Asian goldsmiths in this country. She also objected to the fact that we were giving a corridor display to the British jewellers Roger Barnes and Clarissa Mitchell,

whose jewellery was heavily influenced by Indian forms of adornment, materials and tools. They also served as a bridge between 'A Golden Treasury' and an exhibition on contemporary British jewellery called 'Special Effects' that had been programmed to run at the same time. The co-ordinator's objection to the exhibiting of the works of Barnes and Mitchell was based on the assumption that they were exploiting the subcontinent for their own ends.

The criticisms were obviously treated with a great deal of seriousness, but in the end they were not taken on board. The goldsmith, for instance, was an expert in filigree, a highly specialized craft, and an area in which the Asian goldsmiths of Britain have no skills. In fact, when the goldsmith started his residency he was inundated with orders, which he had to refuse, from Asian jewellers wanting to˚ make use of his considerable talent while he was in the country. The British Asian goldsmiths approached to run workshops had declined the offer on the grounds that they were intensely busy and a day off at Cartwright Hall meant the loss of several hundreds of pounds, if not more. Clarissa Mitchell and Roger Barnes did not imitate Indian jewellery so much as let the influence of India itself impress itself upon their work, often in highly original ways. For instance, Roger Barnes' 'Last Tiger' brooch was a flattened, roughly textured silver tiger rug with a tiny cornelian to indicate the bullet-hole, a beautiful combination of good craftsmanship and the making of a statement. Consequently, since the criticism indicated a certain narrowness of vision and prejudice, it was, after careful consideration, ignored. The voices of the community are important voices, but they do not necessarily always embody a God-like infallibility or collective wisdom.

The sticking point of the exhibition, however, was of course attendance of the exhibition itself. Fortunately, it did attract large numbers and, though Bradford Art Gallery's method of clicking people in does not allow for separating the Asian figures from the overall figure, it was patently obvious that attendance was unusually high.

There were, however, other criticisms, particularly of the book that accompanied the exhibition (Stronge *et al.* 1988). One of the Asian sponsors of 'A Golden Treasury' objected to the fact that one catalogue entry described a *Swami* bracelet as:

Swami work is peculiar to Southern India, and represents in embossed style, distinct designs or figures of *Heathen* deities . . . of the Hindu pantheon.

It was pointed out to him that the description was actually a quotation from the nineteenth-century English firm's advertising brochure, but the sponsor did not see this as a totally mitigating factor. Such terms he felt

could not be used even in quotations without any attempt at qualifying them, and the unquestioning way it was presented implied an acceptance and endorsement of the rather derogatory language.

Although the writer of that particular section had no intention of offending, it did highlight the importance of being vigilant about every nuance and shade of meaning. There was also criticism from a lender to the exhibition who was rather taken aback by the terseness of the description of the Sikh emblem usually worn as a brooch, or a pin in the folds of the turban, or as a ring. The emblem incorporates two swords that represent secular and temporal power and is of fundamental importance in understanding the Sikh faith. This all-important reference and even the fact of its Sikh provenance had been accidently edited out. The result was a quietly reproachful Sikh community. They accepted the explanation, however, with dignity.

I will now turn to 'Traditional Indian Arts of Gujarat' curated by Julia Nicholson for Leicestershire Museums Service in 1988. In many ways this is a model exhibition when it comes to interaction between the exhibition and the public. Nicholson had advocated an exhibitions and collections policy for Leicester on themes that had 'direct links with the experience of local communities . . . (that) would be planned and executed in consultation with local Indian communities' (Nicholson 1990: 3). Discussions with individuals and groups from the Indian community about collecting identified specific areas—performance, religion, dress and personal decoration. To quote Nicholson: 'These areas are also the principal means by which Indian communities in Leicester still express their ethnic identities' (1990: 4).

Unlike 'A Golden Treasury', which had to rely heavily on national museum collections, 'Traditional Indian Arts of Gujarat' drew most of its material from it own permanent collections, acquired by Nicholson on a ten-week, collecting trip in 1985. The material, however, was displayed only three years later, the main reason being the length of time it was scheduled to run for, six months, which involved finding an unbooked space well ahead of time. The comparatively long time span of the exhibition was because of the 'heavy investment involved and the likely demand from visiting school groups' (Nicholson 1990: 6).

Long-term temporary exhibition space is a problem with all galleries. But it works against shows such as 'A Golden Treasury' or 'Traditional Indian Arts of Gujarat', which in lieu of permanent display areas (which are almost exclusively reserved for a gallery's European collection) served as an important semi-permanent collection resource particularly for the community whose culture it is depicting.

Nicholson was anxious that the collection be interpreted as part of a culture that was still alive. To quote her again:

As we were presenting a 20th century collection I was keen to interpret the collection as part of a living heritage . . . One of the criticisms of traditional museum ethnographic displays is that they tend to present material as if it were part of a timeless 'ethnographic present' where isolated societies are presented as untouched by industrial or international influences. This picture is not an accurate reflection of the contemporary reality of most societies. Unless ethnographic displays are placed in historical contexts, they must be updated by including recent specimens or other images in order that the image presented is not misleading. The criticism of the exhibition 'Hidden People of the Amazon' held at the Museum of Mankind a few years ago in which an idealized picture of Amazonian Indians was presented, with no reference to the genocide currently occurring as a result of the exploitation of the land by outsiders is one example of debate in this controversial area.

A major consideration for our exhibition, therefore, was that a balanced and accurate image of 20th century Gujarati life and arts should be presented. This was not straightforward because our museum collections acquired in India were largely traditional material, representing village life in Gujarat in the mid-20th century. This bias had been based on interests expressed by the local Gujarati community for the material they would like to see in a museum collection. Yet in many respects Gujarat today is very modern, both in terms of technology and in the contemporary 'international' arts emerging from the art colleges. To present a fair picture of the state these modern aspects should be included (Nicholson 1990: 5–6).

With the help of an advisory body, exclusively from the community, Nicholson decided to have four introductory panels. One examined the modern face of Gujarat to 'counteract the traditional image of Gujarat which was being presented in a large part of the exhibition'. The other three panels looked at the patterns of emigration of the different communities of Gujarat, at 'the practical and spiritual issues' surrounding water in Gujarat and finally 'at the central place of cattle and milk in the farming economy, as well as the spiritual associations of the cow' (Nicholson 1990: 13).

Nicholson had acquired nearly 1,000 objects from her buying trip to India and the selection of materials for the exhibition was a difficult one, but once again the advisory community were involved. As in Bradford, their contribution went beyond time and advice. Two members, for instance, translated the labels used in the exhibition into Gujarati, a lengthy and time-consuming activity at the best of times.

Nicholson was faced with a minor dilemma when deciding on the design and conservation requirements of the textiles and other objects. A

number of them, through their original use, were dirty. There is considerable debate as to whether ethnographic material should be cleaned, as many ethnographers would argue that dirt is an intrinsic part of the history of a museum specimen.

In this instance, however, it was apparent that the Indian community in Leicester may be offended if the heritage of their community was represented with soiled items. As the collection had been made on behalf of that community and the display was intended as a platform for Gujaratis to show their heritage to a wider audience I decided that these factors should take precedence over research considerations and, therefore, to have the costumes cleaned (Nicholson 1990: 20).

In addition to the textiles — embroidered, printed, woven and tie dyed — Nicholson with the help of advisory committee selected a range of marriage and dowry items such as a dowry chest, an assemblage of small objects from an annual Hindu religious fair, icons, votive figures, toys, vessels and farming and domestic items.

As in 'A Golden Treasury', 'Traditional Indian Arts of Gujarat', although depicting general and specific aspects of the subcontinent's heritage, was aimed at a much larger national public than the Asian audience. For instance, the Leicestershire Embroidery Workshop had made a study of the embroidery in the museum's Indian collection, which was meant to culminate in an exhibition of their own work. Together with the museum, they co-produced an embroidery leaflet which provided working drawings of most of the types of stitches used in Gujarati embroidery. Predictably, as with 'A Golden Treasury', the demand and take-up from schools and colleges was enormous.

A number of the tours, workshops and lectures were targeted at the Gujarati community. A Gujarati woman led an embroidery workshop and because of the informal nature of all the workshops the community responded well. One related event which was highly successful and serves to emphasize how exhibitions, particularly on Asian themes, need to be as interdisciplinary as possible was the fashion show organized by the London-based Asian fashion house Libas. The tickets that were distributed to Indian community groups were sold out in four days.

The two exhibitions looked at so far have been in the regions, and the public discussed so far in connection with the two exhibitions have been in the main a 'specialist' public, in the sense that I have concentrated on members of the community who had a direct input into the exhibition, and served as a channel to the wider public. I now turn to an even more 'specialist' and narrow public, if you can call them that, the arbiters of taste, who inform the larger public about these exhibitions. I refer to the

media. Both 'A Golden Treasury' and 'The Traditional Indian Arts of Gujarat' attracted a range of press coverage, almost uniformly favourable. This was largely due, one suspects, to the non-confrontational and historical/traditional nature of the material displayed. 'Traditional Indian Arts of Gujarat' had been accompanied by an exhibition of contemporary art called 'Gujarati Indian Artists' which although excellent, was still non-confrontational to the extent that it was largely apolitical. But 'The Other Story' curated by Rasheed Araeen for the Hayward Gallery in 1989, generated a phenomenal amount of publicity, most of it of a considerably less bland nature than that received by the other two exhibitions.

If 'A Golden Treasury and 'Traditional Indian Arts of Gujarat' took a long time between conception and realization, Rasheed Araeen's labour of love took far longer to bear fruit, because it was a full eleven years before he could find a national venue such as the Hayward Gallery that was prepared to accept the show. 'The Other Story' is an exhibition of Afro-Asian artists in post-war Britain. To quote Araeen:

> It is a story that has never been told. Not because there was nobody to tell the story but because it only existed in fragments, each fragment asserting its own autonomous existence removed from the context of collective history. It is therefore a story of those men and women who defied their 'otherness' and entered the modern space that was forbidden to them, not only to declare their historic claim on it, but also to challenge the framework which defined and protected its boundaries (Araeen 1989: 9).

Araeen not only curated the show, but selected all the twenty-four artists included in it as well. Much has been made of the fact that five well-known artists, Anish Kapoor, Dhruva Mistry, Veronica Ryan, Shirazeh Houshiary and Kim Lim, though invited to participate in the show declined. Much has also been made of the fact that the show included only four women artists. Araeen offers an explanation of sorts in his postscript to the catalogue. Referring to the five artists who refused to participate he says:

> I understand their fears, and I sympathise with their positions, but the success of these artists does not vindicate the establishment or invalidate my argument. Can we separate the success of some of the above artists from the anti-racist struggle waged particularly against the art establishment in the 70's? Instead of a serious debate within the dominant discourse, we now have new categories — 'black arts' and phoney pluralism to confuse the issue . . . The issue of equal gender representation remains unresolved here. We have included only four

women artists, which is regrettable. But this must be understood in terms of socio-historical factors, rather than through a continually repeated rhetoric of mythical 'blackwomen artists' who have been ignored. It seems that in the 50's and 60's 'black' women artists who had come here from Africa, Asia or the Caribbean, returned home when they had completed their education, unlike male artists who stayed on. On the other hand, black women artists who have recently emerged were either born or brought up in Britain and they have no choice but to assert their presence here. They are an important part of our Story (Araeen 1989: 106).

The Horizon Gallery, London, in order to make a point about the way 'The Other Story', as it perceived it, had not reflected the art scene accurately enough, staged its own show 'In Focus' which included a number of women artists now shown in 'The Other Story'. Araeen was dismissive of the exhibition, since it confused the issue as he saw it, and the vast majority of artists 'In Focus' had not had exposure from the Horizon before, in spite of it being exclusively a gallery for contemporary Asian art. But the most interesting factor about 'The Other Story', to my mind at least, was the reception it got from the British Press, ranging from the savage to the sometimes lyrical.

It was widely reviewed and, at the last count, it got coverage from *The Sunday Times, The Financial Times, The Times Literary Supplement, The Sunday Telegraph, The Guardian, The Independent, The Observer, The Tatler, New Statesman and Society, The Listener, Apollo, Arts Review, Art Monthly, Spare Rib, The Catholic Herald, The Christian Science Monitor* and various European and South American publications. It was reviewed twice on *Kaleidoscope* (BBC Radio 4) and discussed on *The Late Show* (BBC2).

But a number of the reviews had been written not so much to assess the exhibition as to denigrate Araeen for daring to put on an exhibition where the colour of an artist's skin was one of the important criteria. But a careful reading of the catalogue will show that Araeen was not seeking to categorize and segregate forever painters who are not white. He was making the point that these artists were marginalized precisely because of the colour of their skin. The best example of this is the 1987 show organized by the Royal Academy on 'British Art in the 20th century' which though it included a number of non-British artists, did not include a single Afro-Caribbean or Asian artist. Incidentally, among seventy-two artists on show at the Academy, there were only six women artists. Araeen himself has stated emphatically that as far as he was concerned 'The Other Story' should be the last exhibition of its kind. Further exhibitions on a similar theme would be seen by him as a sad admission of defeat.

While most of the reviews tried and kept a not so successful balance between critical assessment and liberal guilt, Brian Sewell, Critic of the Year, wrote two savage tirades against 'The Other Story' in *The Evening Standard* and *The Sunday Times*. I single out his writing not in an effort to be negative, but because it is perhaps an icy blast of reality for those of us who think all is well with the multicultural world. We need to remind ourselves from time to time that there can be this degree of overt hostility from well–respected establishment figures, whose opinions do influence the public.

> Those who argue now, in Britain, that art should embrace the influence of its ethnic minorities, and that we should acknowledge the mastery of those who practise it, present us with a dilemma, for their work is too new, to immature, too hybrid to exert an influence on the western stream from which, in essence, it derives (Sewell 1989).

He concluded by saying:

> The dilemma for the Afro-Asian artist is whether to cling to a native tradition that is either imaginary, long moribund or from which he is parted by generations and geography, or to throw in his lot with an ancient tradition of white western art, from which he borrows, but with which he has scant intellectual or emotional sympathy. Whatever he chooses he must not require praise, nor demand a prime place in the history of art, simply because he is not white. For the moment, the work of Afro-Asian artists in the west is no more than a curiosity not yet worth even a footnote in any history of 20th century western art.

My fear is not whether Sewell's harsh last lines have a ring of truth, but whether they have the ring of prophecy. Is there not the danger, in spite of the riots of 1981, the supposed change of direction in arts policy, the creation of posts such as Nicholson's and mine, and the Hayward Gallery exhibition, that the arts we try to exhibit will be treated as even less than 'a footnote in any history of 20th century western art'?

The artist F. N. Souza's all to brief a summer in the 1950s in Britain may have had everything to do with the vagaries of a fickle art market, or his own inability to grow, or the transient flirtation of the West with exotica. Rabindranath Tagore had experienced this as well, both with his painting and his writing. Could the experience of these individual artists from two totally different periods, extend and apply eventually to contemporary (and historical) Asian and Afro-Caribbean art as well. The 1980s emphasized them, as they had never been emphasized before, and even though it was still not sufficient and comprehensive enough

exposure, in comparison with the preceeding decades, it looked and seemed like a lot.

But one wonders if the 1990s will sustain this, or abandon it. One is chilled by the fact that the Arts Council Collection for instance, which laudably bought a number of works by non-British artists in the 1980s, felt they had redressed their balance in the collections, and could revert to their earlier policies. One is equally chilled by the seminar organized by the Museums Association at Cartwright Hall in December 1989 to talk about multicultural provision, to note that the speakers present there were almost identical to the speakers who had spoken on exactly the same subject four years earlier.

I am sure there will be several people who will tell me that this dilemma is not exclusive to black art, that all movements have their day, as do interests their phases. But, in the interests of multiculturalism or pluralism, we cannot afford these brief flirtations to be the burning issue one day and the object of a sharp withdrawal of interest the next. For a sustained growth and understanding both contemporary and historical art needs steady nurturing and one wonders if Britain can or is willing to provide that. At the end of the day not all our changes of policy or funding or strategy will change the scene apart from cosmetic ways. Is that not why we are still between the horns of a dilemma about phraseology? Black artists, non-British artists, multiculturalism, pluralism, ethnic — if the separate tags are not affixed these elements are in danger of being swallowed up in the mainstream, yet when we do use those labels we separate ourselves and are separated.

A change of consciousness from both sides, an increase of awareness are the only solutions and these are intangibles that cannot be easily fostered or gauged, it calls for radical changes within the education system itself for a start. The Asian and Afro-Caribbean community have to exercise a rigorous self–discipline as well, and not give in to the occasional temptation of glorifying their culture and their oppression at the cost of the host community. Ultimately neither community, in art or in life, should define the others' reality for them, for in so doing we narrow this reality.

BIBLIOGRAPHY

Araeen, R., 1989. *The Other Story: Afro-Asian Artists in Post-War Britain*, South Bank Centre, London.
Nicholson, J., 1990. 'Co-ordinating an exhibition: traditional Indian arts of Gujarat' (unpublished Museums Association Diploma dissertation), London.
Sewell, B., 1989. 'Pride or prejudice', *The Sunday Times*, 26 November.

Stronge, S., Smith, N., and Harle, J. C., 1988. *A Golden Treasury: Jewellery from the Indian Sub-continent*, Mapin Publishing, London.

9 *Collecting Reconsidered*

SUSAN M. PEARCE

Collecting Reconsidered

SUSAN M. PEARCE

Sweden. Lapp. Pouch made from a blackthroated diver (Colymbus Articus). Male specimen, probably taken in the nuptial season.

Eastern Eskimo. Iglulik Tribe. Pouch made from the footskin of an albatross. Collected during Admiral Sir Leopold McClintock's expedition in H.M.S. Fox. 1859.

Faroe Islands. Strono Kvivig. House broom of four puffin's wings.

Labels from the Pitt Rivers Museum, Oxford, quoted by James Fenton as Exempla 10, preceding his poem on the Pitt Rivers Museum (Fenton 1983: 79).

It is a truism, but still true, that museums hold the stored material culture of the past. They share this characteristic with a number of other institutions, like great houses, perhaps churches, perhaps libraries; but museums alone exist in order to hold material objects.[1] In a unique sense, our collections are what we are, and from this all our other functions flow. It is strange, then, that until very recently, the study of these collections by museum people, and from a museological stance, has been comparatively neglected, certainly in comparison with the amount of effort which has been poured into this study from a field or discipline base. This, it seems to me, has been a major weakness, for it is only when practitioners turn their attention to the history and nature of their own field, and begin to develop a critical historiography proper to it, that the field can be said to have come of age. This has clearly been true of the history of science as a study, it is beginning to prove itself in archaeology (for example, Fahnstock 1984), and now a parallel development is gathering momentum among museum workers which, I think, can properly be called Collection Studies.

Collection Studies can be seen to embrace three broad areas. The one which has been most familiar to us is the large and complex area of collection policies, that range of issues, part philosophical and part practical, which include decisions about what any particular museum should and should not collect, why and how material may be disposed of, and the relationship between documentation systems and the kinds of research which can be generated. The second broad area covers the history of collections, and of collecting from its beginnings in the ancient world up to the present day. The focus is upon the tracing of acquisitions and dispersals, the editing of relevant surviving documents and the biographies of collectors, together with themes like the relationship between collections and the idea of the museum. Study here is not new, but it has been put on a new footing by the work of Arthur Impey and Oliver Macgregor (Impey and Macgregor 1985; Macgregor 1983) and by the *Journal of the History of Collections* which they founded in 1989. The third area concerns the nature of the collections themselves, and the reasons why people collect, both the explicit intellectual or 'presentable' reasons, and the more obscure psychological or social reasons. Curators are now realizing that we must start to understand the history and nature of our collections and the reasons behind their formation, so that we can appreciate better the assumptions about knowledge and value which they embody (see Stewart 1984). This understanding lies at the heart of all interpretative activity. All three areas are intimately interwoven, and, in sum, Collection Studies present an exciting field for thought and work. I have chosen in this paper to concentrate on aspects of the nature of collections and of collecting, in an effort to explore some of the cultural implications.

Museums may hold the stored material culture of the past, but this stored archive has not arrived in bland, sanitized form in, as it were, uniform storage boxes coming in at so many on the first of every month. Quite the contrary: the material has come in fits and starts. It comes in all kinds of relationships to the progress of human lives, including bequests made after death. It comes incomplete, imperfect, and with associated documentation and information, itself immensely variable in quality and quantity. Above all, it comes in groups, in sets of material. Even the accession of a single object is perceived as part of a set, either in relationship to others of its kind or in relation to the other elements in the life history of the original owner or collector. But, in fact, by far the greater proportion of the material in museums has arrived not in single objects, but in groups. We are accustomed to call each of these groups 'a collection' and to refer to the whole assemblage as 'the collections'. The notion, then, of group identity is deeply embedded in the material itself and in museum language, the two combining to play a part in constructing the curator's world.

An attempt to understand the nature of these collections is one way of exploring our human relationship with the external physical world of which they are a part. The material comes as part of a context, part of the web of relationships, for which ideological is a useful word, which involve persons and the material world. The forming of the collection is part of the relation between the subject, conceived as each individual human being, and the object, conceived as the whole world, material and otherwise, which lies outside him or her. The collections, in their acquisition, valuation and organization, are an important part of our effort to construct the world, and so it is with this large and fascinating area that this paper will be concerned. I shall try to distinguish three modes of collecting, to which it seems to me most of our collections belong, and these may be called 'collections as souvenirs', as 'fetish objects' and as 'systematics'. I shall try to draw out the characteristic features of each mode, using as framework some of the ideas usually described as phenomenological, and associated originally with Hegel, and especially the concept of 'objectification' abstracted by Miller (1987) from Hegel's ideas, which supposes a dual relationship of process between subject and object. 'Process' is an important word to which we shall return. These will be linked with concepts of the romantic, an important group of ideas which is now being applied to the history of collecting (Wainwright 1989), and which have been greatly developed over the last few decades. These two interlinked ideas are to the fore in contemporary cultural studies, in writers like Eagleton (1983) and Miller (1987) although naturally each author will make his or her own use of them, and to both I shall return in a moment.

Let us make a start with that material which I have characterized as souvenir. These are the objects which take their collection unity only from their association with either a single person and his or her life history, or a group of people, like a married couple, a family or, say, a scout troop, who function in this regard as if they were a single person. They cover a huge range of possible objects. Examples chosen at random include children's toys in the York Castle Museum, a sampler in the Victoria and Albert Museum, a piece of patchwork in Exeter City Museum, a powder compact in Leicestershire Museums Service, and a small, modern blue-glazed pottery scarab made specifically to act as a souvenir of the Egyptian collection, which can be purchased in the British Museum shop for 5p. The range of such pieces formally accessioned into museums is, of course, only a tiny fraction of the number which actually exists out in world, but they are, nevertheless, very characteristic types of museum accession.

They usually arrive as part of what curators call 'personalia' or 'memorabilia' and sometimes the personality to which they are attached was sufficiently interesting or notorious to throw a kind of glamour-by-

association over the pieces, an interesting aspect of the way in which museum objects work, which is susceptible to analysis as signs and symbols but which must not delay us here (but see Pearce 1990). I am reminded of a playlet written by Laurence Binyon, formerly an Assistant Keeper at the British Museum and best known as the author of the poem 'For the Fallen'. He imagines an altercation between two exhibits, the bust of a Roman Emperor and the mummy of an Egyptian queen (quoted in Holmes 1953: 3). Each claims precedence on the grounds of past importance and present popularity. The lady makes good her claims in one devastating couplet:

I lived in scandal and I died in sin;
That's what the world is interested in!

Generally, however, the personalities are not particularly distinguished and unless the objects have acquired the kind of interest which accrues to survival through the passage of years and increasing rarity, like the Leicester powder compact made for Boots Ltd in the 1930s, they are experienced as boring and embarrassing. James Fenton, one of the few modern poets to have written a poem about a museum, says of the Pitt Rivers Museum

Outdated
Though the cultural anthropological system bc
The lonely and unpopular
Might find the landscapes of their childhood marked out
Here, in the chaotic piles of souvenirs.
The claw of a condor, the jaw-bones of a dolphin. . .
(Fenton 1983: 82)

The Pitt Rivers aside, such objects will not be displayed unless they can be hooked on to an historical exhibition in which their personal connections will be mentioned.

And yet we know, in our hearts if not in our minds, that souvenirs are moving and significant to each of us as individuals; otherwise we would not keep them. What, then, is the nature of these pieces? Souvenirs are intrinsic parts of a past experience, but because they, like the human actors in the experience, possess the survival power of materiality not shared by words, actions, sights and the other elements of experience, they alone have the power to carry the past into the present. Souvenirs are samples of events which can be remembered, but not relived. Their tone is intimate and bittersweet, with roots in nostalgic longing for a past which is seen as better and fuller than the difficult present. The spiral is backwards and inwards as the original experience becomes increasingly

distant and contact with it can only be satisfied by building up a myth of contact and presence. Souvenirs discredit the present by vaunting the past, but it is an intensely individual past — no one is interested in other people's souvenirs. Souvenirs speak of events that are not repeatable, but are reportable; they serve to authenticate the narrative in which the actor talks about the event. As a part of this they help to reduce a large and complex experience, like the Somme or the Western Desert, to a smaller and simpler scale of which one human can make some sense. They make public events private, and move history into the personal sphere, giving each person a purchase on what would otherwise be impersonal and bewildering experiences (Stewart 1984: 132–150). Souvenirs, then, are lost youth, lost friends, lost past happiness; they are the tears of things.

They are also something else, and the phrase just used 'can make sense' was chosen deliberately. Souvenirs are intensely romantic in every way, and especially in the ways in which that idea is now often applied. The romantic view holds that everything and, especially, everybody, has a place in the true organic wholeness which embraces human relationships, the traditional continuity of past into present, the landscape and the changing seasons. It asks us to believe that life is not fractured, confused and rootless, but, on the contrary, suffused with grace and significance. It is no coincidence that in Europe generally, and especially in England, the romantic movement came to birth at the moment in the late eighteenth century when religion had begun to loose its hold over the thinking classes and when the new factories were manifesting the shape of things to come. It was this dislocation between things as they are and things as they ought to be which aroused the characteristically romantic emotions of alienation and despair. In terms of a concept, and nowhere more than in its mystical and metaphysical side, romanticism is about as convincing as a leaking sieve, but, unquestionably, it has a powerful hold over our deepest hopes and feelings: it shows life as we would wish it to be.

It is in these hopes and feelings that the souvenirs belong. They are an important part of our attempt to make sense of our personal histories, happy or unhappy, to create an essential personal and social self centred in its own unique life story, and to impose this vision on an alien world. They relate to the construction of a romantically integrated personal self, in which the objects are subordinated into a secondary role, and it is this which makes them, all too frequently, so depressing to curate and to display.

This brings us to the second of our broad collecting modes, that which was described at the beginning as fetishistic collecting. This is in many ways an unfortunate, or even unpleasant term, and perhaps a phrase like 'devoted', or even 'obsessive collecting' might be an improvement; but 'fetish' and 'fetishistic' are now enshrined in the literature to such an

extent that to avoid the term would create more misunderstandings than it solves, so it will be used here on the understanding that nothing inherently pejorative is intended.

Our museum collections hold vast quantities of material which are almost never put on show; the reasons why this is so are part and parcel of the nature of these collections and we shall return to them in a moment. These collections span the disciplines, and they are, significantly, usually known not by the location from which the material derived, nor by the subject upon which it concentrates, but by the name of its original owner and collector. In museums across the country, and in their equivalents across the world, the Pritchard Collection will turn out to be 15,000 foreign stamps, the Sandford Bequest 10,000 cigarette cards, and the John and Sarah Hart Loan over two thousand crochet hooks.

Close spiritual kin to this kind of collecting are those accumulations which have been gathered by the so-called 'serious' collectors. These include very famous collections in the art and antiquities fields, like those of the Arundel or Townley classical marbles, which have always been valued for their perceived intrinsic, and therefore, financial, quality, and which have been taken correspondingly seriously by the museums who have come to hold them. Paralleling these are the major collections of curiosities, rarities and assorted *objects de vertu* accumulated by renowned collectors like the Tradescants, Sir Hans Sloane and Joseph Mayer which stand at the beginnings of some of our most important national collections, and the huge number of essentially very similar, but much less famous collections, some in museums, but many now broken up. What links these collections with their humbler cousins of the matchbox tops and beer mats is the lack of an intellectual rationale by which the material and its acquisition was informed, and this notwithstanding the fact that cigarette cards and the like are classified into sets which collectors try to complete: the sets have no rhyme or reason outside the covers of the album.

A quantity of occasional verse has been perpetrated to make fun of this kind of collecting, from Sir Charles Hanbury Williams, a friend of Sir Hans Sloane, in the eighteenth century who wrote

The stone whereby Goliath died,
Which cures the headache, well applied.
A whetstone, worn exceeding small,
Time used to whet his scythe withal.
The pigeon stuff'd, which Noah sent
To tell him when the water went.
A ring I've got of Samson's hair,
The same which Delilah did wear,

St Dunstan's tongs, which story shows
Did pinch the devil by the nose.
The very shaft, as you may see
Which Cupid shot at Anthony.
(Brooks 1954: 193)

to Ogden Nash in our own century who penned

I met a traveller from an antique show,
His pockets empty, but his eyes aglow.
Upon his back, and now his very own,
He bore two vast and trunkless legs of stone.
Amid the torrent of collector's jargon
I gathered he had found himself a bargain,
A permanent conversation piece post-prandial,
Certified genuine Ozymandial,
And when I asked him how he could be sure
He showed me P. B. Shelley's signature.
(quoted in Bray 1981: 227)

The collecting practice lends itself to parody.

This kind of obsessive collecting, in which the intention is to acquire more and more of the same kind of pieces, and in which the accumulation stops only with death, bankruptcy, or a sudden shift of interest, has been the butt of journals like *Punch* even since the 1850s, and it has loomed large in the image which museums have been at great pains to dispel since the early 1960s. It would, however, be a major mistake to suppose that this kind of collecting belongs with our Victorian, or at least pre-Second World War, past, and is a part of our inherited museological baggage which can be decently buried in distant storage. A glance at the issue of *Exchange and Mart* dated 8 March 1990 (current when this paper was written) shows us *Collecting* as a major heading. Here we find 'Muffin the Mule items wanted by collector, puppets, badges, annuals, etc.'; 'Wanted by collector pit checks, pay checks, time checks etc., . . . best prices paid for brass'; 'Must sell: dearly loved collection of 350 antique china half-dolls'. These have been picked at random from over three hundred such advertisements, including those for large collectors' fairs. There are separate sections for bottles, cigarette cards, coins and medals, buttons and matchbox labels, and some hitherto unknown, at least to me, like smokiania, which turns out to include tobacco tins and cigarette packets. In a more up-market world, the sales catalogues of Sothebys and Christies tell exactly the same story. It is an important characteristic of these collections that they are bought, or sometimes exchanged, at an agreed valuation on the open market, in which the price reflects a

perceived level of desirability. It is a fair guess that many of these collections, especially those which achieve substantial dimensions, will end up being offered to a museum, and probably accepted, with varying degrees of reluctance.

However, the reluctance on the part of our curatorial successors in the coming decades may be less than we think. There are signs that this kind of collecting, so widespread in the community that it clearly answers a fundamental need, is beginning to be given the serious attention which its social significance demands. In May-June 1990, Walsall Museum and Art Gallery, under the able guidance of Peter Jenkinson, mounted a new kind of exhibition called *The People's Show*. Material for display was recruited by a flyer which says

> We are looking for collections by Walsall people for a new exhibition at Walsall Museum and Art Gallery called The People's Show. If you collect anything as an interest or a hobby, or simply as a decoration in your home, we would like to hear from you ... If you have a collection which you think people in Walsall would enjoy seeing, please fill in this form.

The answers are being followed up by a questionnaire which is designed to discover the history of the collection, the process by which it was accumulated, the rationale behind the collection, how the owner is viewed by family and friends and what the future of the collection will be. At the time of writing the museum has been offered collections of football shirts, eggcups, model frogs, Madonna posters and international travel sick bags taken from aircraft. When the data and the experience of this exhibition have been digested, the results should be extremely interesting.

I have said that the use of the word 'fetish' in relationship to objects and collections viewed in a particular way is now a normal part of discussion. A random dip into fairly recent writings in the related fields of literary and linguistic theory, material culture and museum studies begins to show us how the word is used. Terry Eagleton in his *Literary Theory: An Introduction*, published in 1983, discusses the nature of society in early industrial Britain. He says:

> In England, a crassly Philistine Utilitarianism was rapidly becoming the dominant ideology of the industrial middle class, fetishing fact, reducing human relations to market exchanges, and dismissing art as unprofitable ornamentation (Eagleton 1983: 19).

Two pages on, he continues:

Art was extricated from the material practices, social relations and ideological meanings in which it is always caught up, and raised to the status of a solitary fetish (1983: 21).

Daniel Miller in his 1987 discussion of material culture and modern mass consumption, speaks of how:

An approach to modern society which focusses on the material object always invites the risk of appearing fetishistic, that is of ignoring or masking actual social relations through its concern with the object *per se*. (Miller 1987: 3).

Three years ago, in the first of our Museum Studies International Conference series, Peter Gathercole gave a paper entitled 'The fetishism of artefacts' where he explored the implications of the display of the Enigma Coding machine (Gathercole, 1989). The idea of fetish objects has entered more generally into the world of writing. A poem by Fenton, entitled 'Nest of Vampires', which was published as a part of the collection already quoted and which strikes in some ways similar notes to those of the Pitt Rivers verses, says

In that chest there was a box
Containing a piece of white coral,
A silver cigar-cutter shaped like a pike,
A chipping taken from the Great Pyramid
And a tribal fetish stolen during the war'
(Fenton 1983: 44)

'Fetish' and 'fetishistic' have come recently into museum and related studies from the broader field of cultural investigation. Psychologists use the word to describe a particular form of sexual orientation, unfortunately in many ways, because it is this that has given a useful idea an uncomfortable feel. The psychologists, however, had borrowed the concept from nineteenth-century anthropologists like E. B. Tylor, just as they have made use of kindred words like 'totem' and 'taboo'. The standard reference works trace the word back to the Portuguese *feiticos*, meaning 'a charm', which was used in the fifteenth century to describe contemporary Christian relics, rosaries and holy medals. When they arrived on the African coast later in the same century, the Portuguese naturally applied the word to the local wooden figures, stones and so on, which were regarded as the residence of spirits and

W. Bosman in his *Description of Guinea* of 1705 uses the word in this connection.

It is worth noting in passing that no racial or colour prejudice was involved: the devout Portuguese used the same word indiscriminately for religious objects regardless of origin, in the same way that contemporary descriptions of African settlements use an ordinary tone equally appropriate to the description of European towns. More to the purpose here, *feitico* also means 'made by man' and carries the idea of something 'artful' or 'magically active'. It was from this web of connections that the anthropologists appropriated the word, and used it to describe material objects which were worshipped for their magical powers, believed to be inherent rather than deriving from an indwelling god or spirit.

This begins to uncover the nature of fetishistic collections and collection-making. Such collections are often very private or rather, sometimes, the owner suffers a degree of tension between his urge for privacy and his desire to display his private universe to others. Joseph Mayer and his collection, which eventually went to the then Liverpool City Museum in 1867, makes the points very well. Between about 1830 and 1886 when he died, Mayer accumulated a very considerable, but very mixed, collection which included classical gemstones, Middle Eastern ivories, manuscripts, and Napoleonic memorabilia. Originally the collection was kept in a series of private homes where it seems to have been open only to close friends, but as it grew in size and fame, Mayer was moved to open his own museum originally called the 'Egyptian Museum' at 8 Colquitt Street, Liverpool (Gibson and Wright 1988).

The portrait of Mayer painted about 1840 by William Daniels gives us a vivid insight into the nature of this kind of collecting. Mayer sits in his study at 20 Clarence Terrace, Everton Road, Liverpool. He is seated in a throne-like chair in the Gothic taste, gazing reflectively at a Wedgwood urn, while light falls on Greek and Etruscan antiquities set out on the table and touches classical marbles and paintings further back in the room. The collection is not organized, but merely arranged by its owner in what seemed to be its best advantage; indeed it seems to have grown up around him as an extension of his person. This notion touches the heart of the matter: this kind of collection is formed by people whose imaginations identify with the objects which they desire to gather. Powerful emotions are aroused by the objects which the objects seem to return, stimulating a need to gather more and more of the same kind. The urge is to samples, and as many of them as possible, rather than to examples, a point to which we shall return when we consider systematic collecting. The whole accumulation process is a deployment of the possessive self, a strategy of desire, in Stewart's memorable phrase. The fetishistic nature lies in the relationship between the objects and their collector, in which it is the collection which plays the crucial role in

defining the personality of the collector, who maintains a possessive but worshipful attitude towards his objects. Such collections and their collector are at the opposite pole to souvenirs discussed earlier. Here, the subject is subordinated to the objects, and it is to the objects that the burden of creating a romantic wholeness is transferred.

We can take the story a stage further by reminding ourselves of the implications of that fact that the fetish concept was taken over not only by the anthropologists and psychologists, but also by the political scientists. In a passage of *Das Capital* famed for its obscurity, Marx says:

> It is a definite social relation between men, that assumes, in their eyes, the fantastic form of a relation between things. In order, therefore, to find an analogy, we must have recourse to the mist-enveloped regions of the religious world. In that world the productions of the human brain appear as independent beings endowed with life, and entering into relation both with one another and the human race. So it is the world of commodities with the products of men's hands. This I call the Fetishism which attaches itself to the products of labour, so soon as they are produced as commodities, and which is therefore inseparable from the production of commodities' (Marx 1906: 203).

This seems to mean that through the operation of the capitalist system, the commodities which people produce come to have a life of their own, irrespective of their makers, the circumstances of their manufacture, or personal relationships which all this involves. These commodities endowed-with-life then operate in an independent fashion, detached from direct social relationships, and capable themselves of being the partner in a relationship with humans, an operation which Marx saw as a distortion of the proper relation betwen men and goods, an abberant evil typical of mass production society.

Leaving on one side the specific argument about the extent to which Marx was right in his analysis of modern capitalist society and of the artefacts which are part and parcel of it (but see Miller 1987), his extended notion of the nature of fetishes gives us an important clue to the nature of the collections which we are considering, and the kind of response which it is possible to make to them, in a museum (or anywhere else). These collections are detached from any context, they are removed from the sphere of actual social relationships with all the tensions, efforts of understanding and acts of persuasion which these imply. This detachment, is indeed, a very substantial part of the attraction for their collectors who use them to create a private universe, but its sterility gives to the material that peculiarly lifeless quality which all curators recognize with a sinking heart. The detachment of fetish collections explains why

they have so seldom been put on display: unless the collection contains objects deemed to be of intrinsic merit, usually in the art fields, or of historic interest, usually in relation to the early history of the museum, the collection languishes from decade to decade undisturbed. It will be interesting to see what impact on this the Walsall exhibition has.

Although souvenirs and fetishistic collections stand at opposite ends of the romantic pole in terms of the ways in which their human subject relates to them, as is so often true, there is a point where opposite ends meet. Both are part of an attempt to create a satisfactory private universe, and both do this by trying to lift objects away from the web of social relationships, to deny process and to freeze time. In museums, therefore, they are perceived as disassociated and static, floating in a kind of purposeless limbo. Very different is the way in which we appreciate what I shall call the systematic collections.

Historically, this kind of collecting can be traced back quite a long way, certainly into the Renaissance, and probably in some respects earlier still, but because this paper is concerned with intentions and implications rather than with historical analysis, I shall take Pitt Rivers and his collection as illustrating what I mean. Pitt Rivers believed two fundamental principles: first, that material culture reveals humankind's essential nature and development; and second, that the progress of artefactual development, and so of human nature, follows broadly Darwinian principles, so that types developed one from another according to a process of selection which modified their forms. The addition to this of diffusionist ideas about the spread of artefacts across the globe meant that the whole structure could be knit together into a kind of lattice-work in which there might be a place for everything.

Pitt Rivers presented his views in three lectures on 'Primitive Warfare' at the United Service Institute in 1867, 1868 and 1869, and offered a general statement of them in *The Evolution of Culture* published in 1875. As far as possible, the material in his own collections, and in the Pitt Rivers Museum, was arranged to demonstrate these principles, but this fell short of Pitt Rivers' ideal museum which would take the form of a rotunda building, arranged in concentric circles which would show the major human phases of artefactual evolution, with the innermost circle for the Palaeolithic, the next for the Neolithic, and so on. The rotunda would also be divided into wedges, so that 'separate angles of the circle might be appropriated to geographical areas' and allied civilizations would 'occupy adjacent angles within the same concentric ring' (Chapman 1985: 41, quoting Pitt Rivers; see also Chapman 1989). So would the conceptual lattice-work be made museum flesh.

The detail of Pitt Rivers' views about material culture has now been discredited, but this does not touch the fundamental idea which informed those views and which, of course, is shown by all the systematic collecting

in the natural sciences (see Morgan 1986 and references there), and equally in the collections which result from planned anthropological expeditions, organized archaeological excavation, or the deliberate assemblage of historical material to create the period room, like those which the York Castle Museum has made famous. It is to the nature of this idea and of its implications that we must now turn.

Systematic collection depends upon principles of organization, which are perceived to have external reality beyond the specific material under consideration, and which are held to derive from general principles deduced from the broad mass of kindred material through the operation of observation and reason; these general principles form part of our ideas about the nature of the physical world and the nature of ourselves. Systematic collecting, therefore, works not by the accumulation of samples, as fetishistic collecting does, but by the selection of examples, intended to stand for all the others of their kind and to complete a set, to 'fill in a gap in the collections' as the phrase so often upon curators' lips has it. The emphasis is upon classification, in which specimens (a revealing word) are extracted from their context and put into relationships created by seriality. This is achieved by defining set limits, which apparently arise from the material. Collecting is usually a positive intellectual act designed to demonstrate a point. The physical arrangement of the finds sets out in detail the creation of serial relationships, and the manipulation implicit in all this is intended to convince or to impose, to create a second and revealing context, and to encourage a cast of mind.

From this emerges a fundamental difference between the systematic collections and the other two modes discussed earlier. Systematics draw a viewer into their frame, they presuppose a two-way relationship between the collection which has something public (not private), to say, and the audience who may have something to learn, or something to disagree with. This is one of the two reasons why curators generally give the lion's share of their blessings, and of their exhibition space, to this kind of collection. In our familiar phrase 'you can do something with it', you can make a point, you can engage your public. The second reason is implicit in the nature of this kind of collecting. It is conceived as display, it requires organized space in which to demonstrate its serial relationships. If museum galleries and glass show cases had not existed, it would have been necessary to invent them; but, of course, museums as the public institutions which we know, and serial collecting, more or less grew up together, uniting to demonstrate the laying-out of material knowledge.

But laying-out has another, and more sinister meaning. Collections and displays of this kind can be experienced as death-like, as mummification rather than interaction. Moreover, we who live in this godless

post-modernist world know that there is no such thing as objective reality, at least as far as human beings are concerned, and that all knowledge is socially constructed and forever bound in the play of ideological relationships. Our systematic collections do not show us external reality; they only show us a picture of ourselves.

Hegel's concept of 'objectification' as developed by Miller may help us here. Hegel overcame the ancient dualism which separates subject and object, or humankind and the whole external world, and which must result in either the subordination of the object to a romantic vision of the essential self, as with souvenirs, or the subordination of the subject to romanticized objects, as with fetish collections: both are static, sterile, and take us nowhere. 'Objectification' is meant to describe the 'dual process by means of which a subject externalizes itself in a creative act of differentiation, and in return re-appropriates this externalization through an act (of) sublation' (Miller 1987: 28). Put rather crudely, this means that the human person as subject creates from within himself an entity of whatever kind — including material artefacts — which assumes an external existence as an object; but then takes back this creation to use it as part of the next burst of creative activity. In this way, the gulf between subject and object is healed and neither is elevated at the other's expense. The essence of the link is relationship, that relationship is always in process, and process is always bringing about change.

This, it seems to me, helps us to understand the nature of systematic collections. They are formed by the imposition of ideas of classification and seriality on the external world, but the world itself has, one way or another, given rise to these ideas. However, this is a process without beginning or end. No one starts to form or to display a collection without inheriting past process, and each collection or display in place contributes its mite to the dynamics of change. The whole continuous reconstruction is part of the concrete appreciation of the world, with all its awkwardness and dislocation, and each actor in the story can be involved in the struggle.

A principal actor is, of course, the curator, and this brings me to my last important point. The position of the curator, it seems to me, is a dilemma central to the profession at this time. On the one hand, there is our professional and discipline training through which we inherit a share in the received knowledge and wisdom of the Western tradition, linked with a particular obligation to try to pass this on to others. On the other, we are aware that this knowledge, wisdom and tradition can have no intrinsic or absolute value, either moral or intellectual, that it is merely a product of specific social relationships, and therefore has no claim to any special position. In archaeological circles, to draw on my own discipline, this dislocation is seen as part of the reason for the growth of so-called 'alternative archaeology' which includes irrationalities like ley-line

dowsing, and abberations (from a classic position) like treasure-hunting (Gregory 1983; Williamson and Bellamy 1983).

The paradox may be eased by linking the idea of collection as process with the notion of consensus as it has been developed for the purpose of discussing the nature of theory in science by Thomas Kuhn and others (1970). This supposes that there is a *research or professional community* made up of individuals who share a general interest and a network of communication, and a *speciality*, that is a segment of the general community who are interested in a particular problem, say the nature and implications of the nineteenth- and early twentieth-century collections of herbaria. The speciality segment will come to a broadly shared view of their subject which they will commend to the wider community, usually with some success. So is a consensus achieved, and the wider the ripples of this can spread, the better for all concerned. But the terms of the consensus are not written on tablets of stone; they are part of the same dynamic process of perpetual change which makes up the relationship between subject and object, between people and the material world of museum collections.

It is time to see, not where we have arrived, but perhaps how hopefully we have travelled. This paper has tried to open up discussion of the nature of collections as they actually are in our museums, as a particular area of social experience. It has suggested that philosophical ideas current in the broad field of cultural theory may help us here, and they have turned out to show us three common collecting modes, two at either pole, frozen and static, and the third engaging itself to bridge the gap. It must be stressed, of course, that many individual collectors and collections show elements of more than one mode, either at the same time or reflecting successive phases of activity. The analysis has thrown some light on why and how curators experience their collections, and so on why and how they are, or are not, put on exhibition.

All this, I am aware, is merely to scratch the surface of one part of collection studies. I have not attempted to discuss topics like the nature of relics, seen not merely as a specific medieval form but as a more general concept; or the idea of collection as deposition or dedication, a mode that links the centuries back to prehistoric times. The idea of collections as treasure is a fruitful one, linking them to the art and antiquities markets and so to the workings of the capitalist world: it is no accident that museums as we know them and modern capitalism came to birth at much the same time. These ideas beckon, and no doubt others lie yet in shadow beyond.

For the moment, we must leave the last word with the Pitt Rivers Collection, which has run through this paper. Fenton saw the Pitt Rivers Museum as full of souvenirs, and perhaps fetishes too. Pitt Rivers saw his collection as bringing systematic scientific classification to bear on the

human material world, and curators have accorded him his historical place while disagreeing with his ideas. The Pitt Rivers labels quoted at the head of this paper, can be read in all three modes, depending upon how one takes them at the time, which illustrates the notion of interaction and change. The labels remind us that, always, we are dealing with attitudes not facts, or, put another way, with human temperament. For the collectors of Walsall, for Joseph Mayer, for Pitt Rivers, as for us all, the glass of a show case gives both a transparent vision and a reflection of our own faces.

NOTE

1. This statement is not intended to exclude natural history specimens. Specimens from the natural world are, of course, to be studied and displayed according to the scientific principles which have been developed in zoology, botany, geology and related disciplines. Collections carry within them much which relates to the history of these disciplines, and are worthy of study on that count also. However, there is a further and very significant point. It is clear that the acquisition of a natural history specimen involves selection according to contemporary principles, detachment from the natural context, and organization into some kind of relationship (many are possible) with other, or different material. This classification process transforms a 'natural' piece into a humanly-defined object, which is to say an artefact, and collections of natural history can probably be discussed in material culture terms just as can those in the other disciplines. This is an important part of the museological aspect of the history and philosophy of science, and requires correspondingly extensive treatment.

BIBLIOGRAPHY

Bray, W., 1981. 'Archaeological humour: the private joke and the public image', in Evans, J., Cunliffe, B. and Renfrew, C. (eds), *Antiquity and Man: Essays in Honour of Glyn Daniel*, 14–27, Thames and Hudson, London.

Brooks, E., 1954. *Sir Hans Sloane*, Batchworth Press, London.

Chapman, W., 1985. 'Arranging ethnology: A.H.L.F. Pitt Rivers and the typological tradition', in Stocking, G. (ed.), *Objects and Others: Essays on Museums and Material Culture*, 15–48, University of Wisconsin Press, Milwaukee.

Chapman, W., 1989. 'The organizational context in the history of archaeology: Pitt Rivers and other British archaeologists in the 1860's', *Antiquaries Journal*, LXIX, 1: 23–42.

Eagleton, T., 1983. *Literary Theory: An Introduction*, Basil Blackwell, Oxford.

Fahnstock, P., 1984. 'History and critical development: the importance of a critical historiography of archaeology', *Archaeological Review from Cambridge*, 3 (1): 7–18.

Fenton, J., 1983. *The Memory of War and Children in Exile: Poems 1968–1983*, King Penguin, London.

Gathercole, P., 1989. 'The fetishism of artefacts', in Pearce, S. (ed.) *Museum Studies in Material Culture*, 73–81, Leicester University Press, Leicester.

Gibson, M. and Wright, S. (eds), 1988. *Joseph Mayer of Liverpool 1803–1886*, Society of Antiquaries, London and National Museums and Galleries on Merseyside, Liverpool.

Gregory, T., 1983. 'The impact of metal detecting on archaeology and the public', *Archaeological Review from Cambridge*, 2 (1): 5–8.

Holmes, M., 1953. *Personalia*, Handbook for Museum Curators, Part C, Section 8, Museums Association, London.

Impey, O. and Macgregor, A. (eds), 1985. *The Origins of Museums*, Oxford University Press, Oxford.

Kuhn, T., 1970. *The Structure of Scientific Revolutions* (2nd ed), Chicago University Press, Chicago.

Macgregor, A., 1983. *Tradescant's Rarities*, Oxford University Press, Oxford.

Marx, K., 1906. *Capital: A Critique of Political Economy*, trans. Moore, S., and Aveling, E., Cassell, London.

Miller, D., 1987. *Material Culture and Mass Consumption*, Basil Blackwell, Oxford.

Morgan, P., 1986. *A National Plan for Systematic Collections?*, National Museum of Wales, Cardiff.

Pearce, S., 1990. 'Objects as meaning; or narrating the past', in Pearce, S. (ed.), *Objects of Knowledge: New Research in Museum Studies*, Vol. 1, 125–40, Athlone, London.

Stewart, S., 1984. *On Longing: Narratives of the Miniature, the Gigantic, the Souvenir, the Collection*, John Hopkins Press, Baltimore.

Wainwright, C., 1989. *The Romantic Interior*, Yale University Press, New Haven.

Williamson, T., and Bellamy, L., 1983. 'Ley-lines: sense and non-sense on the fringe', *Archaeological Review from Cambridge*, 2 (1), 51–8.

10

'Feasts of reason?' Exhibitions at the Liverpool Mechanics' Institution in the 1840s

KEVIN MOORE

'Feasts of reason?' Exhibitions at the Liverpool Mechanics' Institution in the 1840s

We were not prepared to expect, much less to meet with, the very sumptuous 'feast of reason' laid out for the public in the rooms of this institution (*Liverpool Mercury*, 31 January 1840).

In March 1840 the Liverpool Mechanics' Institution announced:

It is the intention of the DIRECTORS to open, during the next Midsummer Holidays, in June and July, a PUBLIC EXHIBITION of Objects illustrative of the FINE ARTS, NATURAL HISTORY, EXPERIMENTAL PHILOSOPHY, MACHINERY, MANUFACTURES, ANTIQUITIES, &c

As similar Exhibitions which have been recently held at Manchester Leeds, Derby, and other places, have been attended with many excellent results, the Directors confidently expect that their endeavours to render this Exhibition as various and as useful as possible will be warmly seconded by the public (*Liverpool Journal*, 16 June 1840).

Liverpool thus joined what has been termed 'the exhibition movement' of the mechanics' institutes, following the first such exhibition in Louth, Lincolnshire, in 1835. By 1845, when the movement appeared to have run its course, 'Almost every town which possessed a mechanics' institute seems to have held exhibitions', and in total 'several million people' had visited them (Kusamitsu 1980: 71). The development of the mechanics' institutes, societies for the education of working-class men, which were established in nearly seven hundred British towns between 1824 and 1851, has been examined by a number of historians (see, in particular,

Harrison 1961: 57-89; Kelly 1952, 1957, 1970: 112-33; Prothero 1979: 191-203; Royle 1971; Tylecote 1957). The exhibitions, however, are discussed in only a cursory manner in these studies. The work of Kusamitsu has therefore been highly valuable in demonstrating the popularity of the exhibitions and in considering their purpose (Kusamitsu 1980). It is clear, however, that such a significant cultural phenomenon warrants further research; and not just from the approach of the historian, but also from that of the museologist. In order fully to understand the exhibition movement, it is essential to examine it in relation to the wider history of museums. Research which is informed by the perspectives of both the historian and the museologist facilitates a much more complete and accurate analysis of the inception, development and decline of this movement.

This paper is offered as a contribution to these research needs by means of a local study. Such a study can test the general validity of Kusamitsu's findings, while simultaneously examining how far the exhibition movement varied due to local circumstances, particularly in terms of the regional specificities of class relations. A local study is also a useful vehicle to extend the analysis to embrace a museological perspective, by relating the exhibitions to the development of museums within the particular locality, and also by considering what the form and content of the exhibitions reveal of the rationale behind their creation.

A local study of Liverpool would appear to be especially valid, for a number of reasons. From the 1820s to the 1850s it was the largest provincial city in Britain, with a population in 1841 of 286,000. The Liverpool Mechanics' Institution was said to be 'by far the most extensive and splendid' of its kind ('London Paper', quoted in Liverpool Mechanics' Institution 1840a: 12). The Liverpool Mechanics' Institution held three major exhibitions, in 1840, 1842 and 1844, which in terms of scale and popularity compared very favourably with those held in other major cities. These three exhibitions drew an estimated 297,000 people; four in Manchester between 1837 and 1842 drew around 300,000 (Kusamitsu 1980: 71). The 1840 Liverpool exhibition contained over 4,000 donated items, in twenty rooms of the Mechanics' Institution, occupying, I estimate, over 20,000 square feet (based on Liverpool Mechanics' Institution 1842a; Liverpool Mechanics' Institution 1840b). Liverpool is also a pertinent choice for a local study given its nationally significant role in the development of museums in the nineteenth century (Clubb 1922).

What was the rationale behind the creation of these 'great exhibitions' which predate the 'Great Exhibition' of 1851? Kusamitsu has argued that the exhibitions were 'an expression of cultural activity', a means of demonstrating the 'flourishing bourgeois culture of the provincial manufacturing towns'. At the same time they were 'tied in with a general notion

of educating "the working classes" (partly with a view to "social control")' (Kusamitsu 1980: 71–2). This replicates the view that the overall purpose of the mechanics' institutes was to regain hegemonic control over at least the skilled working class, at the time of Chartism (Harrison 1961: 57–89 *passim*).

An examination of the rationale behind the Liverpool exhibitions does much to undermine this analysis. The decision to hold the first Liverpool exhibition was not taken until December 1839, by which time twelve other towns had already successfully mounted exhibitions (Kusamitsu 1980: 70–1). The Liverpool Institution had 'long contemplated something similar', but as it ran unusually successful day schools as well as evening classes, the building was only vacant for six weeks, during the school holidays, and there had been doubts as to whether an exhibition could be organized in time (*Liverpool Journal*, 26 June 1840). By March 1840, the directors had decided that 'No exertion will be spared to render it worthy of the Institution and of the town . . . not only may the Institution be assisted by the proceeds, but that the collection of articles may be such as to instruct, as well as amuse and gratify the public' (Liverpool Mechanics' Institution 1840a: 31). Instruction (and by implication, 'social control'), therefore appears to have been only one of several factors in the rationale, the others being civic pride, profit, and entertainment. The desire to make the exhibition 'worthy of the Institution and of the town', relates to the intense rivalry which was already developing between the provincial towns and cities. Once the institutes in Manchester and other places had held exhibitions, it was a matter of pride that Liverpool hold an equally successful one. The 1840 Liverpool exhibition was reported in the local press to be, 'with the exception of the philosophical and scientific departments . . . superior to any thing of the kind which has been exhibited at any similar institution in the country' (*Liverpool Journal*, 26 June 1840).

It appears, however, that the most important factor in the decision to hold exhibitions in Liverpool was that they were seen as a way of raising much-needed funds for the Institution. The directors gleefully noted 'the pecuniary results' of the 1840 exhibition, a profit of over £2,000 (Liverpool Mechanics' Institution 1841: 33). Hodgson, the secretary, stated at the close of the 1842 exhibition that 'One object was to raise a sum of money by means of which the Institution might be placed in a more effective state as an educational establishment' (*Liverpool Journal*, 2 August 1842). The desire of the directors that the exhibition should 'amuse and gratify' the public was closely related to this, as a way of attracting a large enough attendance to ensure a profit. For this reason, many of the displays at the Liverpool exhibitions were, as we shall see, more akin to fairground attractions than contemporary museum exhibits. There is evidence that the profit motivation was not confined to

Liverpool, but was an important factor in the exhibition movement nationwide. Tylecote has argued that while the decision by the Manchester Mechanics' Institute to hold their first exhibition derived from a desire to combine 'relaxation and amusement with the communication of knowledge', the financial aspect predominated as soon as the profit value of the exhibitions had been proved. Further exhibitions were held 'primarily with a view to paying off the debts of the Institution' (Tylecote 1957: 178).

The Liverpool exhibitions, did, however, also set out to instruct. Hodgson, the secretary of the Mechanics' Institution, stated in 1842 that the second object, after the financial one, 'was to do something towards raising the standard of public taste, by gathering together such a number of articles as was not collected together even in the mansion of the richest individual . . . viewing such a magnificent congregation of articles of ingenuity, rarity, beauty and splendour . . . (would be of) permanent advantage to the moral and intellectual character of the reflecting visitor' (*Liverpool Journal*, 2 August 1842).

Before considering how the exhibitions were meant to do this, it is necessary to consider who the 'public' were conceived to be. Kusamitsu argues that the exhibitions were aimed at 'educating' the skilled working class, but the Liverpool exhibitions' organizers were as keen to solicit the attendance of the middle class. While the first Manchester exhibition was for 'the working classes', Hodgson stated that the 1842 Liverpool exhibition was for 'the different classes of society' (*Liverpool Journal*, 2 August 1842). This lack of focus on the working class was reflected in the admissions charges: 'The price of admission to the Manchester exhibition was sixpence to the whole. Here the price of admission is a shilling, from nine o'clock until four and sixpence from that hour until the close (ten at night)' (*Liverpool Journal*, 19 June 1840). This higher charge in Liverpool reflects the overriding concern to make a profit. It was also a result of the fact that the Liverpool exhibitions could rely far less on a skilled working-class audience than those in, for example, Manchester, given the much smaller number of such workers in the city. Liverpool had a far larger proportion of unskilled workers, as a result of its primary role as a port rather than as a manufacturing centre. The large numbers of dock labourers and porters meant that the unskilled made up over 20 per cent of the male workforce in the city in 1841, compared with less than 10 per cent in Manchester and Salford (Moore 1987: 9). It can also be argued that the comparative lack of desire to attract the working class to the exhibitions in Liverpool reflected local politics. The city had a comparatively weak Chartist movement, the majority of the working class in the city supporting the Whigs and the Tories throughout this period. This was partly a reflection of the occupational structure, but also a result of peculiarly local political factors (Moore 1987, 1989). The

working class was not seen as a 'threat' as it was in Manchester, for example, and thus there was less desire to use the exhibitions as a device to reassert hegemony.

The evidence regarding the social composition of the visitors to the Liverpool exhibitions tends to support these arguments. The directors claimed that 'nearly 100,000 persons' visited the 1840 exhibition (Liverpool Mechanics' Institution 1841: 33). However, this included 'No fewer than 16,000 children belonging to the various charity schools . . . the police and military forces, &c, (who) were invited gratuitously' (Liverpool Mechanics' Institution 1842a: 29). It is impossible to calculate accurately how far the remainder were working class or middle class, but some inferences can be made. The attendance was generally far greater after four o'clock in the afternoon, when the entrance fee was reduced from a shilling to sixpence. During the 1842 exhibition, 18,802 adult visitors paid the one shilling entrance fee, 57,014 the reduced evening rate (*Liverpool Mercury*, 5 August 1842). One local newspaper commented that 'In the latter part of each day the crowd is indeed so great that no single visit can do more than give a very superficial notion of the several arrangements' (*Liverpool Mercury*, 8 July 1842). Less complete figures for the 1844 exhibition show that in the last two weeks, 4,427 adult visitors entered before four in the afternoon, and 19,447 afterwards at the lower rate (*Liverpool Mercury*, 5 July 1844; 12 July 1844). However, the greater attendance at the reduced entrance charge does not necessarily indicate a high proportion of working-class visitors. The middle class were just as likely to visit in the evening, after work. A local newspaper which was highly sympathetic to the exhibition reported after its first week of opening, 'We have been somewhat surprised to find so few mechanics present in the evening, and that nine-tenths of the visitors, during that period, are composed of well-dressed ladies and gentlemen, who, we should have supposed, would have chosen the more select portion of the day for the purpose' (*Liverpool Journal*, 26 June 1840). Lack of working-class attendance is also indicated by the fact that though the directors opened the 1842 exhibition 'to the domestic servants of those persons holding season tickets . . . very few of the latter class had taken advantage of the opportunity, only 380 servants having attended, whilst no less than six or seven thousand season tickets had been issued' (*Liverpool Journal*, 2 August 1840). The exhibitions also did little to encourage working men to become members of the Institution, which had 1,595 Annual Members in 1840, but only 1,575 in 1841 (Liverpool Mechanics' Institution 1842a: 20).

It can be argued that even the sixpence entry fee per person was beyond the means of the vast majority of working-class people, particularly if they attended in family groups. Only a very small proportion of Liverpool's skilled workers earned more than thirty shillings a week, the

wages of the majority of artisans being between eighteen and twenty-five shillings per week (Moore 1987: 12–35). During the first exhibition the *Liverpool Mercury* received many complaints about the cost of attending, particularly as to the expense involved in taking a family. These also pointed to the extra 'hidden' charges for admission to some parts of the exhibition, such as the 'fire cloud display' and the musical lectures, and the non-returnable penny 'demanded for the safe custody of an umbrella' (*Liverpool Mercury*, 10 July 1840; 17 July 1840). The 1842 exhibition was held at a time of acute depression which further lessened the likelihood of the working class being able to afford to attend. A survey of one area of Liverpool in that year revealed that of the skilled workers, only 35 per cent were fully employed, 28 per cent employed only one to three days a week, and 29 per cent completely unemployed (Moore 1987: 290). That the overall attendance figure at the 1842 exhibition was the same as in 1840 and 1844, which were much more prosperous years, strongly suggests that the majority of those who attended all three exhibitions were middle class.

The social control of the working class does not appear, therefore, to have been a major aim or result of the Liverpool exhibitions, and it is possible that Kusamitsu has exaggerated its importance in the country as a whole. The Liverpool exhibitions were, however, still seen as potentially having the power to 'civilize' skilled working men: 'exhibitions of this nature must bring out their best qualities, elevate their minds, and produce that spirit of emulation which, while it polishes the handicraftman, must make him a reputable member of society and a good citizen' (*Liverpool Journal*, 18 June 1840). Extending Kusamitsu's argument, the exhibition movement as a whole might be seen as part of the general middle-class attempt in this period to replace 'traditional' working-class leisure activities with 'rational' forms of entertainment (Kusamitsu 1980: 76–7; Bailey 1978; Cunningham 1980). As one correspondent of a local newspaper commented,

Since the exhibition was opened, it has been crowded night and day by thousands of the middling and lower classes. What would these thousands have been doing if there had been no exhibition? . . . many would be walking in the streets, or viciously indulging themselves in the company of tavern or beer house frequenters; many would be immersed in their cellar-kitchen prisons, slaves without prospect of emancipation (*Liverpool Mercury*, 7 August 1840).

The exhibitions were seen by one journalist as both demonstrating, and partly causing, a distinct shift in working-class leisure patterns: 'The age of bull baiting, bear baiting, and other degrading so-called "sports" may

be said to have entirely passed away, and now are patronised recreations which tend to elevate the taste, enlarge the understanding, ennoble the desires, and improve generally the moral and intellectual condition of man' (*Liverpool Mercury*, 30 June 1843). Recent research, however, has begun to suggest that middle-class efforts to 'reform' working-class leisure were far less successful than their propaganda claimed, and that in the early nineteenth century there was actually an increase in leisure activities of an 'undesirable' kind for the poor (Cunningham 1980). Given also the relatively small number of working people attending the exhibitions in Liverpool, they can have had very little impact on the leisure of the working class.

Whatever the motives were for holding the exhibitions, primarily pecuniary in Liverpool, perhaps more for the instruction of the working class elsewhere, it needs to be considered why exhibitions of this kind were seen as a useful means of achieving these ends. Kusamitsu argues that popular and profitable exhibitions of machinery and scientific instruments, which were developed in London from the late 1820s, were the role models for the mechanics' institutes' displays (Kusamitsu 1980: 71). However, it is clear that they owed as much, if not more, to contemporary museums and galleries. This can be seen from the kinds of material displayed in them. Kusamitsu notes that objects in the mechanics' institutes' exhibitions across the country (including those in Liverpool) fell into five main categories: 'experimental philosophy' (largely scientific items); machinery and manufactures; the fine arts; natural history; and antiquities and curiosities (Kusamitsu 1980: 77–82). They therefore *combined* the kinds of material displayed in the London exhibitions of the late 1820s, namely the first two categories, with that on show in contemporary museums and galleries, that is, the latter three categories. The influence of museums on the exhibitions is hardly surprising, given that many of the mechanics' institutes already possessed their own museums and galleries (Kelly 1970: 128). In 1840 the museum at the Liverpool Mechanics' Institution was described as containing 'an extensive collection of objects of Natural History . . . Mineral and Geological Specimens . . . Antiquities and Curiosities' (Liverpool Mechanics' Institution 1840b: 60). Paintings were also permanently displayed around the building, and a sculpture gallery developed (Liverpool Mechanics' Institution 1841: 32).

Displays of the kind of material found in contemporary museums and galleries would have been seen as likely to attract large numbers of visitors. It has been argued that museums were becoming increasingly popular in the 1830s, particularly among the working class, through the introduction of free admission on certain days (Minihan 1977: 87–9). While the decision to hold an exhibition in the Liverpool Mechanics' Institution reflected the success of those already held elsewhere, propo-

nents could also point to the growing popularity of museums in the city. William Bullock had operated a popular Museum of Natural and Artificial Curiosities in Liverpool between 1801 and 1809, when he moved to London (Alexander 1985: 119–20; Hunt 1974: 15; Morton 1894: 20–1). A 'Museum of Natural History and Antiquities' and an art gallery were opened by the Royal Institution in Liverpool in the 1820s, which were comparable to those established by Literary and Philosophical Societies around the country at this time (Morton 1894: 26–31; Ormerod 1953: 32–41; Brears 1984). In 1838 the museum was opened free of charge on Queen Victoria's Coronation day, and attracted 1,200 visitors. As a result a free day on the first Monday of each month was instituted from January 1839, and 41,161 people, including many from the 'labouring classes', were admitted on these days during the year (Ormerod 1953: 39; Kelly 1960: 19; Minihan, 1977: 52). The success of the Mechanics' Institution's exhibitions in Liverpool, as in the country as a whole, was thus to some extent guaranteed by growing interest in museums among both the middle class and also the working class.

While the Liverpool exhibitions consisted of the same five main categories of material as the other exhibitions throughout the country, it is important to note local differences of emphasis in this respect. While the Manchester exhibitions had a plethora of machines, there were few in Liverpool, reflecting the fact that it was not a major centre of large-scale and mechanized manufacturing. Instead, there were an abundance of 'objects of curiosity and interest from every quarter of the globe' (*Liverpool Mercury*, 21 June 1844), gathered through the worldwide business activities of Liverpool's merchants and shipowners. The 1842 exhibition had two rooms containing over eight hundred 'Antiquities etc.', 'collected' from every continent, as the catalogue entries demonstrate: 'Mandarin's Sword, with Tortoise-shell Scabbard . . . Two New Zealand Dresses . . . Curious old Arabian Riding Whip, Ornamented with Beads . . . Pair of Bombay shoes . . . Needle Case from 500 miles up the Niger . . . An Iroquois Indian Tobacco Pouch' (Liverpool Mechanics' Institution 1842b, 66–73). There were also items which spoke even more clearly of the barbarity of British imperial conquest and plunder, such as the 'Dress of a Chinese Mandarin, killed at the attack of the fort North Wang Tong, viz:- Cap and Tail, the Outer and Under Robes, Petticoat, Pair of Boots, Pair of Chop-sticks and Knife, and two Mariner's compasses' (Liverpool Mechanics' Institution 1842b: 73). This was donated by the Shipmasters' Association, which was thanked by the exhibition organizers for having 'lent every thing they had that was rare and curious' (*Liverpool Journal*, 2 August 1842). The catalogues of the exhibitions show that a large proportion of the artefacts were loaned by merchants, shipowners, and ship's captains. Other members of Liverpool's middle class drew upon such contacts to build collections.

William Bullock and later Joseph Mayer developed notable collections in this way (for Mayer, see Gibson and Wright 1988; Nicholson and Warhurst 1983). Mayer, in a commentary on the 1842 Liverpool Mechanics' Institution exhibition, presented an idealized, sanitized view, devoid of the elements of conquest and plunder, of the almost unique opportunities available to collectors in Liverpool:

> The young collector . . . need not look upon the first beginnings of a collection with disparagement. For there are museums in our own country which, at the beginning, have sprung from a single specimen, or a few specimens, and which are now the greatest pride of the metropolis. And where is there a town so well fitted to become a rival as Liverpool, which, by her commercial intercourse with all parts of the known world, through the industry and enterprise of her merchants, and no less so by the intelligence and habits of observation of the captains, officers, and seamen of her ships, is daily receiving some relic of bygone times, at the sight of which the bosom of the antiquary thrills with delight; some gigantic fossil, or well-marked geological specimen, to excite the wonder of the scientific inquirer; some rare animal whose uses and value are unknown to us; or some mechanical work that kindles up a feeling of emulation in the minds of our artisans, and produces a new train of thought and action, from which results may accrue which no foresight dares avow? (Mayer 1842: 3).

The collections of Bullock and Mayer are merely the most well-known of many made in the first half of the nineteenth century in Liverpool through the opportunities provided by the city's world–wide connections, a number of which were donated to the Liverpool Royal Institution's museum (Hunt 1974: 15; Morton 1894: 29). Collecting appears to have been highly popular among Liverpool's middle class. A correspondent of a local newspaper commented that 'There are very few persons who are not collectors of *some* sort of curiosities' (*Liverpool Mercury*, 3 June 1842). The Mechanics' Institution exhibitions, which were made up of the contributions of literally hundreds of local people, were a testament to this. As regards the working class, E. P. Thompson has noted the 'museums' formed by working-class collectors, particularly handloom weavers in Lancashire and Yorkshire, in the early decades of the nineteenth century (Thompson 1968: 322–5). The greater proportion of unskilled, lower-paid work in Liverpool may have prevented working people from being able to form collections of this nature, though further research may well contradict this. There is certainly evidence that Liverpool seamen of a later period took advantage of their opportunity to bring home 'curiosities' from around the world (Lane 1987: 30, 100).

It is possible to attempt to assess retrospectively the form of the Liverpool exhibitions, using the valuable categorization of exhibition

forms developed by Cärlsson and Ågren (see Kavanagh 1990: 132–5). The Liverpool exhibitions, it can be argued, were a mixture of the two most primitive of the five forms of exhibition they have identified, namely 'mass', a clutter of objects displayed together, usually unlabelled, and the 'label' form, where objects are ordered in seriated ranks with basic labels. One journalist commented on the third exhibition in 1844 that it is 'pleasant to have the "far-fetched" rarities picked up by enterprising travellers thrown in a magnificent heap before you for calm and leisurely inspection' (*Liverpool Mercury*, 20 June 1844). Some parts of the exhibition were labelled, the Exhibition Committee ordering 2,000 labels for the first exhibition, and catalogues were also available for each exhibition, which provided simple names for at least some of the objects. In all this, the exhibitions appear to have largely followed contemporary museum practice.

The mechanics' institute exhibitions, both in Liverpool and elsewhere, were thus largely traditional in their content and form. Nor were they particularly novel in encouraging the attendance of working-class people. What was new, and what primarily explains their enormous popularity, was the *scale* of the displays. The 1840 Liverpool exhibition, for example, contained over 1,000 paintings; 200 watercolours; 330 engravings; 190 sculptures; 100 pieces of ceramics; 350 phrenological casts; 200 items of 'philosophical apparatus' (mostly scientific models); 50 pieces of machinery, and several rooms with displays of artisan crafts; 160 architectural models and drawings; over 900 'antiquities and curiosities'; 83 donations of items of natural history, just one of which consisted of 160 cases of stuffed birds; and the institution's own museum. A local newspaper later claimed that it was 'perhaps the grandest congregation of specimens of the rare, the curious, the interesting, and the useful, in nearly all branches of science and art, which had been seen in any provincial town in Europe' (*Liverpool Journal*, 25 June 1842). The organizers wanted the exhibitions to fill the building, there being little or no selection policy within the predefined categories, gathering together as much material as possible from private collectors. In this sense the exhibitions can be described as fetishistic collections of fetishistic collections (on fetishistic collecting, see Pearce 1989: 7–8). As one newspaper commented on the gallery of paintings in the 1840 exhibition, 'the good and the bad have been mingled together without care, quantity seeming to have been preferred before quality' (*Liverpool Mercury*, 26 June 1840).

What were the organizers attempting to communicate to visitors through exhibitions of this content, form, and scale? In terms of the form, Ettema has argued that nineteenth-century museums in general adopted what he terms a 'formalist' perspective to material culture, objects being allowed to 'speak for themselves', with little or no interpretation or explanation, from the belief that they intrinsically held

a moral, civilizing power (Ettema, 1987: 64–71). The Liverpool exhibition organizers consciously averred this perspective:

> The miscellaneous assemblage of natural productions, or works of art, involuntarily excites the attention and awakens the curiosity of those whose minds are in a healthy state, and disposed to dwell upon objects which connect the past, the present, and the future; who relish the contemplation of those causes which have aided the advance of civilization, and continue to accelerate the progress which intellectual improvement, under a variety of influences, continues to make among mankind in their present imperfect condition (Liverpool Mechanics' Institution 1840b: 14).

This explains the desire to make the exhibitions as large as possible, since scale was equated with value: the more objects of cultural 'worth' displayed, the greater the 'civilizing' impact. In displaying the kinds of material already held in museums and galleries, the exhibitions reflected what it seemed 'natural' to display, that which was already defined as of cultural value by the dominant social class. However, by combining such material with mechanical and scientific objects, the exhibitions' organizers sought to redefine what was adjudged to be of cultural value to include the kinds of artefacts which most fully expressed the 'progressive' influence of the middle class and were the finest symbols of *their* 'civilizing' impact. The exhibitions, it can be argued, were a celebration and a demonstration of the flourishing wealth and self-confidence of the nascent middle class. This was particularly marked in Liverpool, where the exhibitions were not only organized by the middle class, and largely consisted of items donated by the middle class, but were also for the most part confined to a middle-class audience.

The particularities of the form of capital production in Liverpool meant that the material displayed to demonstrate the 'civilizing' impact of the city's middle class was not so much scientific and mechanical items, as artefacts which reflected their trading activities, and their role in the expansion of the empire. The Liverpool exhibitions thus attempted to show the global extent of the 'civilizing' influence of the city's merchants and shipowners. In addition, it can be argued, they anticipated the Great Exhibition of 1851, in terms of what Greenhalgh has identified as the attempt to 'simultaneously glorify and domesticate empire', through the kinds of material displayed, and their juxtaposition with other items (Greenhalgh 1988: 54). Some items in the Liverpool exhibitions, such as the 'Burmese Imperial State Carriage and Throne', 'captured' in 1824, and shown in the 1844 exhibition, demonstrated the exotic wealth generated by British imperialism (Liverpool Mechanics' Institution 1844b: 111). Other artefacts, such as items of dress, suggested the

'ordinary' nature of the empire, how it seemed to fit naturally into the British way of life. This was accentuated by the way in which such items were displayed, intermingled in an unorganized fashion with material of British origin. In the 1840 exhibition, taking one example from amongst many, 'Three American Indian Dresses, ornamented with quills and hair', were displayed next to 'The Breeches in which King George II, of England, won the Battle of Dettingen, 15th June, 1743' (Liverpool Mechanics' Institution 1840b: 16).

While one can argue that these were the kinds of messages, whether consciously or unconsciously, communicated to, and perceived by, visitors, there is little direct surviving evidence of visitor reactions, beyond the reviews by local journalists. Their comments tended to reflect the 'formalist' perspective of the organizers:

> There are manifestations of human skill in a thousand forms; intellect is the presiding feature; mind, which has in the present age attained a development before unknown, here exhibits its wondrous and varied power, and by this classified aggregation of its noblest works not only shows what has been done, but incites to further exertion, and to a confident belief in the progression of the human race (*Liverpool Journal*, 20 June 1844).

Yet the sheer scale of the exhibitions was also felt to limit the possibility of any effective communication: 'the mind of the spectator may become bewildered amid the immense variety. This, in fact, is the observation of the many. All express unqualified admiration, but the attention is wearied by the multitude of objects' (*Liverpool Courier*, 24 June 1840). One can also suggest, despite a lack of evidence, that visitor perceptions differed between social classes. To the middle class, it was a self-celebration, of both their wealth and power: many hundreds of them had some of their own possessions on display. To the working class, the exhibitions would also have communicated the rising prominence of Liverpool's bourgeoisie. Yet was the further reaction one of accord, seeing the opportunity to share in this wealth produced by the middle class, or of disgust at such a show of conspicuous consumption amidst the poverty and deprivation of early Victorian Liverpool? Given the weakness of radical politics in the city in this era, it can be suggested that the former reaction was probably the most common.

While the later Liverpool exhibitions were largely carbon copies of the first in terms of their content and form, and their ideological under-pinnings, some notable innovations were made. In particular, exhibitions from London, hired on a temporary basis, began to form a key part of the displays. Other mechanics' institutes also did this, but it is not clear where or when this was initiated (Kusamitsu 1980: 81). The financial

success of the 1840 Liverpool exhibition encouraged the directors to hold another in 1842. There was, however, some concern that simply to largely repeat the first would not be financially successful, and efforts were made to provide novel attractions. They were able to secure

MR. CATLIN'S MUSEUM OF NORTH AMERICAN INDIAN CURIOSITIES, Which contains 500 PAINTINGS (exhibited with great success in London for the last three years), made by Mr. CATLIN amongst the wildest Tribe of the RED INDIANS, in NORTH AMERICA, with whom Mr. C. lived eight years; and several thousand Specimens of their Manufactures, with Costumes, Weapons, Pipes, Scalps, &c.&c. Living Figures in full Indian Costume, will be constantly in the Room. THE COLLECTION CONTAINS, ALSO, A LARGE AND PERFECT MODEL OF THE FALLS OF NIAGARA (Liverpool Mechanics' Institution 1842c).

Catlin was the first great painter of native Americans and a pioneer student and interpreter of their life. His sympathetic treatment, rather than exploitation, of native American culture has been noted (Altick 1978: 275–9). The exhibition organizers had the courtyard of the Institute roofed, providing 4,500 square feet for his display, which included a wigwam capable of sheltering eighty people (Catlin 1842: 48; *Liverpool Mercury*, 3 June 1842). The exhibition also included John Austin's collection of 'Animals of Opposite Natures, Living in One Cage', in which 'the rats and mice go to sleep under the cats; rabbits and pigeons playfully contend for a lock of hay; birds sometimes perch on the head of a cat, eat, and frequently rest for the night there' (Liverpool Mechanics' Institution 1842b: 103). Austin's display was on a permanent pitch near Waterloo Bridge in London from 1820 to 1856, apart from five months at the Liverpool and other mechanics' institute exhibitions (Altick 1978: 431; Kusamitsu 1980: 81). The exhibition as a whole drew 3,000 less visitors than that in 1840, but made the same profit, £2,000, a portion of which was spent on an extension for the Library and the Sculpture Gallery of the Institution (Liverpool Mechanics' Institution 1843: 33).

This 1842 exhibition took place during a mounting national political crisis, as the Chartist movement continued to gain strength, though it remained weak in Liverpool. Although the exhibition was organized, it can be argued, for largely financial rather than ideological purposes, its success was used by the organizers to publicize their Liberal political perspective. William Rathbone, at a meeting to close the exhibition, remarked that 'Liverpool had redeemed the character of England, and shown that if the people were trusted, they would prove themselves worthy of being trusted' (*Liverpool Journal*, 2 August 1842). The exhibition, it was argued, had heightened class harmony in Liverpool, at

a time of sharpening class divisions in the country as a whole. Hodgson, the secretary of the Mechanics' Institution, at the meeting which closed the exhibition, claimed it had done this by educating the rich about the poor, and vice versa. He argued that different parts of the exhibition performed these functions:

> For all classes, as well as for all tastes and for all ages, some form of instruction, besides amusement, has been provided. For the rich, who see works of art at home and in the houses of their friends, there have been machines, and models, and processes of manufacture, from which they may learn something of the occupations of their poorer fellow countrymen, on whose labours they themselves depend; for the poor, to whom the processes of the mechanical arts are necessarily more familiar, have been provided pictures, and statues, and engravings ... specimens of the beauties of nature, and the wonderful creations of science, of which they had never perhaps, formed any previous conception (*Liverpool Mercury*, 5 August 1842).

It was argued above that few, if any, of the working class could have afforded to attend this exhibition. As for the rich, far from learning about 'the occupations of their poorer fellow-countrymen', they were presented with only a highly partial, sanitized view of workers and their work. The exhibition (like those in 1840 and 1844), included craft demonstrations by men and women in such trades as printing, engraving, bookbinding, fringe weaving, pottery, glass-blowing and lace-making (Liverpool Mechanics' Institution, 1842b). These were crafts which employed only a tiny number of workers in Liverpool, and were confined to the most skilled and highly-paid. The exhibitions thus ignored the experience of the vast majority of the city's workforce.

This politicization of the exhibition movement in Liverpool was greatly accentuated in the following year. The success of the Liberal-sponsored Mechanics' Institution led the Liverpool Tories to establish a rival Collegiate Institution, which opened in January 1843 (Wainwright 1960). In the summer it held a 'Great Polytechnic Exhibition' which 'almost literally' followed the Mechanics' Institution's displays in its structure and the nature of its contents (*Liverpool Journal*, 24 June 1843). It is unclear how far it was held to popularize the Collegiate, or to score a political point against the Liberals. However, financial considerations appear to have been uppermost, given an admission charge of one shilling, and a season ticket charge of ten shillings. Certainly there was no attempt to attract working people, as 'the terms of admission (to say nothing of the extra charges) now place this beyond the reach of nine-tenths even of the upper class of workmen' (*Liverpool Mercury*, 30 June 1843). The largely middle-class audience were treated to an exhibition

which the anti-Tory newspapers had to concede was 'the most extensive which has been presented in this town to public notice. The articles occupy forty rooms'. The picture gallery was 220 feet long, and displayed over 400 works of art, 'the greatest number of high class pictures ever brought together in this part of the kingdom' (*Liverpool Mercury*, 7 July 1843; 14 July 1843). Despite this, it was still felt necessary to court visitors with a range of novel attractions, such as a 'Model and Panoramic view of Hobart Town, New South Wales', 'The Invisible Girl', and (again) Austin's 'Happily Family' (Liverpool Collegiate Institution 1843). The exhibition was just as successful as those at the Mechanics' Institution had been, drawing over 100,000 visitors, with receipts of £4,500 and a profit of £2,000 (*Liverpool Mercury*, 11 August 1843).

The Mechanics' Institution decided to hold a further exhibition in 1844. While the profit motive was still pre-eminent, the exhibition may also have been seen as a valuable way to publicize the institution, as nearly 400 Annual Members had transferred their support to the Collegiate (Liverpool Mechanics' Institution 1843: 19). There was a perceived need to provide new attractions, to maintain public interest, for it was reported in March that 'the obvious difficulty of procuring attractive novelties has been, in a great measure, overcome' (Liverpool Mechanics' Institution 1844a: 30). The apparently waning interest in the more 'traditional' displays such as fine art or natural history, meant that the novelty features were given 'top-billing' on the exhibition's poster, which increasingly read more like an advertisement for a fairground. The prime attraction was 'The GLACIARIUM, OR ALPINE WINTER SCENE. Spectators will walk among the Scenery, and have an opportunity of witnessing or enjoying the exercise of Skating on ARTIFICIAL ICE, representing a FROZEN LAKE' (Liverpool Mechanics' Institution 1844c). This was hired, at a cost of £200, from Henry Kirk, patentee of a process for producing artificial ice, who ran a 'Glacarium' in the Baker Street Bazaar in London. It occupied a space of over 2,500 feet in the basement of the Mechanics' Institution (*Liverpool Mercury*, 10 May 1844; 21 June 1844). The second major attraction was 'A LABYRINTHINE GROTTO, OR CAVERN ... at the several points of its windings are introduced a series of PICTORIAL EFFECTS, of various wonderful productions of Nature and Art'. In addition, 'in order to render the exhibition as attractive and novel as possible', the organizers bought 'the original casts by Belzoni from the Tombs at Thebes', and a 'Diving Bell, which was exhibited at work in a large tank in the Lower School yard' (Liverpool Mechanics' Institution 1844c). These purchases, and the inclusion of other novel attractions, meant that while the exhibition grossed as much as the previous ones in admissions, the profit was down to £1,100 (Liverpool Mechanics' Institution 1845: 12).

It was presumably as a result of this decline in profits that this was the

last exhibition held at the Mechanics' Institution. The Collegiate Institution delayed until 1847 before holding a second exhibition, doubtless believing that after a break of three years the public would find a further exhibition enough of a novelty for it to be profitable. However, it was still felt necessary to hire expensive new attractions to secure an audience. In addition to recalling the 'Glacarium', the exhibition included 'A grand dioramic panorama of Alpine wonders and beauties of the Rhine, painted by Danson, expressly for the exhibition, on 2150 feet of canvas'; and 'A maze or labyrinth, on the same plan as that at Hampton Court' (Liverpool Collegiate Institution 1847). This was to be the last exhibition at the Collegiate also. It appears that the public's demand for greater and greater novelties meant that the exhibitions became financially inviable. For it seems clear that the novelties, rather than the displays which mirrored contemporary museums, had always been the most popular part of the exhibitions, particularly for children. One man recalled, in 1900, a visit as a child to the 1840 Liverpool exhibition: 'All I saw was full of interest to me, but what took my attention most were the diving bell in the lower schoolyard, the models of steam engines, and the model steam boats. These last had real engines which propelled them through real water contained in large iron tanks. There were dissolving views too in some rooms' (Diogenes 1900: 33–4).

The popularity of the novelty attractions needs to be placed in a wider context. Though museums were becoming increasingly popular in the 1830s, they were probably being outstripped by the likes of dioramas, panoramas, and other kinds of more 'exotic' exhibitions and shows. The boy who visited the Mechanics' Institutions' exhibition in 1840 also recalled the other attractions in Liverpool at this time:

On the western side of South Castle Street several pieces of land, unoccupied after the widening of Pool Lane, were the happy hunting ground of the penny-gaff men, and in the evening their numberless lamplights, the sound of trumpets, the squeal of fife, and the beat of drum, the pressing invitations of the showmen (male and female), and the noisy hilarity of the gaping crowd were to me a never-ending mystery, interest and delight. There was a spot in Lime Street, too, from St John's Lane southwards, with another saturnalia of the same kind, but of lower character, while not far off, old Islington market, in Commutation Row . . . was the home of panorama, cyclorama, and exhibition, so that all classes were provided with amusement (Diogenes 1900: 32).

It was in this context that the Mechanics' Institution and the Collegiate had to provide more and more novel attractions, which rapidly made the exhibitions too much of a financial risk.

What was the museological impact of the Mechanics' Institution's exhibitions, and also those at the Collegiate? They seem to have had an adverse effect on the Mechanics' Institution's permanent museum. The annual report of March 1840 stated that 'The Museum has been recently fitted up with shelves, and lighted. A curator has been appointed, by whose exertions the numerous specimens, chiefly of ornithology, which have been either purchased or presented, have been arranged' (Liverpool Mechanics' Institution 1840a: 30). However, in the next report, following the first exhibition, the directors commented that 'It is to be feared that this department of the Institution does not excite the interest among the members to which its importance entitles it' (Liverpool Mechanics' Institution 1841: 32). After the second exhibition it was reported that given the lack of interest, the museum committee had 'deemed it advisable to dispense, for a time, with the services of the curator' (Liverpool Mechanics' Institution 1843: 32). The major exhibitions thus appear to have made the permanent museum displays seem too dull to attract much interest. It is interesting to note that the museums in the mechanics' institutes around the country were 'in the main a failure' (Kelly 1970: 128).

The exhibitions did, however, have a beneficial impact on the later development of museums in Liverpool. Joseph Mayer, whose own collection was to become the most important in the Liverpool Public Museum, was heavily involved in the organization of the exhibitions. Mayer was a director of the Mechanics' Institution, and a member of both its Exhibition and Museum Committees. He also contributed a great deal of material to the exhibitions, as the catalogues demonstrate. The impact of Mayer's involvement in the exhibitions on his later contributions to Liverpool museums has not been recognized by his biographers (Gibson and Wright 1988; Nicholson and Warhurst 1983). Many other items donated to the exhibitions were eventually deposited with the Liverpool Museum, and many listed in the catalogues are on display today.

There can be little doubt, as Kusamitsu has argued, that the exhibitions in Liverpool and elsewhere were a major influence on the Great Exhibition of 1851 (Kusamitsu 1980: 85-6). The mechanics' institutes' exhibitions precursed the 1851 exhibition in terms of content and format; they also demonstrated how much could be achieved in such a short space of time. The Liverpool exhibitions, it can be argued, also anticipated the 1851 exhibition in terms of the ideology behind its representation of the British Empire. However, further research is required to examine the precise nature of this relationship.

An understanding of the mechanics' institutes' exhibitions is also of value to museum workers today. The history of these exhibitions demonstrates many of the problems faced in producing large temporary

exhibitions, at relatively short notice, without previous collections to draw upon. The 'Glasgow's Glasgow' exhibition, of 1990, for example, was very much in the tradition of the mechanics' institutes' exhibitions, both in terms of logistics, and also through the potential for the scale of the displays simply to bewilder rather than to entertain or inform. The mechanics' institutes' exhibitions also anticipated many of the problems inherent in the development of the 'heritage industry', through the desire to make exhibitions profitable. The Liverpool Institutions' exhibitions, through the desire to make money, increasingly relied on gimmicks to attract crowds, at spiralling costs, which soon satiated public interest. Equally, they showed how, then as now, admissions charges will largely exclude a working-class audience.

An understanding of this exhibition movement, however, also has much of value to offer museum workers today. The craft demonstrations, though restricted to trades which produced items of aesthetic value, and which did not reflect the working lives of most Liverpool people, were undoubtedly a valuable innovation within the exhibition form, and worthy of imitation. The same can be said of the working models of machinery, the demonstrations of scientific experiments which were regularly held, and the way in which lectures and musical concerts were interlinked with the exhibitions. George Catlin's Indian Gallery, through his use of costumed interpreters, and his emphasis on integrated educational activities, anticipated many of the museum developments of today. As Catlin later recalled of his display in Liverpool in 1840:

> I kept several men in Indian costumes constantly in it, and twice a day gave a short lecture in the room, explaining the costumes and many of the leading traits of the Indian character, sung an Indian song, and gave the frightful war-whoop . . . During the last week of their noble exhibition, the children from all the charitable and other schools were admitted free, and in battalions and phalanxes they were passed through my room, as many hundreds at a time as could stand upon the floor, to hear the lectures (shaped to suit their infant minds), and then the deafening war-whoop raised by my men in Indian paint and Indian arms, which drove many of the little creatures with alarm under the tables and benches, from which they were pulled out by their feet; and the list that we kept showed us the number of 22,000 of these little urchins, who, free of expense, saw my collection, and having heard me lecture, went home, sounding the war-whoop in various parts of the town (Catlin 1848: 99).

Indeed, one can suggest that far more of value to current museum practice can be learned from such private museums and travelling

displays, than from the typical Victorian museums of glass cases and serried rows, which were simultaneously being developed.

The mechanics' institutes which spawned the exhibitions also have something to offer us, in the way that they integrated museums and galleries into a single educational and cultural institution, along with evening classes, days schools, libraries, and lecture and concert halls, within one building. The institutes also attempted, if largely unsuccessfully, to give working-class people access to this full range of cultural and educational facilities. Might not the mechanics' institutes offer a model for surmounting two of our most pressing current problems, namely, the isolation of museums and galleries from other cultural and educational institutions, and also the failure of museums to attract a working-class audience? This time, however, the aim must not be social control, but social liberation.

BIBLIOGRAPHY

Alexander, E. P., 1985. 'William Bullock: little remembered museologist and showman', *Curator*, 28 (2): 117–47.
Altick, R. D., 1978. *The Shows of London*, Belknap/Harvard University Press, London/Cambridge, Mass.
Bailey, P., 1978. *Leisure and Class in Victorian England. Rational Recreation and the Contest for Control, 1830–1885*, Routledge and Kegan Paul, London.
Brears, P. C. D., 1984. 'Temples of the Muses: the Yorkshire Philosophical Museums, 1820–50', *Museums Journal*, 84 (1): 3–19.
Catlin, G., 1842. *A Descriptive Catalogue of Catlin's Indian Gallery; Containing Portraits, Landscapes, Costumes, &c. and Representations of the Manners and Customs of the North American Indians*, Liverpool.
Catlin, G., 1848. *Catlin's Notes of Eight Years' Travels and Residence in Europe with his North American Indian Collection*, Vol. 1, London.
Clubb, J. A., 1922. 'The public museums of Liverpool', *Museums Journal*, 21: 164–6.
Cunningham, H., 1980. *Leisure in the Industrial Revolution, c.1780 – c.1880*, Croom Helm, London.
Diogenes, 1900. 'Some Institute recollections', *Liverpool Institute Schools Magazine*, 14 (3): 31–4.
Ettema, M. J., 1987. 'History museums and the culture of materialism', in Blatti, J. (ed.), *Past Meets Present. Essays about Historic Interpretation and Public Audiences*, Smithsonian Institution, Washington.
Gibson, M. and Wright, S. (eds), 1988. *Joseph Mayer of Liverpool 1803–*

1886, Society of Antiquaries in association with the National Museums and Galleries on Merseyside, London.

Greenhalgh, P., 1988. *Ephemeral Vistas. The Expositions Universelles, Great Exhibitions and World's Fairs 1851-1939*, Manchester University Press, Manchester.

Harrison, J. F. C., 1961. *Learning and Living, 1790-1860. A Study in the History of the English Adult Education Movement*, Routledge and Kegan Paul, London.

Hunt, C., 1974. 'Ethnography in Liverpool 1800-1900', *Museums Journal*, 74 (1): 15-16.

Kavanagh, G., 1990. *History Curatorship*, Leicester University Press, Leicester.

Kelly, T., 1952. 'The origins of the Mechanics' Institutes', *British Journal of Educational Studies*, 1 (1): 17-27.

Kelly, T., 1957. *George Birkbeck, Pioneer of Adult Education*, Liverpool University Press, Liverpool.

Kelly, T., 1960. *Adult Education in Liverpool. A Narrative of Two Hundred Years*, Department of Extra-Mural Studies, University of Liverpool.

Kelly, T., 1970. *A History of Adult Education in Great Britain*, Liverpool University Press, Liverpool.

Kusamitsu, T., 1980. 'Great Exhibitions before 1850', *History Workshop*, 9: 70-89.

Lane, T., 1987. *Liverpool: Gateway of Empire*, Lawrence and Wishart, London.

Liverpool Collegiate Institution, 1843. *Catalogue of the Great Polytechnic Exhibition, at the Liverpool Collegiate Institution, Mid-summer, 1843*, Liverpool Collegiate Institution.

Liverpool Collegiate Institution, 1847. 'Grand Polytechnic Exhibition' (advertisement placard), Liverpool Record Office.

Liverpool Mechanics' Institution, 1840a. *Report of the Directors of the Liverpool Mechanics' Institution to the Annual Meeting of Members, 1840*, Liverpool Mechanics' Institution.

Liverpool Mechanics' Institution, 1840b. *Catalogue of the Exhibition of Objects Illustrative of the Fine Arts, Natural History, Philosophy, Machinery, Manufactures, Antiquities, etc., Liverpool Mechanics' Institution, June 1840*, Liverpool Mechanics' Institution.

Liverpool Mechanics' Institution, 1841. *Report of the Directors . . . 1841*, Liverpool Mechanics' Institution.

Liverpool Mechanics' Institution, 1842a. *Report of the Directors . . . 1842*, Liverpool Mechanics' Institution.

Liverpool Mechanics' Institution, 1842b. *Catalogue of the Second Exhibition . . . 1842*, Liverpool Mechanics' Institution.

Liverpool Mechanics' Institution, 1842c. 'Second Exhibition at the

Mechanics' Institution' (advertisement placard), Liverpool Record Office.

Liverpool Mechanics' Institution, 1843. *Report of the Directors . . . 1843*, Liverpool Mechanics' Institution.

Liverpool Mechanics' Institution, 1844a. *Report of the Directors . . . 1844*, Liverpool Mechanics' Institution.

Liverpool Mechanics' Institution, 1844b. *Catalogue of the Third Exhibition . . . 1844*, Liverpool Mechanics' Institution.

Liverpool Mechanics' Institution, 1844c. 'The Third Exhibition at the Liverpool Mechanics' Institution' (advertisement placard), Liverpool Record Office.

Liverpool Mechanics' Institution, 1845. *Report of the Directors . . . 1845*, Liverpool Mechanics' Institution.

Mayer, J., 1842. *A Synopsis of the History of the Manufacture of Earthenware; with References to the Specimens in the Exhibition of the Liverpool Mechanics' Institution, 1842*, Liverpool.

Minihan, J., 1977. *The Nationalisation of Culture: The Development of State Subsidies to the Arts in Britain*, Hamish Hamilton, London.

Moore, K., 1987. ' "This Whig and Tory ridden town": popular politics in Liverpool, 1815–1850', unpublished MPhil. thesis, University of Liverpool.

Moore, K., 1989. 'Liverpool in the "heroic age" of popular radicalism, 1815 to 1820', *Transactions of the Historic Society of Lancashire and Cheshire*, 138: 137–57.

Morton, G. H., 1894. *Museums of the Past, the Present, and the Future, particularly those of Liverpool*, Liverpool.

Nicholson, S. and Warhurst, M., 1983. *Joseph Mayer 1803–1886*, Merseyside County Museums, Liverpool.

Ormerod, H. A., 1953. *The Liverpool Royal Institution. A Record and a Retrospect*, Liverpool University Press, Liverpool.

Pearce, S. M., 1989. 'Museum studies in material culture: introduction', in Pearce, S. M. (ed.), *Museum Studies in Material Culture*. Leicester University Press, Leicester.

Prothero, I. J., 1979. *Artisans and Politics in Early Nineteenth-Century London, John Gast and his Times*, Dawson, Folkstone.

Royle, E., 1971. 'Mechanics' Institutes and the working classes, 1840–1860', *The Historical Journal*, 14 (12): 305–21.

Thompson, E. P., 1968. *The Making of the English Working Class*, Pelican, Harmondsworth.

Tylecote, M., 1957. *The Mechanics' Institutes of Lancashire and Yorkshire before 1851*, Manchester University Press, Manchester.

Wainwright, 1960. *Liverpool Gentlemen. A History of Liverpool College, an Independent Day School, from 1840*, Faber, London.

Index